The Joy of Photographing People

The Joy of Photographing People

The Editors of Eastman Kodak Company

Addison-Wesley Publishing Company

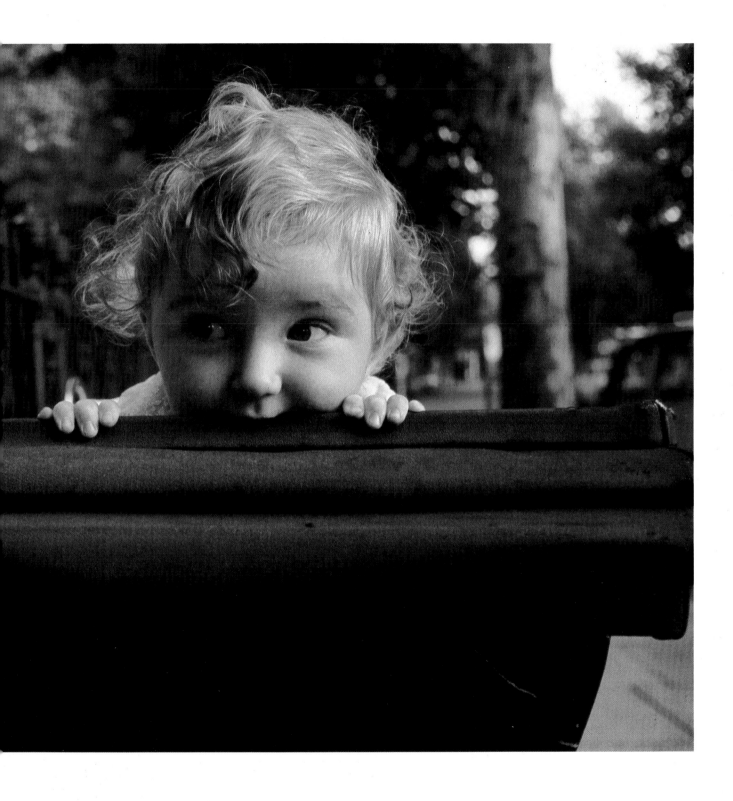

The Joy of Photographing People Staff

Eastman Kodak Company

Keith A. Boas	Editor
Paul F. Mulroney, Jr.	Managing Editor
Charles W. Styles	Production Supervisor
Annette L. Dufek	Production
Grace Brown	Editorial
Rosemary Coleman	Editorial
Judith L. Johnston	Editorial
Tom Beelman	Technical Photography
Robert Clemens	Technical Photography
Martin Czamanske	Technical Photography
Norman C. Kerr	Technical Photography
Steve Labuzetta	Technical Photography
Neil Montanus	Technical Photography

Addison-Wesley Publishing Company

Lori Snell	Editor
Doe Coover	Executive Editor
Barbara Wood	Managing Editor
Paul Souza	Designer, WGBH Design
Jim Georgeu	Manufacturing
Ann DeLacey	Manufacturing
Amy Bedik	Photo Researcher
Donald Earnest	Writer
Stuart Cohen	Writer
Gerry Morse	Copy Editor
Kendra Crossen	Copy Editor
Joan Croce	Indexer

BCDEFGHIJ-KR-876543
Second printing, November 1983

Library of Congress Cataloging in Publication Data
Main entry under title:
The Joy of photographing people.
 Bibliography: p.
 Includes index.
 1. Photography – Portraits. I. Eastman Kodak Company.
TR575.J64 1983 778.9'2 83-12215
ISBN 0-201-11694-4
ISBN 0-201-11695-2 (pbk.)

The Joy of Photographing People
was set in the Zapf International family of typefaces by Graphic Typesetting of South Boston, Massachusetts.

The design and production were supplied by WGBH Design, Boston, Massachusetts.

The color separations and camera work were supplied by Color Response, Inc., of Charlotte, North Carolina.

W. A. Krueger Company of New Berlin, Wisconsin, printed and bound the book on 70-pound Celesta Web Gloss stock supplied by Westvaco Corporation.

KODAK, EKTACHROME, KODACHROME, KODACOLOR, VR, PANATOMIC-X, PLUS-X, and TRI-X are trademarks of Eastman Kodak Company.

Cover photographs:
(Front) Walter Ioss/The Image Bank
(Back, clockwise from top left) David Burnett/Stock, Boston; Eric L. Wheater/The Image Bank; Rene Burri/Magnum

Contents

Introduction

Part I

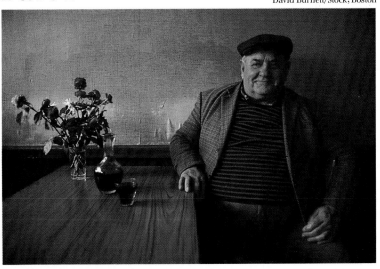

A World of Expression

Part II

Rene Burri/Magnum

Tools and Techniques

Part III

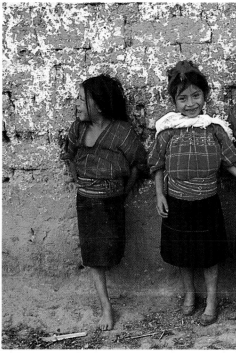

Photographing People

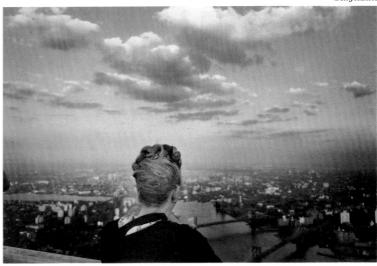

Appendix

Introduction

The joy of capturing people on film is one of the most universal pleasures in photography. We use photography to remember the special times and people of our lives, to document the events of our world, and to express our personal vision about humanity everywhere. As diverse as our reasons are for taking photographs of people, so too are our reactions: pictures of people can make us smile and laugh, cry and feel pity, or become nostalgic. Yet such images, whether they are of the people we know best or ones we have never met, have a universal ability to move us profoundly, touching our emotions at their most human core.

The Joy of Photographing People is designed to help you take better pictures of people, to see the message in faces, to capture the special moments and people in our lives. And although this book contains a wealth of technical information for the seasoned photographer to use, the novice, too, will absorb much simply by listening to the constant refrain that to see better pictures of people is to take better pictures of people.

In Part I, **A World of Expression,** we examine the vast and varied world of people photography. People have long been photographers' favorite subjects, and in this section we look at a brief history of people photography, as well as dozens of ways you can become a better observer of people – the first step toward being a better photographer of people.

Part II, **Tools and Techniques,** reviews the basic technical information you need to be a competent camera handler. With special emphasis on the equipment and techniques necessary for taking good pictures of people, this section covers cameras, lenses, film, exposure, composition, and light. A special section illustrates how a portrait studio is set up.

Finally, Part III, **Photographing People,** presents over one hundred pages of advice and instruction on taking the best possible pictures of people. Arranged by the many types of photographs you take, this section features ways to photograph:

Children – from babies to adolescents, including how to photograph a child's special world and groups of children

Families and Friends – how to photograph family events, including reunions and weddings, older people and groups

Portraits – advice on taking portraits of people at work, at home, in groups, or alone, with a special section on self-portraits

Photojournalism and Travel – from street photography and news documentation to feature story pictures and vacation and travel photos

Sports – how to capture the excitement of sports, with tips on photographing peak action and faces

Theater, Dance, and Fashion – how the professionals photograph the arts, and what you can learn from them

The Nude Form – photographing the figure, with special sections on lighting, posing, and shape abstractions

Interviews with professional photographers, including Lucien Clergue, Joel Meyerowitz, Neal Slavin, and Mary Ellen Mark, highlight their work and offer tips from which everyone can benefit.

An appendix tells you how to display your photographs, as well as how professionals can restore old pictures.

We at Kodak and Addison-Wesley hope you find *The Joy of Photographing People* both inspiring and instructional. It has been designed to be as accessible, as informative, and as beautiful as its predecessors, *The Joy of Photography* and *More Joy of Photography*. And yet in many ways it is the most valuable of all these titles, for it addresses the type of photography we like to do most of all – photographing people.

A World of
Expression

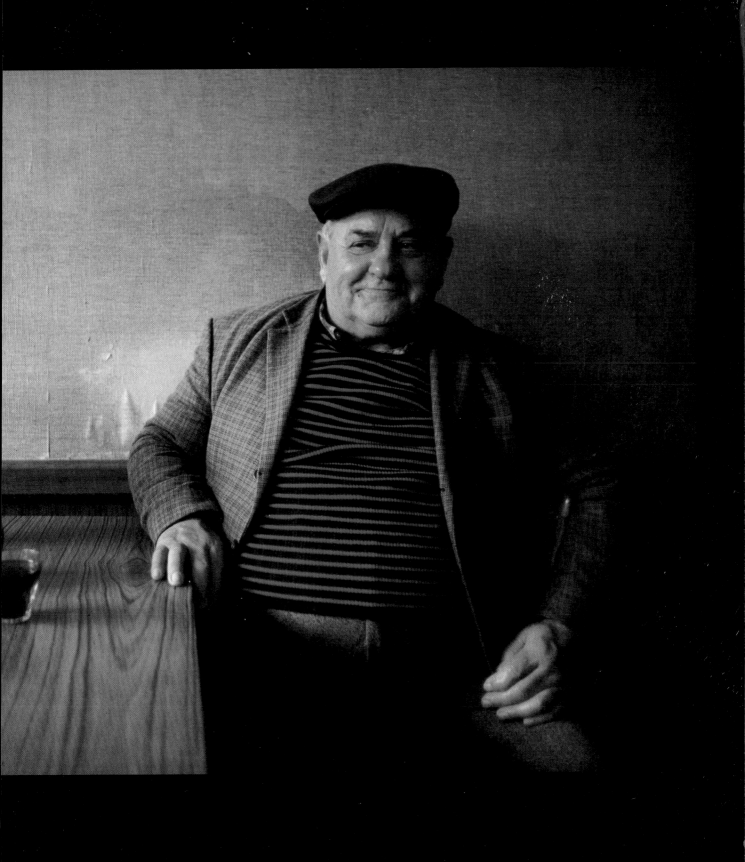

Our Favorite Subjects

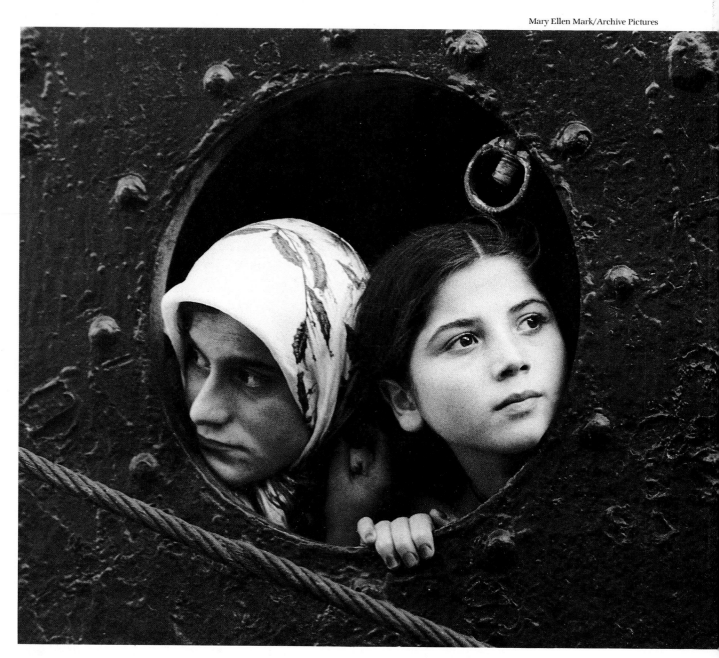

Two immigrant women look hopefully through a ship's porthole, their faces poignantly framed. Without knowing their reasons for passage we can sense their anticipation.

People have long been photographers' favorite subjects. Many of the earliest photographs were portraits, as pioneer photographers attempted to mimic the prevailing art form of the day – portrait painting. When photography was made available on a wider scale, thousands of people flocked to have their images engraved on tin and preserved for posterity.

Our motives for taking pictures of people haven't changed much since those early days. Now, as then, we seek to preserve the faces of those who are special to us, to record the scenes and people who carry a message to our viewers, and to convey universal feelings about humanity.

People are a continually fascinating source of subjects. From formal portraits to candid street photography, from family reunions to world news events, the world of people photography is a vast and varied one. You have only to sit on a park bench for an hour, observing people as they pass, to know how uniquely interesting each individual is. To the photographer, whether amateur or professional, this variety presents a wealth of challenges – to capture an expression, remember a character, preserve a face.

We take pictures of people for a variety of reasons. For many, the principal motive is to record the changing scene of life around us – children as they grow, family events that occur all too seldom, or special moments with loved ones. For others, people photography is a means of self-expression or social commentary. For still others, it is a way of life, a professional career in which they invest years of hard work and dedication.

No matter the motives – or the subjects – people photographs are the ones that touch us most deeply. We identify with the human condition, be it frightened and lonely or ebullient and joyous. Only a photograph can so accurately capture all the nuances present in human interaction, whether it is children gathering to play or immigrants staring hopefully from their freedom-bound vessel. Photography calls on us to bear witness to our fellow human beings – and to share their experiences.

Photographs of people thus reach our very core of humanness – the need to understand life. We all want to know who we are and why we are here. Photography is uniquely suited to this quest because it isolates moments of our lives, allowing us to scrutinize them, and because it continually teaches us anew about ourselves and others. Ultimately, photographing people aids us in the process of self-discovery.

Adam Woolfitt/Woodfin Camp

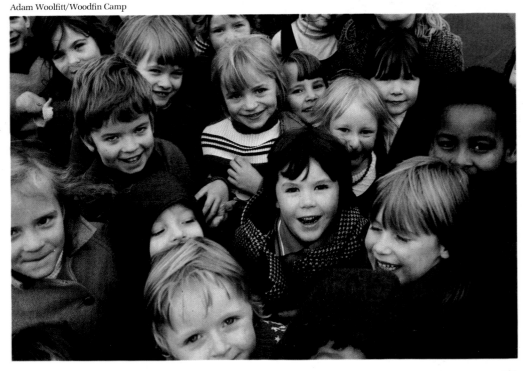

Happy children are universal subjects for photographs. Their spontaneity and aliveness touch our hearts, for we recognize the joy of childhood.

A Way of Communicating

Roberto Brosan/The Image Bank

"The whole point of taking pictures is so that you don't have to explain things with words," comments well-known photographer Elliott Erwitt. While this may seem something of an exaggeration, it is a fact that we receive over 80 percent of our information about the world through our eyes, and less than 10 percent through words. Thus photographs deal with the most receptive of our senses and are a powerful means of nonverbal communication. And pictures of people speak most eloquently to us, revealing more character in the click of a shutter than could be described in thousands of words.

Photographs reach others directly. And every photograph conveys a multitude of messages. You can look at the same photograph time after time and always find some new meaning or memory in it. New details surface for the first time, or suddenly the picture takes on a nostalgic dimension. And different people can look at the same photograph and see different things. An evocative portrait of a lonely child might bring back memories of a sad childhood for some, while for others the image may speak to the needs of children everywhere.

For you as a photographer, too, a picture can be a way of communicating a message. We all have trouble expressing what we think or feel sometimes, and photographs can often help articulate those thoughts. Many professional photographers started taking pictures because they had something to say but were too shy. Others recognized the potential in photography to convey more than one idea at once. For all photographers, however, whether your subjects are a royal family or your own children in the backyard, the camera allows you to express what you feel about the people you're photographing.

Finally, photography is a form of nonverbal communication between the subject of a photograph and the viewer. Through the subject's pose, facial expression, and surroundings, we immediately identify with the person and the human qualities being conveyed. And even though we may not know the subject personally, we seem to comprehend who he or she is – and what the person is like. A rapport is established that takes place entirely in the mind of the viewer. The magic of photography comes full circle.

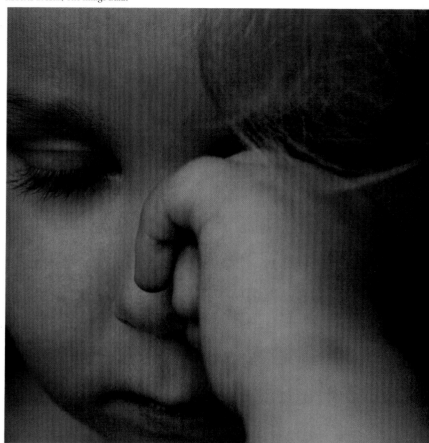

We have all been touched by the tenderness of a sleepy child. This tightly cropped photo has all the visual elements – the tired face, rubbing hand, even the wispy curls – that say this little one is ready for bed.

Marcia Lippman

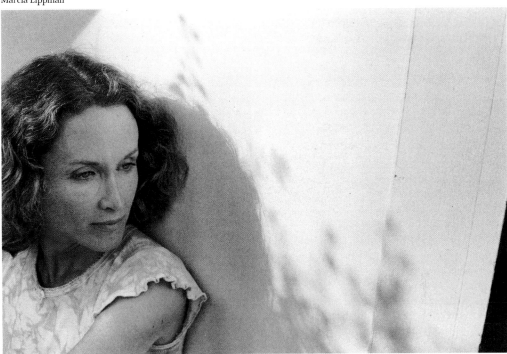

Anestis Diakopoulos/Stock, Boston

This woman's face tells us instantly that her solitude welcomes no intruders.

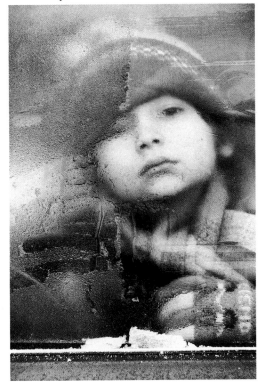

The reflective mood of this child's face speaks to the loneliness of a cold winter day spent without play-mates.

The Message in Faces

When people are the subjects of pictures, it is usually their faces that hold our interest. A person's face can convey so much in a single expression; the emotion captured in the instant of picture-taking tells a story to the photo's viewer, whether it concerns a small boy's pride in his new pet or a mother and child's playful, joyous love. Faces tell us what people are all about – where they have been and where they are going.

The human face is capable of an infinite variety of expression, much of it subtle and fleeting. "What is there that is more fugitive and transitory than the expression on a human face?" asks Henri Cartier-Bresson, one of the most influential photographers in history. To capture that one expression, that one glance, which sums up a person's emotional character is a challenge facing photographers of all levels.

Photographing people successfully depends on a great many factors, some of which are technical and will be discussed later in this book. But mainly it is a question of observing people closely. One hardly needs to work at looking at faces. We do it every day – with photographs, television, the people we know and meet. And for the most part it is a person's face that first attracts us; we can look at someone's eyes and know he or she is a person we can trust or someone we want to confide in.

Yet too often we look past people's faces – especially those of people we already know. We fail to see their changing expressions. To be a good photographer of people, one must constantly look anew at people. Examine faces with freshness and openness, recognizing that each person is both similar to and different from every other person – including yourself.

To capture a person's essence you must show the qualities that make that person distinct and particular as well as the ones that are universal. It is a task that requires you to be open and free, to mold your picture-taking to a person as he or she changes instant by instant. Diane Arbus, whose pictures cut through our preconceived notions about the unusual subjects she photographed, said, "The thing that's important to know is that you *never* know."

Chester Higgins, Jr./Photo Researchers

You often do not know about people in a logical, verbal way. But what you sense and feel about a person can be transmitted visually through the marvelous, wordless medium of photography.

The unbridled joy between this mother and child is enhanced by the child's stance and jubilant gesture.

Ernst Haas

Neil Montanus

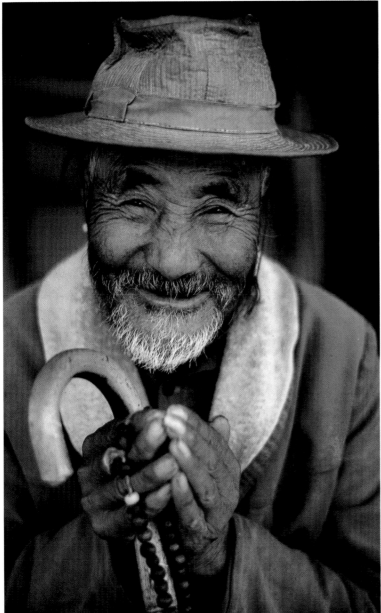

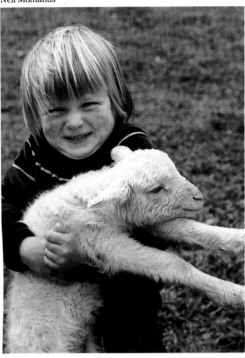

A youngster and a baby lamb make a cheerful, if somewhat precarious, pair of subjects.

This man's prayerful yet welcoming gesture is one no language barrier could impede.

17

Capturing Special Moments

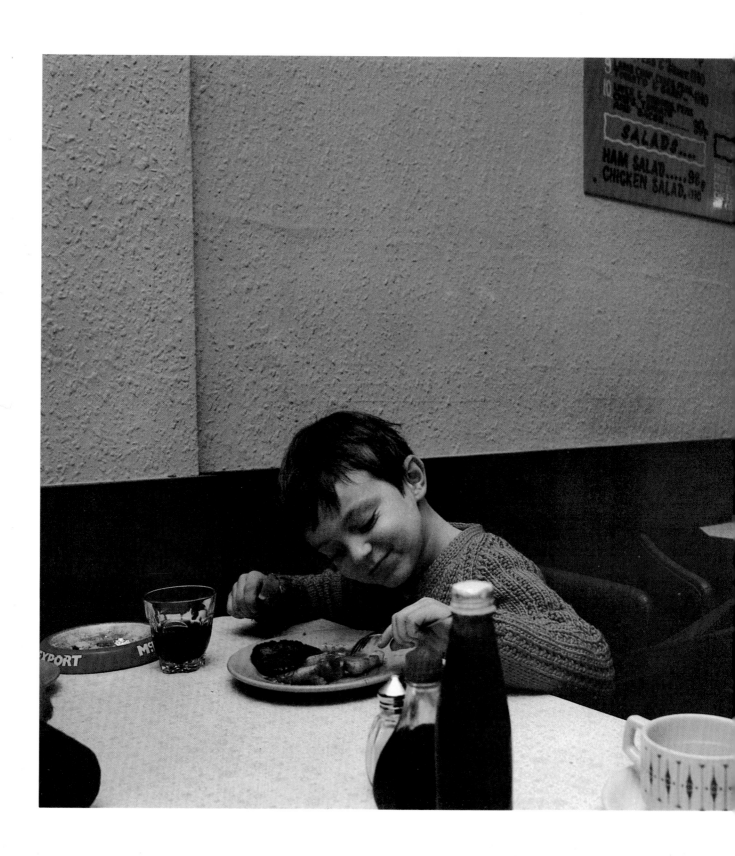

Leo Rubinfien

People are the most exciting subjects to photograph because they are always changing. Facial expressions and body positions shift constantly. Interactions between people happen quickly, reach a peak in an instant, and are gone. The best photographs of people reflect this dynamic spirit of their subjects.

To capture the special moment is the great challenge of photographing people, and to do it requires skillful timing. This is true of all types of people photography. In journalistic photography, timing is necessary to get the picture that best tells the story. At a sporting event, peak action happens unpredictably and passes in seconds. Good timing is necessary for portrait photography, too. Even the most carefully posed portrait subject changes expression frequently, and the successful portrait will capture the moment in which the face is the most expressive, the most natural.

Good timing requires an attentive eye and quick reflexes. You first must see the perfect moment before you can photograph it. Better still, you must learn to anticipate it, to have your picture planned and your camera ready when the elements of a scene come together. In some photographs of action the peak moment will be a split-second one; you'll want to capture the batter just as bat meets ball, or the youngster about to come down the slide. For such fast-action shots you actually need to click the shutter an instant before the moment is at its peak.

For other photographs, such as the one here, the peak moment relies more on expression, lighting, and subtle movement. Henri Cartier-Bresson calls this the decisive moment, when all the aspects of a scene come together perfectly. Here we sense the boy's enjoyment of eating in a restaurant – perhaps for the first time. For this

photographer, capturing the special moment meant framing the scene carefully and waiting for the appropriate moment when the boy's expression and posture were best.

You can practice timing every day by looking carefully at faces and interactions and judging which moments seem to express the people or events best. The effort you put into learning good timing will be repaid by pictures that capture the excitement and aliveness of the people you photograph.

By allowing the menu sign and the table condiments to be included in this picture, the photographer offers unmistakable clues as to the location – and to what makes this moment so special.

A Combined Effort

Even though it is the photographer who clicks the shutter and takes a picture, photographs of people are always the result of a combined effort between photographer and subject. People photographs are unique in this fashion: they represent the interaction of two human beings. Even candid photographs in which the subjects are unaware of the photographer's presence require the subjects' participation: it is, after all, their actions that motivate the photographer. Of course, in situations where the subjects face the camera or pose for it, they are full partners in the photographic process.

Having people pose for pictures can be more difficult than snapping candids, but it can also be more rewarding. The photographer must be prepared to sacrifice a certain amount of spontaneity and perhaps to get only self-consciousness in return. Yet by interacting directly with the subject, a photographer gains control and can produce an image with startling immediacy and human feeling. Through conversation and suggestions about pose, expression, and setting, the photographer can create the image he or she envisions. The photographer can also inspire particular attitudes in a subject.

In the pictures on these pages we see three very different emotions; each of the subjects seems to be saying something different to the viewer. But they are all strong and clear messages.

When you photograph someone you know well, a family member or a good friend, the interaction changes dramatically. Sometimes all it takes is one word – "Smile!" – and the eager ones mug for the camera. At other times you may have to coax a shy person into letting you take his or her picture. In either case the interaction can produce rich, memory-filled photographs you will treasure. For what you have captured on film is not only an image of someone you love; it is also a reflection of the love between you.

Evelyn Hofer

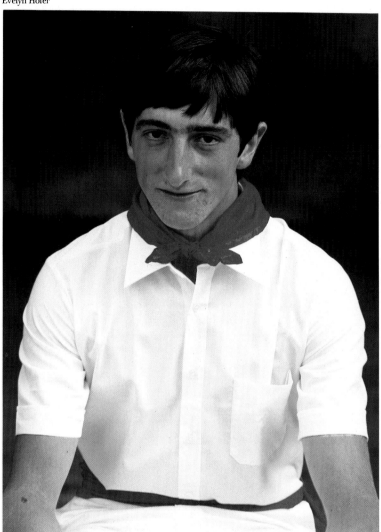

The colors are rich, the pose is straightforward. The photographer wisely chose a direct interaction with her subject to preserve this young man's intensity.

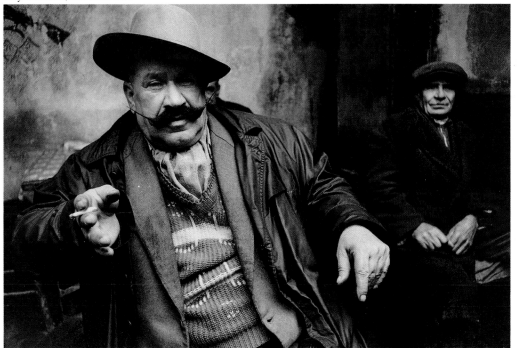

People come to life when they interact with other people. This man's gesture would not be nearly so expressive were he not consciously interacting with the photographer.

By letting these boys pose themselves, the photographer shows them as they want to be seen. As we look closer, we see both their similarities and differences. The boy on the left, for example, seems more comfortable being photographed than the one on the right.

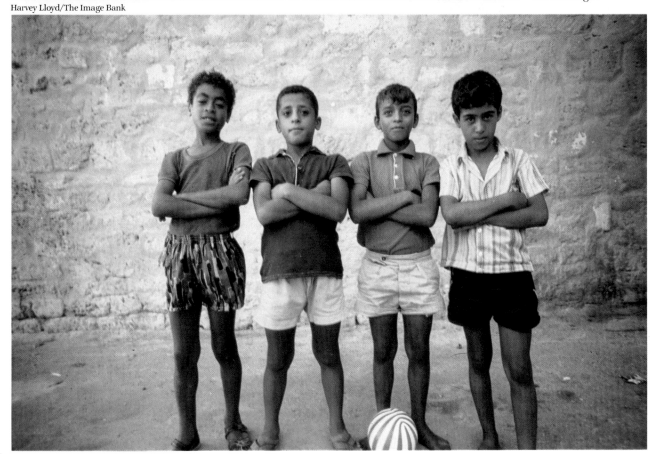

Why Photograph People?

The reasons we take photographs of people are many and varied. And these reasons can change as your picture-taking situations change. You may take a great many photos to record your family milestones, whereas the pictures of architecture or flowers you take reward you aesthetically and help you convey ideas about design and beauty. As your picture-taking reasons and situations change, so do the techniques you use. Thus understanding what motivates you to take photographs will help you become a more effective and successful photographer.

By far the most basic – and most popular – reason people take pictures of other people is to have a keepsake. Our pictures of family and friends show who we were and what we looked like at those times in our lives. These pictures evoke memories of people who perhaps are gone and places we may never see again. They celebrate once-in-a-lifetime events and capture simple day-to-day happenings that might otherwise be overlooked and forgotten.

Sometimes these pictures are planned; more often they are spontaneous. As the two pictures on these pages show, both can be very successful. And while it is important to document family events such as reunions, holidays, and birthdays, it is also nice to have recollections of quiet, tender moments, the everyday occurrences that are part of being human. Sometimes these moments will seem too mundane to photograph, but remember that it is frequently these "unspecial" times that provide us with the most "special" memories.

When taking pictures of family and friends, there are a few guidelines to remember: get close enough to your subjects to show their faces well, aim for sharp, well-exposed images, and be patient! No matter how comfortable some people are in front of the camera, there are always others who respond shyly or uncomfortably. Help them relax and you'll see better, more natural-looking pictures as a reward. These and many other tips will be covered later in this book, and through them you will learn how to photograph the important people and special times in your life, to produce the fullest and most beautiful record.

James Carroll/Archive Pictures

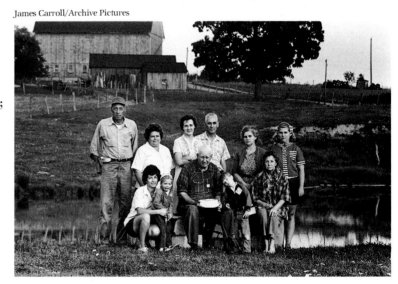

Family pictures are our personal souvenirs, remembrances of the important people in our lives. Gathered in front of their farm, this family's portrait offers a remembrance of their livelihood as well.

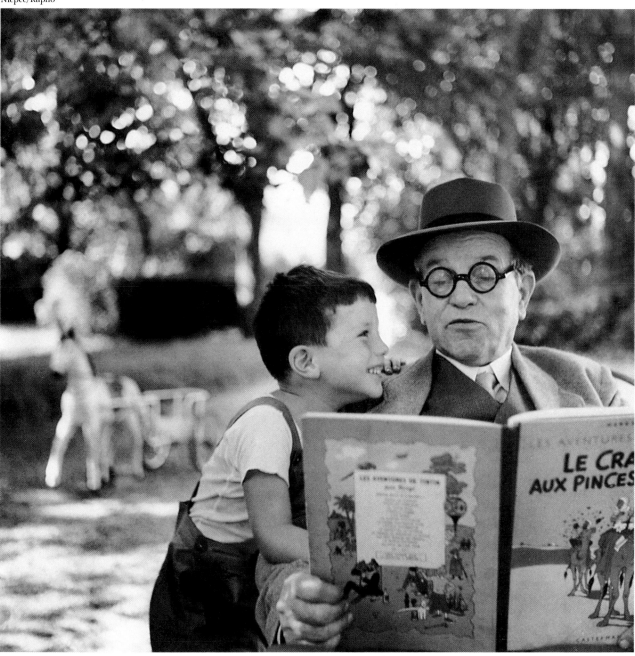

Sometimes the simplest things make the happiest pictures. Here a grandfather-grandson outing is a delightful remembrance of an everyday occurrence.

Why Photograph People?

Sometimes the photos you take are, like family photos, a document of people and places. However, these pictures may be intended for other people's eyes. Whether photography is your profession or simply a serious hobby, the concerns of photography for others are the same. The range of subjects and settings can be enormous, as the pictures here show. The work can be done outdoors on location or in a studio, using models or real people. And whether you are working chiefly in photojournalism, portraiture, fashion photography, or any other form of commercial photography, there are special considerations that set this type of photography apart from more casual family photography.

When you photograph for someone else, your approach automatically changes. You can no longer photograph simply what you like; your priority is now what another person wants. In planning these kinds of pictures, try to think as if you were that other person, and take your pictures according to his or her desires.

For example, if you were covering a high school football game for the school yearbook or local paper, you'd approach it much differently from the way you would if you wanted pictures of your son or brother playing in the game. In approaching the game, you would look for important players and key plays, concentrating your efforts more near the goal line when the teams were about to score than at midfield when not much was happening.

In documentary photography or photojournalism, too, your thinking would probably shift. This time your priority would be to get a picture or a series of pictures that tell a story. This requires objectivity – assessing what is happening and figuring out how to get the picture that best shows it. You may need to include more hard information than you would in a personal picture. When you are taking pictures for others' eyes, your message must be clear and understandable.

Charles W. Bush/The Image Bank

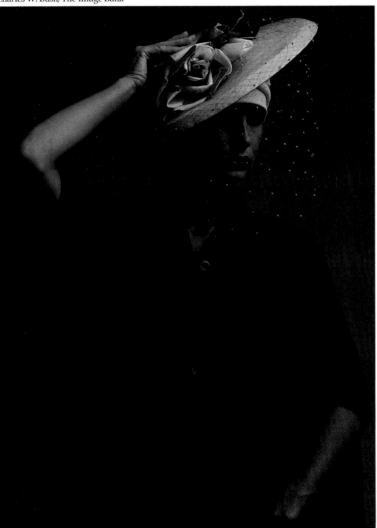

Full-time professional photography is a giant step from even the most advanced amateur work. As a career, it has many rewards, but it can be very difficult and frustrating. It takes stamina, business acumen, and, of course, talent. Above all, you should love photography if you are going to do it for a living. But if you truly love the simple act of making a photograph, you will find joy and satisfaction in your work, whether your pictures are seen by millions of others' eyes or just your own.

This fashion photograph highlights the real subject of the picture – the hat. The model's face becomes a mere accessory.

Richard Noble

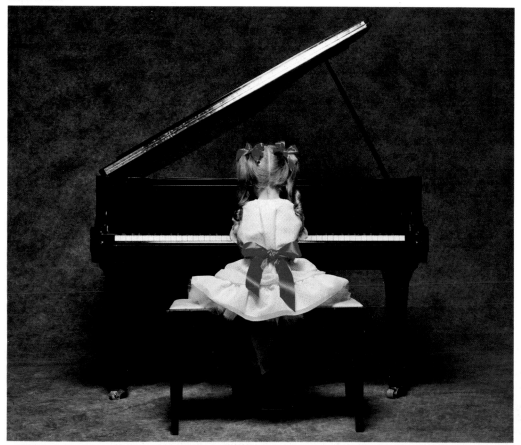

We learn about this young girl's character not from her face but from the details of her hair and dress and her position at the piano. It is the photographer's creative approach to a studio portrait that makes the picture successful.

Well-known photographer Neal Slavin purposefully posed these two stately businessmen in front of the most distinguished symbol of their community.

Neal Slavin

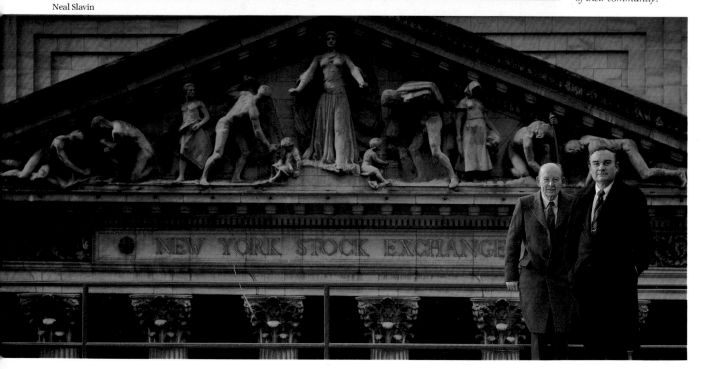

Why Photograph People?

Those photographs we all take that go beyond a simple record and are not taken for other people serve another purpose in our lives. They fulfill our need to express ourselves. Everyone has this expressive urge. We find ways to exhibit it in our work and our hobbies – even in conversation and the way we dress or decorate our homes. Photography offers us a special realm for self-expression because it produces a series of lasting images that, collectively, become a reflection of us. And in people photography the challenge is particularly interesting because the resulting image will say something about both the subject and the photographer.

Every photograph is self-expressive to some extent, for to take even the most practical of images requires aesthetic decisions that only you, as the photographer, can make. The angle of the camera, the distance between yourself and your subject, the time of day you choose to photograph: these are all rudimentary concerns that have expressive impact.

As your photographic skills and confidence increase, so will your quotient of self-expression in each image you take. You may begin to use certain creative techniques or to develop a personal style of photography that you feel most enhances your work. Perhaps your style is to photograph rich colors that stimulate the emotions; perhaps you always include empty space in your pictures so that the people seem alone; perhaps you enjoy using unusual techniques, as in the pictures here, to accent your message in photos. Whatever your style, it is a natural evolution of the skills you learn and your own aesthetic impulses.

How do we know which pictures are the truest expression of ourselves? They are the ones that seem most subjective in the taking and provide the greatest inner satisfaction to view. They are the ones that capture the emotions you felt when you lifted your camera.

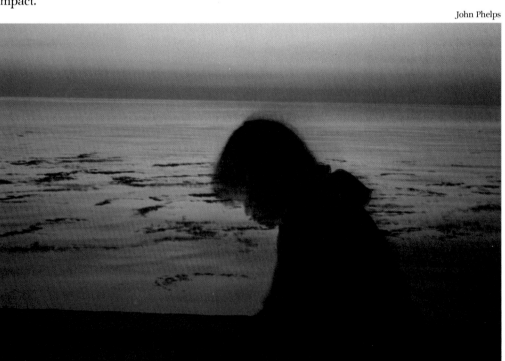

The quality of light and the inherent mood in this photo create a unique experience. The intimacy it conveys strikes a chord in each of us.

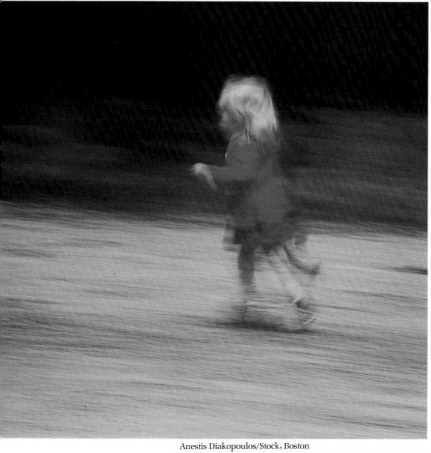

Self-expression in people photography sometimes means using a creative technique. Here, panning accentuates the child's movement.

Anestis Diakopoulos/Stock, Boston

Sometimes a single detail can capture our imagination more strongly than the surrounding image. These soiled hands and dirty uniform also tell us much about this high school football player.

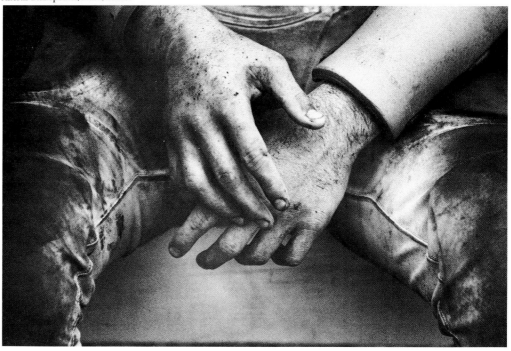

History: A New Invention

It was an incredible phenomenon, this new invention that came to be known as photography. For the first time in history, the image of a person could be captured.

Several inventors in England and France had been experimenting with light-sensitive materials in the 1830s and 1840s. But it was Frenchman Louis Daguerre's little "mirror with a memory" that emerged as the first commercially successful photographic technique.

Within a decade after Daguerre had perfected his discovery, enterprising daguerreotypists set up shop in virtually every major city in Europe and America, eager to provide portraits of the local citizenry. Peasants and landowners alike flocked to these portrait studios, and families often called on photographers to take a picture of a relative who had recently died, since this was the only way they could have an accurate remembrance of the deceased.

Of course, early photography, in which an image was exposed directly onto a silvered metal plate, had many limitations. The pictures were small and fragile, and the equipment was cumbersome and inflexible. Subjects had to sit motionless for half a minute or more (which explains why daguerreotype subjects often look rigid and have such blank expressions), and each photograph had to be developed immediately after taking.

Still, early photography was very successful. Never before had an exact likeness been available. And for two dollars, it was far cheaper than hiring an artist to paint a portrait.

The advent of the tintype in 1856 popularized photography even further. Tintypes used a simpler process and cheaper materials to place an image on a black-backed piece of metal. Tintypes were very inexpensive, and soon most families had an album full of family portraits – hence the origin of the family photo album. Although tintypes were still only black and white, cheeks were often tinted pink by hand to give faces a rosier, more lifelike look.

After the tintype, photographic technique advanced quickly. Within a few years a negative-to-positive process had been developed. This meant a single image, recorded on a glass negative, could be reproduced many times and at a much lower cost than other methods.

Barton • 108 HURON AVE.
PORT HURON, MICH

The *carte de visite* (French for "visiting card") became the standard in photography. These newer pictures, printed on paper for the first time, became fashionable to collect. Soon *cartes de visite* of royalty and other celebrities found their way into photo albums on both sides of the Atlantic.

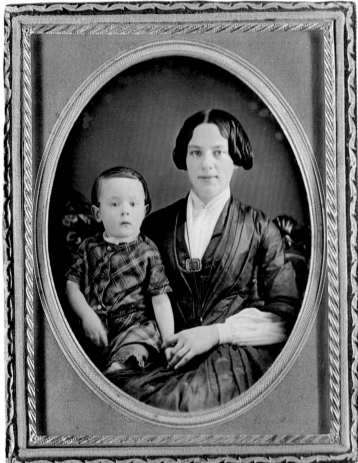

Collection of Kenneth E. Nelson

Collection of Keith Boas

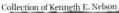

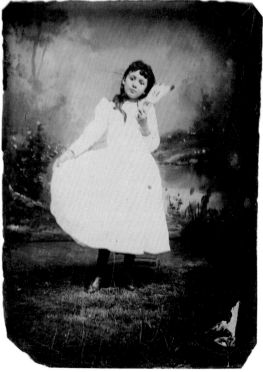

(Above) These pictures, shown actual size, represent a sampling of early photographs. *Daguerreotypes,* such as the one at top left, for the first time allowed people to obtain an image of friends or loved ones. With the advent of *tintypes,* such as the two pictures shown at right, photographs of people were more readily accessible to a large segment of the populace. Cartes de visites, *as shown above right,* allowed photographers to produce multiple images on paper. (Opposite) *Cabinet cards* were produced similarly to cartes de visite *but were larger in format and never gained the immense popularity of* cartes de visite.

History: An Expanding Vision

Julia Margaret Cameron/The Metropolitan Museum of Art, McAlpin Fund, 1952

While commercial photographers churned out portraits for the masses, artists saw photography in a new and different way. If photographs could show people and scenes exactly as they looked, the artist reasoned, why not arrange the subject matter to make a visual statement? Thus photographers began taking still-life photographs, as well as carefully posed allegorical photographs that preached the local morality of Victorian times.

Some artists turned to fine portraiture, seeking to reveal more about a subject than a commercial portraitist could. Julia Margaret Cameron devoted her passion to photographing some of England's best-known literary figures, faithfully recording "the greatness of the inner as well as the features of the outer man." Lewis Carroll made sensitive, pensive portraits of his favorite child, Alice Liddell, later to become the inspiration for *Alice in Wonderland.*

Other photographers traveled, using the still-young medium of photography to reveal worlds most people would never see; for the first time true glimpses into the exotic lands of Egypt and the Orient were available to the mass public. When the Civil War broke out, Mathew Brady and his intrepid assistants documented the armies, the battles, and the casualties of war. In the American West, Edward Sheriff Curtis embarked on a thirty-year project to photograph all the Indian tribes of western North America before they were wiped out by the white settlers' consuming march to the Pacific.

By the early 1900s photography had begun to be used as a medium of personal expression. Jacques-Henri Lartigue's photos, taken before he reached the age of fourteen, show a childlike fascination with adults, cars, and flying machines. Eugene Atget sought to "collect" the artistic and picturesque side of Paris. His elegant photographs of buildings and people alike reveal the humanness and empathy of his vision. Meanwhile, Alfred Stieglitz, with masterful composition and impeccable honesty, emerged as America's premier photographer of everyday life.

Photography as art had arrived. The number of exhibitions soared as the world began to recognize the photograph for its uniquely instantaneous and artistic means of communicating about the world.

This photograph is by Julia Margaret Cameron, a British photographer who worked in the second half of the nineteenth century. Her work is characterized by sensitive, lyrical portraits such as this one, called "Enid."

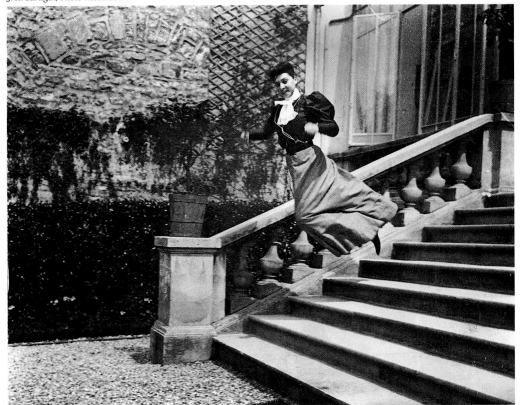

One of J. H. Lartigue's most famous images, this photograph, taken in 1905, when Lartigue was an eleven-year-old child, was one of the first to capture such exuberant motion.

French photographer Eugene Atget lived in Paris from 1857 to 1927. His work, much of it produced in the last third of his life, provided a documentary of the people and architecture of his city.

Edward Curtis provided a visual documentation of America's Indian life, soon to be a vanishing culture. The Indian girl pictured here is from the Qahatika tribe.

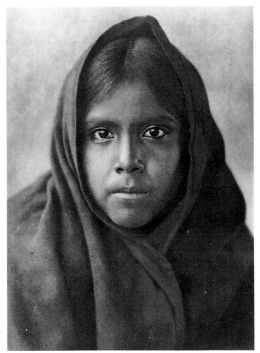

History: A World Revealed

Although photography had begun to establish itself as an art form, it was not until the first decades of the twentieth century that photography also gained serious social impact. This medium, which had been primarily an interesting phenomenon of art and recreation, quickly became the tremendous influence on our lives that it is today.

When new technology permitted the reproduction of high-quality halftoned images, the photograph became an important vehicle for conveying the news. Stories that previously had to be interpreted through written articles or line drawings could now be illustrated realistically. The effect of a visual, often unpleasant confrontation with hard reality was astonishing.

Photographers realized this evocative characteristic of their medium. Many set about documentaing elements of society that had heretofore been hidden. Jacob Riis, a journalist horrified by the squalid living conditions of lower Manhattan, photographed poverty, overcrowding, and the hopelessness on the faces of the people who lived there. Lewis Hine, a sociologist, sympathized with the social underclass, particularly the vast numbers of immigrants who were pouring into New York. His eloquent pictures of small children toiling in the sweatshops were a major factor in the institution of child labor laws.

Later, during the Depression, even the federal government recognized the power of photographs to arouse feelings and influence people. The government-sponsored Farm Security Administration photographers made poignant statements about how Americans lived through these difficult times. Dorothea Lange, who had been a successful portraitist, covered the plight of the migrant farm workers in California. Walker Evans, more of an art photographer, shifted his attention to life in the South. Among his most famous subjects is a family of sharecroppers in Alabama, whose lives would be unimaginable to most Americans without those pictures.

Good photographs were available to more and more people. *Life* magazine was born in 1936, and with it the picture story became a regular weekly feature in homes across the United States. The world became

Jacob Riis was an American reporter turned reformer who used photography to depict the squalid living conditions in New York's immigrant ghettos. This photograph, taken in 1890, shows the only sleeping quarters this man had had for four years.

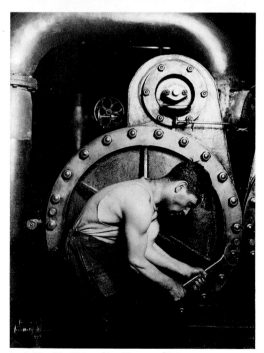

Another American documentary photographer who sought to improve poor conditions through his work, Lewis Hine worked in the emerging industrial sectors of America. Although this 1920 photograph shows an adult steamfitter at work, Hine's main interest was photographing child labor in order to end such exploitation.

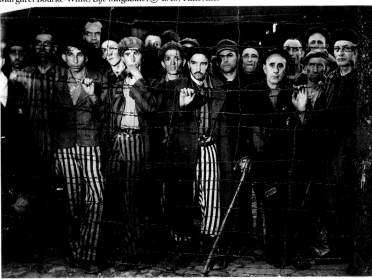

During the Depression the government hired many fine photographers to travel across America, documenting the country's life in the 1930s. Walker Evans, whose work continued through the early 1970s, captured this evocative portrait of a sharecropper.

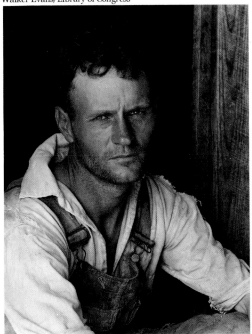

One of America's finest photojournalists, Margaret Bourke-White covered World War II for Life *magazine. Her compelling photos of the atrocities of war, such as this one of Buchenwald concentration camp in 1945, brought a different dimension of the struggle home to readers.*

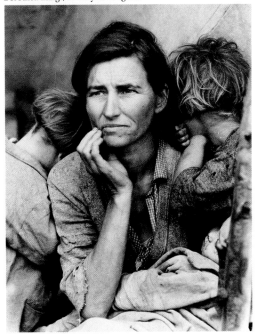

smaller, more familiar, as photographers such as W. Eugene Smith showed the work of Dr. Albert Schweitzer in Africa. Margaret Bourke-White, ever the searching journalist, covered the statesman at the spinning wheel, Gandhi, in India. Her pictures of the vacant faces in German concentration camps brought World War II home to Americans even more than the images of soldiers and battles.

Photography had changed the way we all live by making the world known to us. The scope of our education and knowledge had been expanded by pictures. No longer could there be an event of importance that wasn't recorded for posterity in a photograph.

Perhaps one of the most famous images to emerge from Depression photographic efforts, Dorothea Lange's memorable portrait of a sharecropper woman and her children speaks to the sadness and hardship wrought by the Depression.

History: A Personal Vision

During the last half-century, photography has taken its place as the medium of personal vision, of commentary about life. Portraiture, in particular, has long since stopped being simply about appearance. Modern portraitists always try to show character and personality, to convey in a single image the way one human being sees and feels about another.

An important early "modern" portrait photographer was August Sander, a German who worked in the 1930s. Sander's ambitious project, cut short by the Nazis' rise to power, was to photograph all the archetypes of German life, thus forming a composite image of his age.

In America, Edward Steichen created technically sophisticated portraits of well-known figures. Steichen relied on a high level of energy and interaction between photographer and subject to produce captivating images that seemed grander than life. Edward Weston became famous for his abstract images of the human form, as well as glistening close-ups of green peppers and other vegetables.

Yousuf Karsh of Ottawa studies his subjects diligently before he even meets them, so that his classic portraits can benefit from all the awareness of the man or woman that he can bring to the photo session. In England, Cecil Beaton developed elaborate setups to harmonize with and emphasize the character of his clients.

Current major portrait photographers include Irving Penn, who insists on a certain quality of northern light to bring out the depth of his subjects. Richard Avedon's style is striking and direct; his work ranges from high-fashion photography to portraiture. Arnold Newman, the principal photographer of artists in the mid-twentieth century, always chooses a setting that reveals something about his subject's work than could a picture of the face alone. Modern portraiture has come a long way since the rigid poses and blank faces of the early daguerreotypists.

Edward J. Steichen/The Metropolitan Museum of Art, The Alfred Stieglitz Collection, 1933

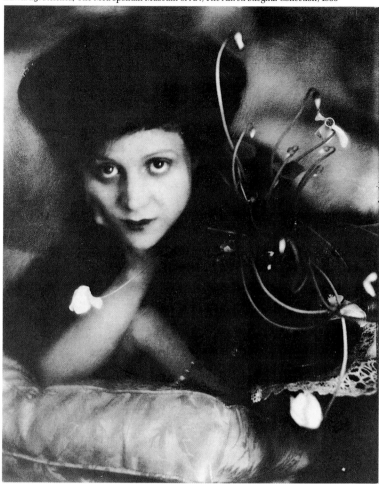

Edward Steichen's portrait of Mrs. Philip Lydig is typical of portraits from his early career. Pictorial in style, Steichen's work often employed soft focus to create very painterly images.

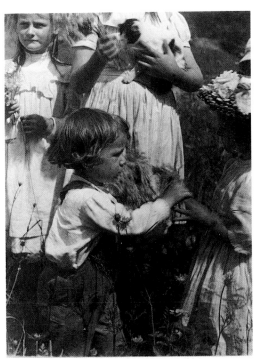

Gertrude Käsebier/The Metropolitan Museum of Art,
The Alfred Stieglitz Collection, 1933

*Trained as a painter,
Gertrude Käsebier turned
to photography after
raising a family. Her work,
always influenced by her
early training, was charac-
terized by the natural
poses of her subjects.*

© Yousuf Karsh, Ottawa/Woodfin Camp

August Sander/The Metropolitan Museum of Art,
Warner Communications, Inc., Purchase Fund, 1979

*August Sander, one of the
members of Germany's
avant-garde art movement
in the 1920s and 1930s,
sought to create a massive
photographic collection of
portraits of everyday
German life. His efforts
were cut short by the rise of
Nazi power.*

*Canadian portraitist
Yousuf Karsh has photo-
graphed many of this
century's famous artists
and writers. This picture of
Georgia O'Keeffe is reminis-
cent of the southwestern
themes in her own paint-
ings.*

History: Impressions of Life

Edward Weston/The Metropolitan Museum of Art, David Hunter McAlpin Fund, 1957

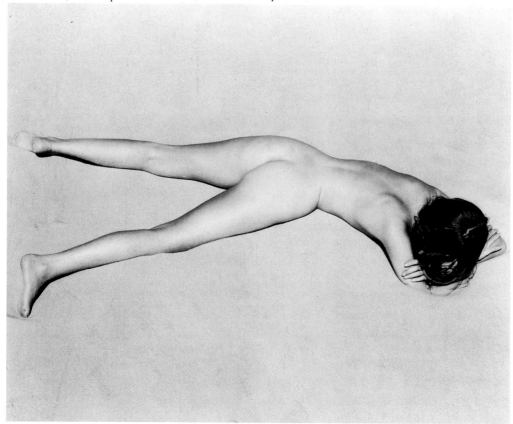

Twentieth-century photographer Edward Weston used a large-format camera and black-and-white film to create sensuous, often abstract portraits of the human form. Throughout his work Weston sought to relate the forms found in nature and the human body.

Artistry and personal vision are no less evident in other kinds of people photography. By mid-century, smaller cameras, larger apertures, and faster films gave photographers of all levels flexibility they had never before had. Because they could make so many images in a short time, they could move quickly in and out of situations and capture subtle variations in their subjects. The vista of truly candid photography was opened by 35 mm cameras for the first time.

No one has embodied the spirit of the quickly taken image as one man's commentary on life more than Henri Cartier-Bresson. Cartier-Bresson has always spoken of the "decisive moment," that one instant in which a scene comes together perfectly. Countless other photographers have emulated Cartier-Bresson, preserving a series of moments to convey their impression of life in a personal photographic statement.

Indeed, this style of photography has been the major contribution to the advancement of the medium of our age. And its practitioners have been many. Robert Frank made his blunt statement about life in the United States in the 1950s in his landmark book, *The Americans.* War photographers such as David Douglas Duncan in Korea and Larry Burrows in Vietnam did more than document what was happening in those confrontations. Their pictures of living, dying, and suffering showed what they as individuals felt about the horrors that surrounded them.

The sequential picture story had given way to the series of pictures connected not so much by the people and events depicted as by the philosophy and point of view of the photographer.

Today, to an even greater degree, the camera is used as a vehicle of personal expression. That photography can present facts is taken for granted. Photographers strive more and more to convey something deeper, more human about the people and events they photograph.

Observing People

Allan Seiden/The Image Bank

The best way to learn to photograph people is to look carefully at them. There are always visual clues to a person's character and emotions, and character and emotions are what you see when you study most photographs of people.

Watch people as they walk down the street, as they talk and laugh, as they think. Develop an appreciation for what people look like as they go through their daily lives. This will prepare you to recognize and transmit that special human essence in your photographs.

Begin with faces. Notice the shape of someone's face, the way it is held, the subtle movements. You'll see that the slightest variation in a person's face can change totally the feeling you get from looking at him or her. A smile, for example, shows obvious joy and contentment. But a half-smile may indicate very different emotions – perhaps dreaminess, perhaps hidden anger.

When you look at people's faces, you'll find that you already know a tremendous amount about human expression. After all, we respond to facial expressions all our lives. By being aware of this type of message, however, you'll find it easier to capture this subtle form of communication on film.

Other things besides the face in a person say something about who that person is. Notice body language. It is an important way in which we reveal ourselves. Observe how people move. Gestures are a fundamental part of human communication, far more universal than language. Often a gesture or the way someone moves is the most eloquent indication of emotion.

Notice other details about people as well: dress, adornments, and unusual features. Sometimes an almost insignificant detail gives the clearest message. A 1952 photograph won the Pulitzer Prize because of one such detail. It showed presidential candidate Adlai Stevenson preparing one more speech in a long and hard campaign. But it was the hole worn through the sole of the candidate's shoe that captured the flavor of how long and tough the campaign had really been.

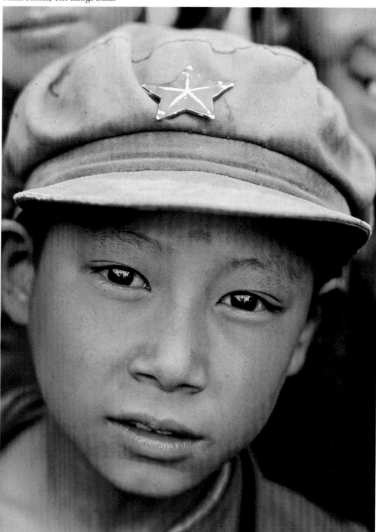

As you get in the habit of watching people in the course of their daily lives, you will start to notice which visual elements are the ones that best convey the spirit of the moment. You will become more sensitive to human personality and emotions. And you will be better prepared to reveal that personality and emotion when you turn to your camera.

Clothing shown in a picture often makes a difference in how we see a person. Without the hat, this boy would appear to be a fairly typical Oriental youth. With the hat, we see him as a young advocate of a political system.

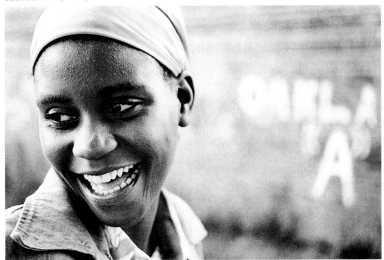

By blurring the background, the photographer here called attention to this woman's generous smile. With her eyes turned to the side, she seems to be laughing bashfully at the idea of being photographed.

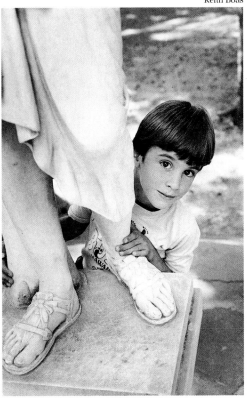

Observing people closely can also mean being alert to unusual settings or situations. Here a young boy's shyness is accentuated by his hiding behind a giant statue.

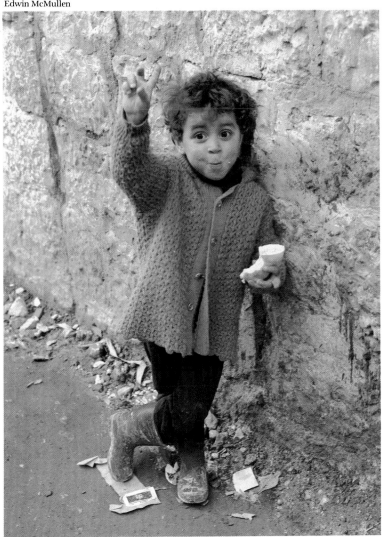

This child's adultlike casual stance and look of surprise combine for an engaging candid portrait. The photographer had to be prepared to capture her expression at the precise moment it occurred.

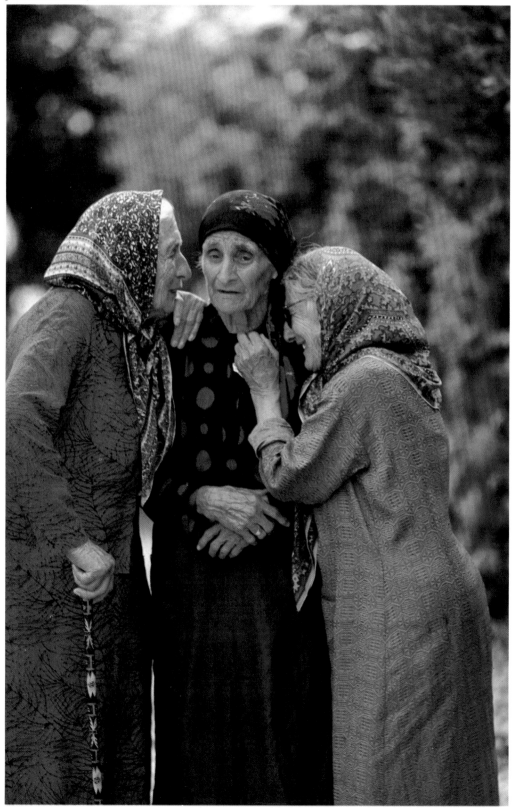

This photograph of women in Russia shows an obviously emotional moment. Their interaction is expressed in their posture, their eyes, and their gestures.

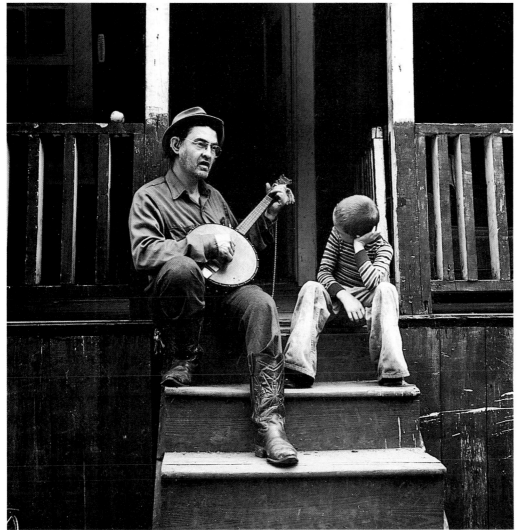

There is a certain quality of life here that we all recognize: a boy learning about life from his father. The picture is thus more about that special relationship than about making music.

Eva Momatiuk and John Eastcott

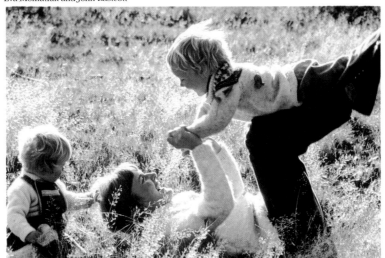

Timing is critical in photographing interaction. Because this picture was taken at the exact right moment, it communicates the joy of this family's playing.

Noticing Surroundings

Observing people closely also means noticing their surroundings and judging the photographic qualities they present. A person's relationship to his or her environment can play an important part in the success of a photograph. Often background will help tell the story in a picture, filling out the portrait with details about the subject's personality, livelihood, or emotional qualities. In the photo at right, the barn adds valuable information about the man being photographed; a close-up portrait might have left us wondering what he did for a living. So, too, in the photo at far right: by including the frame of the subway window and some of the other passengers' faces, the photographer gives us a keener sense of this young woman's isolation and pensiveness.

As you take pictures of people, notice their environments. Consider what you are trying to say in the picture and then decide whether you should include the background to help your message. In travel photography, for example, background can add much information. In souvenir photographs of your traveling companions, background helps tell viewers where you were. Photographs of residents of foreign lands are usually richer, more meaningful, if some of the local color is visible around them.

When taking any pictures of people that include their backgrounds, be sure the background adds something to the photo. Otherwise it can distract from your true subject – the person. It also helps if the person is interacting with the environment in some way: here the simple act of the man leaning on the barn creates an interaction between the subject and his environment. Pay particular attention to the relative sizes of subject and background, and watch out for distractions. You need to control where the eye of the viewer will be led when looking at the picture. When either the subject or the background is relatively larger than the other, it usually places more emphasis on that part of the picture. Bright colors, reflections, or oddly placed lines can draw your viewer's eye away from more important elements.

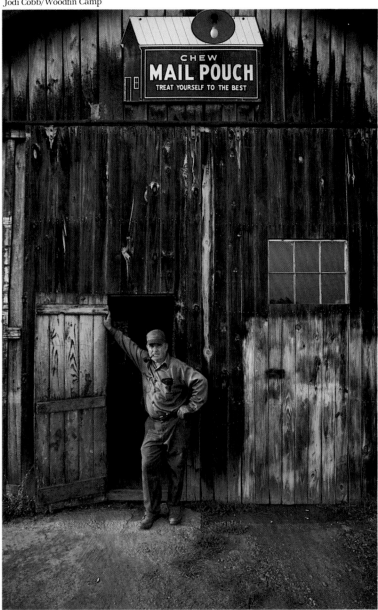

Finally, background can also add visual interest to your pictures. As you observe settings, look for strong design elements – lines, shapes, colors, textures. Notice natural frames and lines that add depth, such as the subway window and barn boards here. Above all, be aware that every element in a photograph, no matter how small, plays a part in the overall impact – and success – of the picture.

Although the man fills only a small portion of the frame, this picture is a successful environmental portrait. The barn, the worn ground, the man's stance, even the sign over his head, all describe the man and how he lives.

Leo Rubinfien

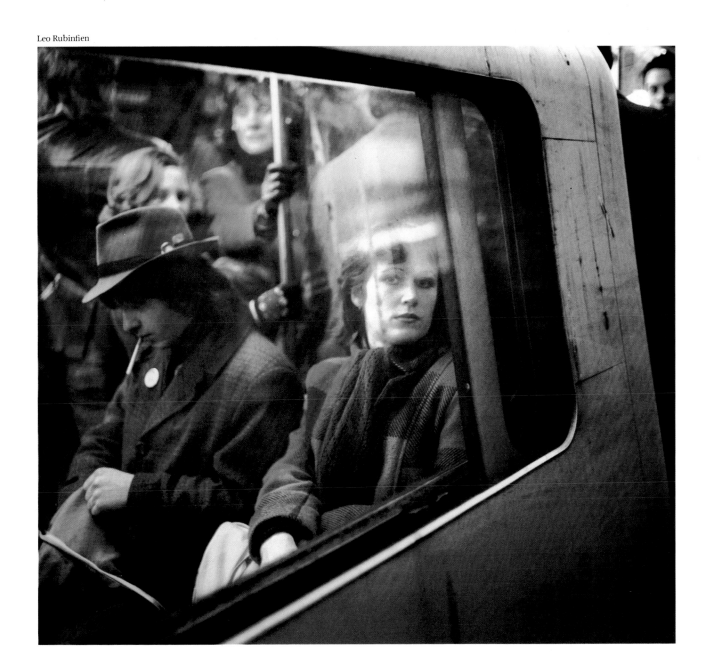

A crowded subway with a lonely figure gazing out is a familiar scene to many of us. A close-up of this woman would be a less satisfying picture, as it is her environment that helps create the atmosphere.

Thinking Visually

Another aspect of successfully photographing people is being able to think visually, to see the photographic possibilities in a situation. Sometimes this means being alert and observing people's actions so you can capture them at the decisive moment. Other times it means being conscious of visual design elements – lines, shapes, colors, and spatial relationships – and taking advantage of them by your choice of camera angle, point of view, or framing. At all times, however, thinking visually means judging a scene for its storytelling qualities, its inherent value as a photograph that must ultimately stand on its own.

To test this quality in a scene, ask yourself a question before you photograph it: "Will this picture need an explanation to convey the impression I want?" If you can answer no, you probably have a picture that will succeed on its visual merits.

Learning to assess scenes for their visual impact is important for several reasons. First, your photographs will be more satisfying to you, for they will more nearly reflect the total image as you saw it when you clicked the shutter. Your pictures will also be more sophisticated aesthetically, and therefore more pleasing to look at. Most important, however, they will carry more emotional impact to your viewers. As a medium, photography can evoke the entire range of human emotions; pictures of people can stir our imaginations and touch our hearts. Photographs have this effect because of our associations with them: we naturally associate what we see with other personal experiences we have had. To produce photographs that touch and inspire people, you will need to evaluate the visual and emotional impact of each scene.

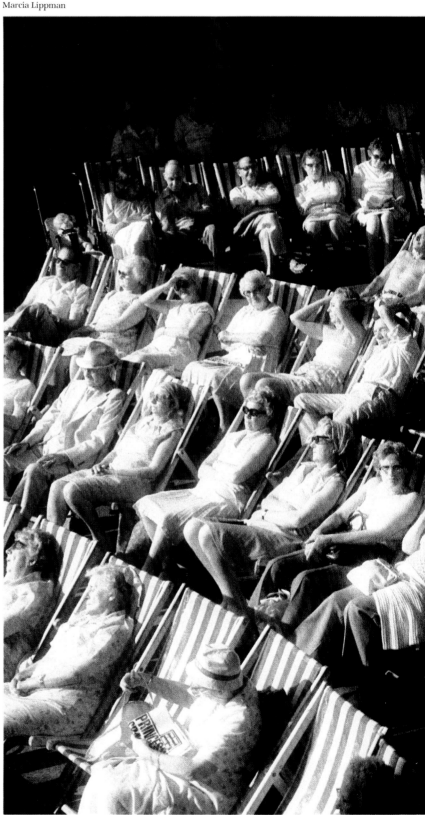

Marcia Lippman

Recognizing the many visual elements inherent in this scene – including the symmetry of the rows and the chair's stripes – the photographer capitalized on them by selecting a high camera angle. Then later she toned the print to enhance the effect of a lazy afternoon spent in the sun.

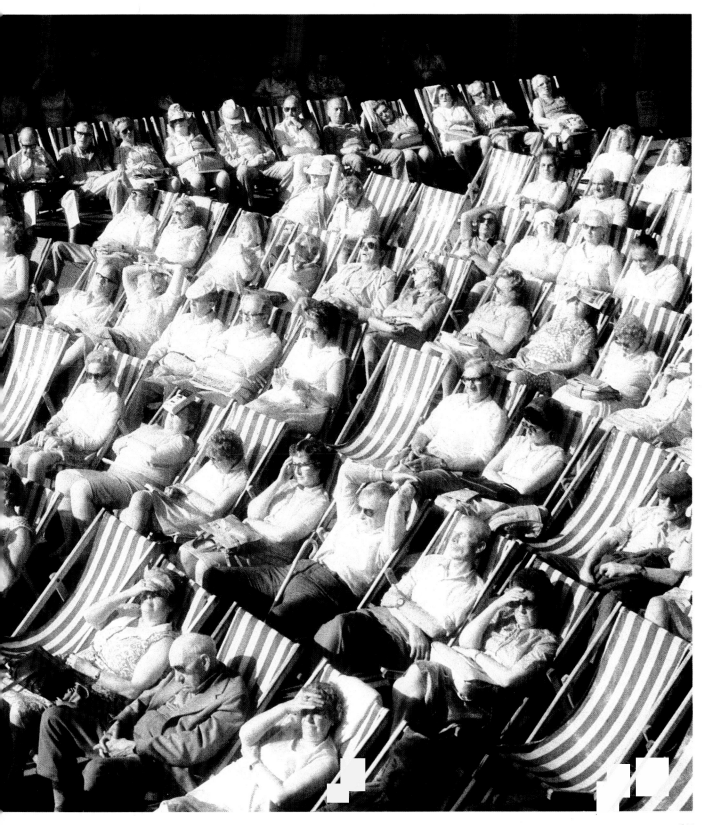

Seeing Humor

Humor in photographs is one of the most elusive things to capture. Besides being a very subjective element, humor is fleeting. A scene appears funny when unlikely visual elements come together, often for only a moment. Or a scene can be funny when common ways of seeing things fall apart. We find some things amusing just because of their incongruity, as in the pictures here of the man with tiny binoculars and the little boy with an oversized pair. At other times the photographer can create humor: a photograph of people behind two telescopes isn't humorous unless we also see the woman with her camera looking in the same direction.

Visual humor is different from verbal humor; only things or people that *look* funny will work photographically. A funny picture described in conversation probably won't be very funny; a photo in which you have to read the words rarely makes much of a joke.

People, of course, can be very funny in the course of their daily lives. The task in getting humorous people pictures is to be alert for odd juxtapositions and bizarre situations that will evoke a smile or a laugh.

Being prepared is essential. Funny things that would translate into funny pictures happen every day, but it is rare that a prepared photographer is there to capture them. Unpredictability is also a key in visual humor: you would have to have a loaded, set camera in your hand practically all the time to catch even a few of the funny things that can happen in a day!

Don't despair if your pictures of humorous events sometimes lose the laugh by the time they come back from the processing lab. Keep looking for humor in your daily life and you will eventually start to pick up more of that quality in your photographs. Besides, if you are constantly looking for humor in your work, play, and family environments, life will be funnier, and that's an attitude we could all have more often.

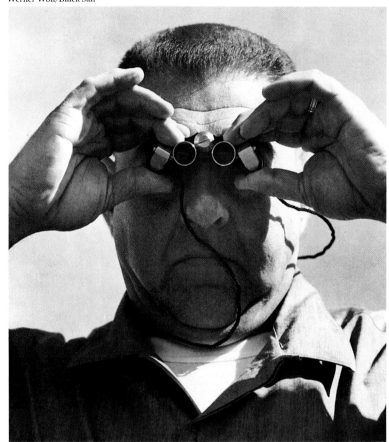

Familiar things in unfamiliar relationships are often funny. The large man with the tiny binoculars is humorous not because of either element, but because of their unlikely combination. Two pictures can become even funnier when a consistent theme is turned around, as the picture of the small boy with the large binoculars attests.

Len Jenshel

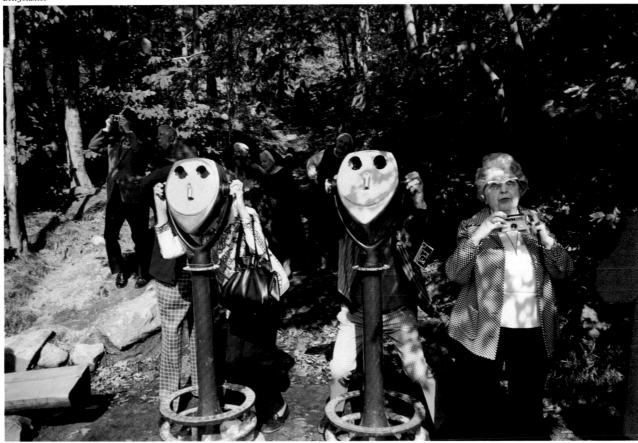

Cary Bernstein

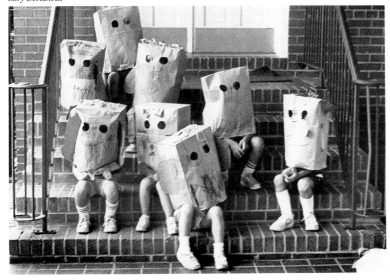

Human characteristics on nonhuman objects are a common source of humor, particularly when juxtaposed with real people in related positions. You can learn to see this kind of humor by responding emotionally to your perceptions before your thoughts interpret the scene.

Children are often naturally funny. Here, a group of kids is reduced to big paper bags, knees, and feet. The group portrait makes it humorous: a single character sitting on the porch might make us wonder what's going on rather than make us laugh.

47

Capturing a Mood

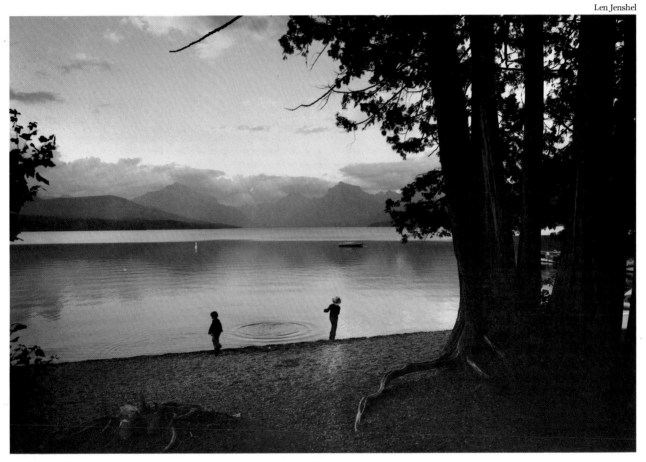

Len Jenshel

Mood is how a picture feels. It is that overall emotional quality that provides us with an immediate response when we look at a photograph. Before the details of a picture become apparent, its mood engages us.

Every picture of people creates some mood. It may be subtle or strong, consistent or varied. But somehow looking at other people always affects our emotions. Look at pictures of people and notice what moods they evoke. Some make you feel compassion, others antagonism. Some draw you into the enthusiasm of the moment, while other pictures make you feel relieved that you are not there.

It is fairly easy to recognize mood in pictures. The pictures here are both examples of pensive, quiet moods. The photographers saw an emotional quality that struck them strongly enough to make them want to capture these moments on film. Then each photographer took the picture in such a way as to capture that emotion.

Mood is also determined in part by the viewer's own interpretation of a picture. A photograph of a calm, still lake may evoke peaceful, quiet memories of summers past, or it may remind you of one special moment when you were a child. Whatever the mood of a photograph, it is usually enhanced by our own associations.

Finally, mood is often the trigger for taking pictures. If you think about your own experience, you'll recognize that the times you most wanted to take pictures occurred when the scenes aroused strong emotions within you.

This picture embodies the relief of getting away from it all. The photographer composed carefully and included enough fore-ground to emphasize the distance to the mountains across the tranquil lake. The ripples on the water and the movement of the people give the scene a real-life presence.

Linda Benedict-Jones

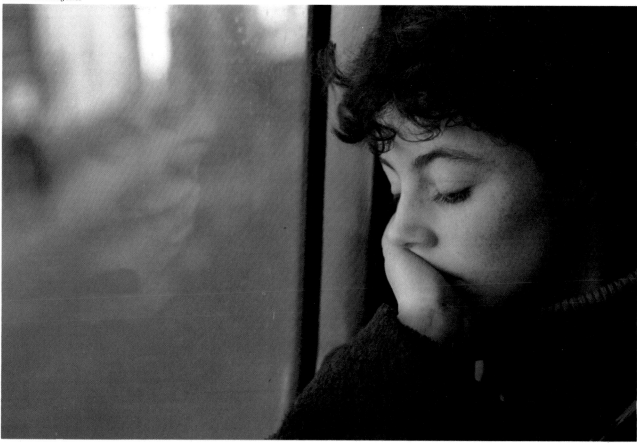

There is no special formula that will guarantee mood in your photographs. But there are a few things you can do that will help. First, recognize what visual elements are most responsible for the feelings you have. It may be a facial expression, a body position, or an interrelationship of two or more people. It will almost invariably have to do with light, since light is an important stimulus to our emotions. Once you are able to single out and concentrate on these factors, you'll take pictures that are more honest emotionally. Your photographs will become a truer expression of the moods that inspired them.

The dreamy mood of a young woman in a bus is one many of us can relate to. The reflection in the window adds a touch of comfort, almost as if she's not alone.

Studying Light

Light is the source of all photography. Light illuminates, colors, and shapes the people you photograph. Light establishes what is possible in a picture – how your subjects will look and whether they can even be photographed.

You should study light, both natural and artificial. Your goal should be to understand light well enough so that you will recognize its characteristics when you take a particular photograph and know how the subject will look in the resulting picture.

Notice what sunlight does to a person's face. The look is different if the sun is coming from the front, side, or back, and changes dramatically from noon to sunset. Observe the difference between sunshine and the softer illumination of a cloudy day.

Artificial light is trickier than natural light. It may produce different colors and come from several directions at once. Overhead lights, for example, tend to highlight a person's nose and deepen the eye sockets. Broad light sources, such as shaded fixtures, throw softer shadows than point sources, such as bare bulbs. If you use a flash, recognize the flattening effect it has on people's faces. Pages 88 through 105 of this book examine in detail the different types of light that you are likely to encounter. But no amount of information will teach you better than what you can observe.

Another important characteristic about light is that it affects more than just what you see – it affects your emotions as well. Certain types of light can add to the mood of a picture or create a distinctive atmosphere. A picture of a family gathered in the glow of the fireplace, for example, feels cozy, almost as if you were there.

Whether you choose to control light or to adapt yourself to its variations, you should strive to become sensitive to the emotional and psychological qualities of your picture that derive from the way it is lighted. Light is more than illumination. It is the primary determinant of mood.

Diffused, directionless light brings out the natural shape of people and objects. The bluish color here, the result of being in shadow under a clear sky, creates a cool, subdued feeling.

David Hamilton/The Image Bank

Backlighting causes silhouettes that highlight shapes and obscure detail. This scene is more about farm life in general than about the individual people we see.

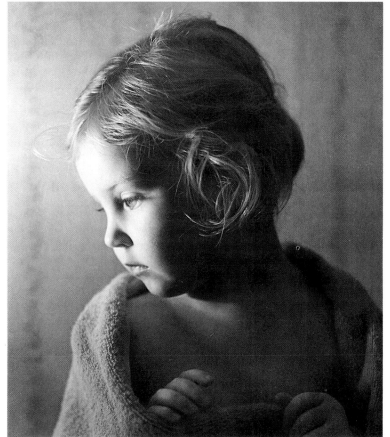

Sidelighting here highlights the little girls's face and brings out the texture of the towel. Straight-on light, such as an on-camera flash, would have flattened the image and failed to show the girl's delicate features.

Enhancing a Mood

Mood is the subjective experience of a photograph. But mood is very changeable, and subtle differences can alter the feel of a picture considerably. Sometimes you may want to manipulate the elements of a picture, either to emphasize the mood you already feel or to change it completely.

Manipulating the mood of a picture means making certain creative adjustments. The key is to think visually, to recognize what psychological and emotional associations the visual elements in your picture will evoke. You will also need to use your imagination, to visualize what your picture will look like so you can manipulate its mood successfully.

The most obvious way in which you can change the mood of a photo is by changing the light. Adding, subtracting, redirecting, or coloring the light will make a difference, either to bring out or alter the spirit of a scene. Sometimes this is as simple as waiting for conditions to change naturally. For example, your friends at an amusement park will look more cheerful under bright sunlight than in the bluish shadow caused by passing clouds. Other times, adding fill light brings out form and lessens dramatic contrast. Colored light, whether warmer or cooler, always changes emotional impact.

After light, point of view and cropping are the most significant ways in which you can control the mood of your picture. As you look through your camera, think about what you want to include that will make the photo better. Choose the cropping that will emphasize what is important, and avoid confusing distractions. If you are in doubt as to whether a certain element should be in your picture or not, try to visualize it in your mind both ways.

Changing the point of view can dramatically alter the mood of a photograph. Each of the pictures here is an example of a particular point of view and camera angle that helps set the photograph's mood. The long point of view used to capture the dock sitters adds a distant, almost anonymous feel to the picture; we can sense the two people are in deep thought or discussion. On the opposite page we see two examples of a high camera angle – one moderate and one extreme. In the top picture the angle and the natural foliage

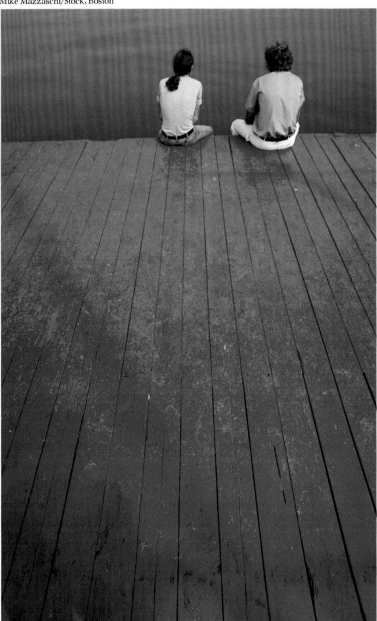

frame accentuate the man's solitary playing, whereas in the bottom picture the extremely high angle focuses our attention on the dancers' shapes and creates a mood reliant on color and movement.

Point of view is an important determinant of mood in this picture. By filling most of the frame with the red dock, the photographer made the picture more graphic and livelier than if he had simply photographed the two people fishing.

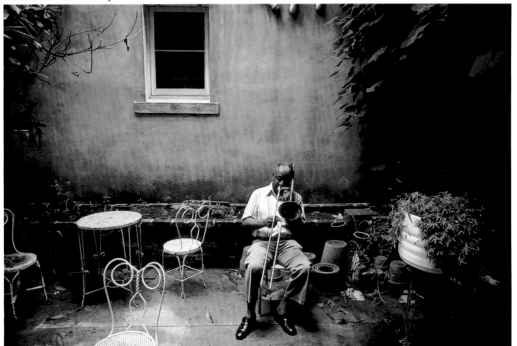

The natural frame of the greenery surrounds this trombone player to draw our attention to him. The photographer has also wisely chosen a time to photograph when the sun's angle highlights the shiny metal of the patio furniture and the man's horn.

Camera angle is the device used to manipulate mood in this picture. By choosing a very high viewpoint, the photographer reduces the figures to colorful shapes and symbols of movement againt the grassy background.

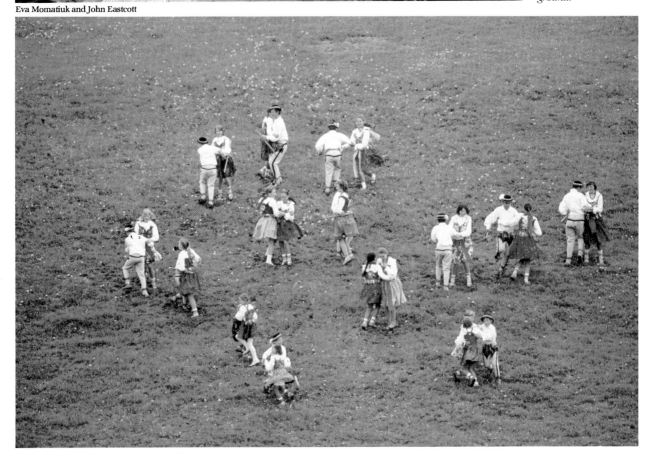

Being Involved!

This jogger's pose strikes an unusual counterpoint to the figures in the monument, and the isolated setting highlights their juxtaposition.

As the photographer, you are the active creator of your pictures. You do more than just "collect" what is in front of you with your camera. You actually make the photograph happen: sometimes by directing the people and events you see, at other times through your decisions about how to frame your subject, establish a mood, or record the action.

The key to all successful picture-taking, especially pictures of people, is to be involved. Participate emotionally. Open yourself up to the possibilities and explore them. If you find certain people interesting-looking or are intrigued with what they are doing, take the picture. Don't wait. If you need to move to another spot or ask them to do something differently, do it.

Pictures in which you have some emotional investment will have more impact than the ones in which you do not. This is true of all people photography, and especially for pictures of family and friends. But even for people you don't know, it can make the picture-taking experience more rewarding and the results more successful.

The Joy of Photographing People is filled with guidelines on how to do virtually every type of people photography. As you go through the book, absorb the information and see how you can improve the pictures you take of people.

Never mistake guidelines for rules. There are no hard-and-fast rules in people photography. Every person is slightly different from every other, and each moment is unlike the preceding one. For your pictures to have that special quality of clarity and immediacy, you need to evaluate the situation and make your creative decisions freshly each time. Fortunately this becomes easier over time as your photographic intuition expands and develops.

There is a world of people out there for you to photograph, an endless array of possible subjects for your camera. Be involved with them, talk with them, laugh with them. You'll discover the human richness that comes with interaction. Your pictures – and your life – will be better for it.

A pensive portrait such as this one can only be created when the subject feels totally comfortable with the photographer. Here the dark background and the subject's dark dress combine to silhouette her face and hand.

Part II

Tools and Techniques

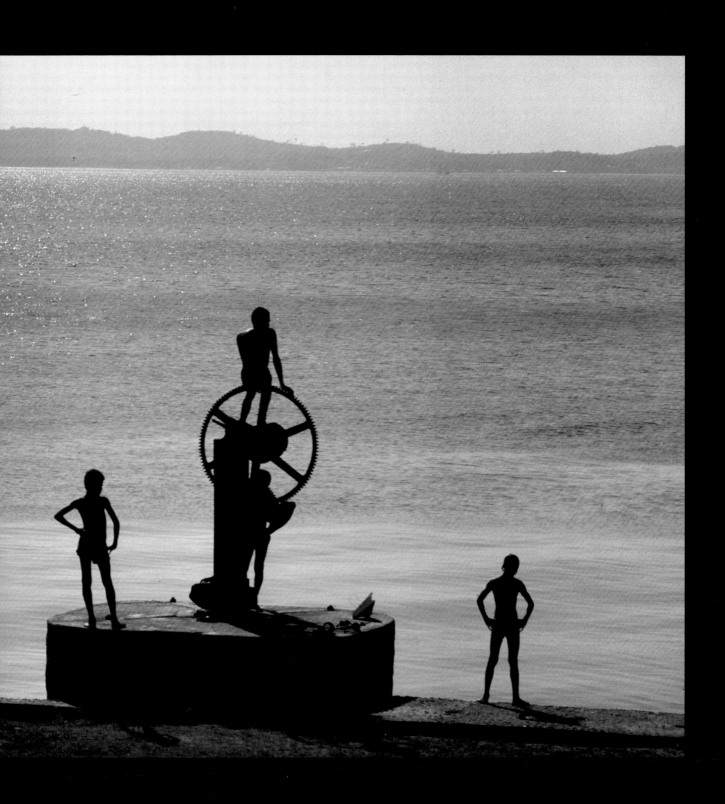

Cameras

Neil Montanus

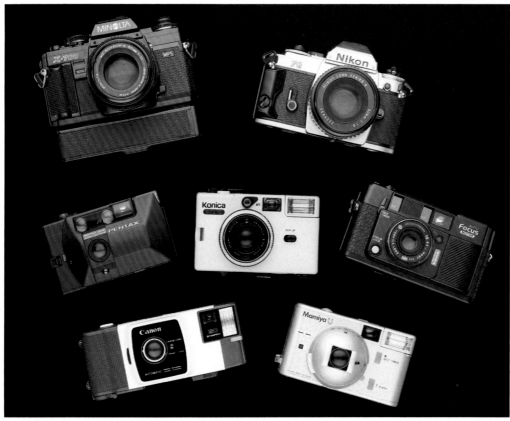

This picture shows only a few examples of the many highly automated 35 mm cameras you can use for photographing people. The two SLR cameras at top offer the greatest flexibility in making exposure adjustments and in using different lenses and accessories. The compact rangefinder models are more pocketable and bring 35 mm quality to casual portraits and candids.

For the photographer intent on taking good pictures of people, many camera choices exist. Small and lightweight hand cameras, such as disc and 35 mm models, permit maximum mobility and allow you to be ready for both spur-of-the moment candids and more formal, controlled photographs. One of the most versatile small camera designs has a through-the-lens viewing system that permits you to frame the subject with great accuracy and to see and control near-to-far sharpness as you focus. This through-the-lens viewing arrangement also makes it easy to see what happens when the lens is changed, or when a lens attachment, such as a filter, is used. By contrast, the viewfinder on a non-SLR camera does little more than approximate the view of the lens. Better models incorporate a rangefinder, a device that allows you to set the focusing distance accurately by matching two overlapping images in the viewfinder.

Whether they are SLRs or rangefinders, most 35 mm cameras produced today incorporate complex circuitry for metering light, controlling exposure, and even focusing

the lens. The simplest system, found mostly on basic model SLR cameras, is *manually operated* exposure. A needle or blinking diodes in the camera's viewfinder tell you when the combination of shutter speed and aperture you select will produce the proper exposure for the average light in the scene. This system allows you to be the final judge of exposure settings when you must deal with tricky lighting or a fast-moving subject, or when you want to manipulate the depth of field or create a special effect. However, you must fine-tune the controls for each picture.

Slightly more complicated are cameras with a semi-automatic exposure system. Most have *aperture-priority* exposure: you set the aperture, or lens opening, and the camera's circuitry selects the corresponding appropriate shutter speed. The only shortcoming of this system is that the shutter speed the camera picks may sometimes be too slow to freeze a moving subject, as the comparison photos of the girl jumping rope at right show. Semi-automatic cameras with a *shutter-priority* exposure

Tom Beelman

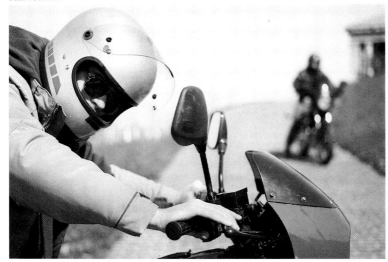

With shutter-priority exposure, you set the shutter speed and the camera sets the aperture. But when you work with fast shutter speeds, the camera may choose a large aperture, limiting depth of field and blurring one of two widely separated subjects (left). Setting a slower shutter speed automatically makes the aperture smaller, providing greater depth of field (below).

◄
1/500 sec, f/5.6

1/30 sec, f/22
▼

system work just the opposite: you set the shutter speed and the camera selects the aperture. This is ideal for freezing sports action, but in some circumstances, the aperture the camera selects may be so large that you won't have enough depth of field to keep widely separated subjects in sharp focus, as the motorcycle comparison photos demonstrate.

Cameras with fully automatic exposure are usually known as *programmed* models, since they have a built-in program that sets both the aperture and shutter speed according to the lighting conditions. You just focus and push the shutter button. The automatic exposure system is best suited for casual snapshots where you want or need little control. However, in poor lighting conditions, the camera may not select an aperture small enough for good depth of field or a shutter speed fast enough to stop action.

Many SLR cameras with partial or fully automatic exposure permit you to switch to manual operation so that you can set both the aperture and shutter speed yourself. A few higher-priced SLR cameras have *multimodes*. Flicking a switch changes their mode of operation from manual to aperture-priority or shutter-priority to programmed.

Many rangefinder and a few SLR cameras have automatic focusing as well as automatic exposure. You can literally point and snap and still get good quality. But these systems can also be fooled – when the subject is not centered or when the scene is dim or has little contrast.

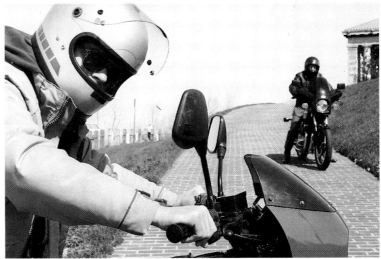

Neil Montanus

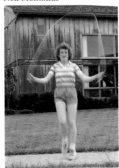

1/30 sec, f/16

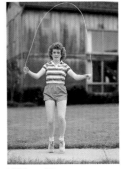

1/500 sec, f/4

With aperture-priority exposure, you set the aperture and the camera sets the shutter speed. But when you use small apertures, the camera may select a slow shutter speed, causing a moving subject to blur (far left). Opening the lens to a wider aperture automatically makes the shutter speed faster, freezing the action (left).

The Portrait Lens

If you were to ask a group of professional photographers which lens they prefer to use when photographing people, the overwhelming favorite would be a telephoto lens (a focal length between about 85 and 110 mm on a 35 mm camera). Indeed, this lens is so popular for taking pictures of people that it is often called a portrait lens. It is especially well suited for head-and-shoulders portraits and tight facial close-ups.

 Chief among the reasons for this lens's great usefulness is the way it renders perspective when you photograph a person, remaining short enough in focal length to be easy to handle. As the bottom picture in the three comparison photos at right shows, a telephoto lens lets you fill the frame with a tight image of a person without noticeable distortion; the lens lets you stand back a good distance from your subject and still get a close view. To take comparable photographs showing the subject the same size using a wide-angle (top picture) or even a normal lens (center), you must move the camera so close to the subject that you distort the scale. At that close range, the subject's nose is much closer to the camera than his ears. As a result, the nose looks much larger than the ears, and the face has a generally bulbous appearance. Similarly, if a subject's hand projects out toward the camera, it will look enormous in comparison with the rest of the body; if a subject's head tilts forward, the top of the head will seem too large. From the remote perspective of a telephoto lens, all parts of the face and body are the same relative distance from the camera, and the resulting image looks proportionally correct.

 The telephoto lens's perspective also has a beneficial effect on background. Its narrow angle of view takes in less of the scene behind the subject, usually simplifying the setting and making the subject stand out from the background. The lens also compresses apparent near-to-far distances, making faraway objects look closer to the subject. This, too, can have a simplifying effect and can be used to make the subject appear close to a picturesque setting like a waterfall or a mountain.

 A telephoto lens's relatively shallow depth of field provides another advantage for photographing people. With a large aperture you can often isolate the sharp image of a subject against an abstract blur of color. Or

Martin Czamanske

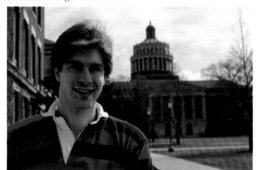

28 mm wide-angle lens

50 mm normal lens

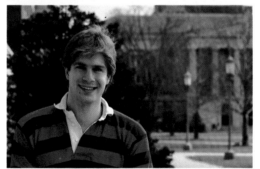

105 mm telephoto lens

you can turn an object that is very near the lens into a softly blurred framing device.

 Besides its photographic advantages, a telephoto lens has a psychological one as well. Since it allows you to stand back from your subjects, they won't feel crowded and will tend to be less camera-conscious and more comfortable than when you photograph them at close range.

 A telephoto lens does have a few shortcomings. You must focus accurately because of the limited depth of field, and you must use a relatively fast shutter speed (at least 1/125 second) to avoid camera shake. In addition, you won't always have as much room to maneuver as you would like indoors.

With a 28 mm wide-angle lens, the photographer had to be within about 2 feet of the subject to get this head-and-shoulders shot. This close distance makes the student's nose look noticeably large compared with his ears. The lens's sweeping 74° angle of view took in the entire campus behind him, making the tower-topped building look unusually far away.

With a 50 mm normal lens, the photographer backed away to about 4 feet to get the same subject size. The nose-to-ears proportion is better, but the nose still appears larger than normal. The lens's less expansive 46° angle of view takes in less of the campus, and near-to-far distances as well as object sizes seem about the same as our eyes perceive them.

With a 105 mm medium telephoto lens, the photographer moved back to about 8 feet to maintain the same subject size. The nose is now clearly smaller, and facial features look more naturally proportioned. The lens's restricted 23° angle of view has taken in only a small part of the building, and the lens's perspective makes it appear very close to the subject.

Neil Montanus

A telephoto lens is useful for taking candids of children, such as this young dog lover charmingly captured by photojournalist Eve Arnold. With the lens's longer-than-normal focal length, you can stay a discreet distance from youngsters and photograph them unaware.

With its ability to compress apparent near-to-far distances, a moderately long (medium telephoto) lens can make a background look closer to the subject. The house in this picture strikingly frames a colorful old-timer and his dog.

Other Lenses

In addition to a medium telephoto lens, other lenses are valuable, even essential, for photographing people. A normal lens, with a focal length of 50 mm, comes closest to approximating our own eyesight, and is useful when you want to give a realistic view of a scene, to show the correct size relationships between subjects at different distances and between subjects and their surroundings. A normal lens tends to have a wider maximum aperture than a wide-angle or telephoto lens; the extra *f*-stop or more lets you use faster shutter speeds to freeze a rapidly moving subject or hand-hold the camera in dim light.

A telephoto lens with a focal length of 180 mm, 200 mm, or even longer is essential for covering sports and other events that require you to keep your distance, as the picture of the horsemen at far right shows. But working with a long-focal-length telephoto lens requires care. You must focus with great accuracy because of the limited depth of field. And, if you are not using a steady tripod, you must use a fast shutter speed to prevent the lens from magnifying any movement of the camera. The general rule is to use the shutter speed that is closest to the reciprocal of the focal length. For a 200 mm lens, this would be 1/250 second; for a 500 mm lens, 1/500 second. When this is impossible, use a tripod or brace the lens against a post or other support to hold it steady.

A moderately wide-angle lens – 35 mm or 28 mm in focal length – offers a sweeping view and, especially at small apertures, great depth of field. It is invaluable for photographing large groups when you must work in a small space. And it is essential when the members of a group are spread out at different distances from the camera, like a family around the table for a holiday meal. With a small aperture – about *f*/11 – it's possible to get everyone from 3-1/2 feet away and beyond in reasonably sharp focus. A wide-angle lens can also be used to shoot action at close range since its broad view tends to minimize the effects of motion.

Since a wide-angle lens exaggerates the relative size of objects near the camera, it is usually best to avoid taking portraits of individuals with this lens. If you do use a wide-angle lens, avoid distortion by keeping the camera parallel to the subject, not tilted up

Martin Czamanske

28 mm wide-angle lens

A 28 mm wide-angle lens's sweeping view shows us the tennis player's nimble grace and encompasses a large area of background. But we learn little about the woman's personality since the size of her face is so small.

50 mm normal lens

When a 50 mm normal lens is used at the same distance, the emphasis is divided almost equally between the player's poised body and her intense expression. The setting has become secondary.

105 mm telephoto lens

When a 105 mm telephoto lens is used, the picture becomes an intimate portrait. The emphasis is almost entirely on the subject's face, although the racket over her shoulder and the hint of court lines in the background tell us that she is playing tennis.

or down. Try not to position an important part of the subject, such as the face, close to the edges of the picture area or have any parts of the body projecting toward the camera. However, these are not hard and fast rules. Sometimes you may want some distortion for a special effect, as the portrait of the man opposite demonstrates.

Zoom lenses can substitute for other lenses when you photograph people, especially when you can compensate for their relatively small maximum aperture by working outdoors or with a flash. A zoom lens with a range of approximately 80 to 200 mm can be quite versatile, serving for portraits at or near its lower focal length and for sports and candid pictures toward its upper end.

A telephoto lens is a necessity when taking pictures of people engaged in sports and other activities that don't permit you to move close. Here, Turkmenian tribesmen in northern Afghanistan play boz-kashi, *a traditional equestrian game akin to polo.*

A wide-angle lens is rarely used for single portraits. But in this photo of a plumber on his day off, the lens's tendency to make body parts that project toward the camera look unproportionally large is used very effectively to give a sense of power to the hands.

Lenses for Special Effects

Wide-angle and telephoto lenses can be used to create unusual effects when you photograph people. They can – either subtly or dramatically – distort a person, make a subject stand out from the background, or compress a scene. The most extreme effects are achieved with ultrawide-angle and extra-long-focal-length lenses. The round picture at far right below was created with a fish-eye lens and illustrates wide-angle distortion at its maximum. A close-up of a face with a fish-eye lens produces a complete caricature: an enormous nose, large eyes, and a mouth on a huge head that leads back to tiny ears.

By contrast, the effect created by a very long telephoto lens relies most often on the lens's ability to compress depth, to make near and far subjects look closer together. A classic example of this shows a multitude of pedestrians on the sidewalk of a busy city thoroughfare jammed together, or faces of fans at a football game seemingly stacked one on top of the other. But as the picture of a farm worker at upper far right shows, a long lens can also be used to isolate a subject dramatically.

Because of these severe effects, most people photographers prefer to use lenses that have less extreme focal lengths. And quite striking effects can be achieved – especially with moderately wide-angle lenses – when you deliberately break the rules about using these lenses. If you ignore the injunction against having a hand or foot extend toward the camera when you use a wide-angle lens, you can emphasize that part of the body, as in the portrait of a man on the preceding page. And if you break the rule about not tilting the camera when you photograph, you can get an image in which a large head surmounts a small body with even smaller legs and feet, as in the picture of the two women at right.

Jim Harrison/Stock, Boston

A wide-angle lens held at close range from a pronounced downward angle created this mild distortion of Shaker women, making their heads look proportionally much larger than their feet.

Dewitt Jones/Woodfin Camp

Neil Montanus

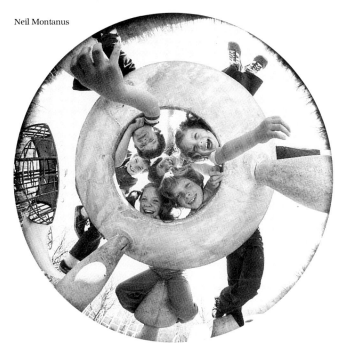

The shallow depth of field of a lens with a very long focal length helps make this California field worker stand out dramatically from the background. The effect is greatly enhanced by the backlighting brightly outlining the subject.

The frolicsome mood of these youngsters is underscored by the extreme distortions created by an ultrawide-angle fish-eye lens. Such a lens, which has a focal length of only 6 or 8 mm and takes in a view of 180° or more, is rarely used when photographing people, except for a special effect.

Color Film

A wide array of color film is available to people photographers who use a 35 mm camera. Your selection of film will depend on a number of factors: whether the light is bright or dim, whether it is natural or artificial, whether your subject is static or moving, and whether you want your final images to be prints or slides.

The choice between color negative film, which produces prints, and color reversal film, which produces slides, is primarily a matter of preference, depending in part on how you want to display the final image. In general, slides are less expensive, since no prints are made. Slides also have vibrance and a brightness range that can never be equaled by an image on paper. But slide film requires careful exposure. For best results, you should not vary from the proper exposure by more than one-half *f*-stop, in either the over- or underexposure direction. A one-stop overexposure will produce a noticeable lightening of the scene, and a one-stop underexposure, a perceptible darkening, though both are likely to be acceptable.

Color negative film, on the other hand, can generally accept a one-stop underexposure and two stops of overexposure, primarily because it is possible to compensate for the resulting negatives when the prints are made. You should use negative film whenever you want the final pictures to be prints and especially when you want a number of copies; this is usually the case when you make a portrait or photograph a wedding. If you want some of the pictures as slides, you can always have them made from the negatives.

Whether you use negative or slide film, the film's degree of sensitivity to light must also be considered. This sensitivity, or speed, is usually expressed in ISO numbers ranging on popular color films from ISO 25 for a less sensitive, slow-speed film, to ISO 1000 for very sensitive, high-speed, or fast, film. A doubling of the ISO number represents a doubling in the light sensitivity of the film. Thus, a film rated ISO 200 is twice as sensitive as one rated ISO 100. (These numbers are the same as the old ASA numbers, and they are often used in conjunction with a second number, as for example, ISO 400/27°. This second number comes from the European DIN system).

Tom Beelman

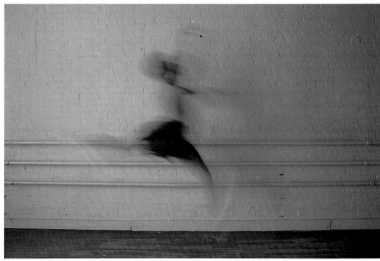

KODACHROME 25 Film

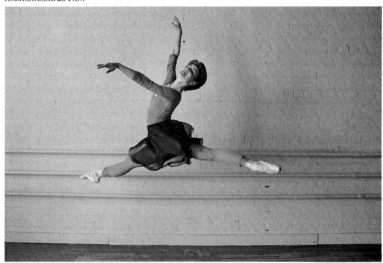

KODACOLOR VR 1000 Film

The faster a film's speed (i.e., the higher its ISO number), the less light needed to create an image, making the film more suitable for photographing when the light is low or when fast shutter speeds are needed to stop action. A high-speed film with a rating of ISO 400 or more is the best choice for photographing sports or other active subjects, for shooting indoors by available light, or for any situation where you need a lot of flexibility, such as taking candids. A very high-speed film, ISO 1000, is especially useful for taking action pictures in very dim light.

In general, the slower a film is, the sharper and more grain-free the resulting image will be. A slower-speed film with a rating of ISO 100, 64, or 25 is the best choice when you pose a subject for a portrait or a

Both of these photographs of a ballerina in mid-leap were taken in the same dim light with the camera set for the same aperture. The upper picture was taken with KODACHROME 25 Film. Its slow ISO 25 speed made it necessary to use a 1/8-second shutter speed, evident from the dancer's blurred image. The lower picture was taken with KODACOLOR VR 1000 Film. Its ultrafast ISO 1000 speed permitted the use of an action-stopping 1/250-second shutter speed.

figure study and want to capture details precisely and get maximum clarity. It is also the film to use when you want giant enlargements of the final picture. You might select a medium-speed film such as an ISO 200 for more normal situations, such as photographing outdoors in shaded areas on a relatively bright day or photographing indoors with a bounced flash.

Also keep in mind that many slide films can be pushed to double their sensitivity if the situation demands. For example, KODAK EKTACHROME 400 Film (Daylight) can be rated at ISO 800 if it is processed appropriately. Pushing film can be handy if you try to take candids in dim light or if you try to freeze sports action with very fast shutter speeds. To push a film, simply set the doubled ISO rating on the camera when you insert the film. Then expose the entire roll at that ISO 800 speed. When you finish the roll, instruct the processor to develop the film for the higher rating. There is some loss in quality, however, so pushing film should be done only when necessary.

Norman Kerr

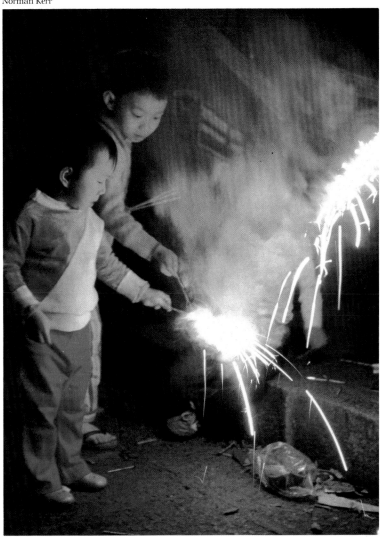

High-speed film enabled the photographer to get a hand-held picture of boys playing in the dim light of fireworks during a spring festival in Macao, China.

Earl Roberge/Photo Researchers

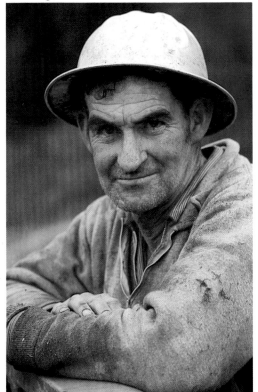

Even informal portraits benefit from the sharpness and fine grain of a slow-speed film. In this color slide of an Oregon lumber-jack taken on an ISO 25 film, you can see every whisker.

Black-and-White Film

When you photograph someone on black-and-white film, the mood conveyed by the resulting picture can often be very different than when you use color film. The image does not have the immediacy of a color picture because it is less realistic. Surprisingly, however, we tend to think of black-and-white photos as more factual and revealing. In part, this is because we still tend to associate black-and-white photography with news stories, even though much of the coverage is now in color. We also tend to associate it with historical pictures and artistic photographs exhibited in museums and galleries. As a result, black-and-white images import a sense of the documentary or a feeling of the enduring classic.

For most photography in black-and-white, the choice of film is primarily a matter of deciding on an ISO speed, bearing in mind that you will usually get greater sharpness and less discernible grain in enlargements with slow-speed films. For a portrait or figure study of a posed subject that will be enlarged to at least an 8×10-inch print, an ISO 32 film, such as KODAK PANATOMIC-X Film, offers fine, crisply detailed results. For general outdoor photography or for taking pictures with a flash, you may want to use a more sensitive but still fine-grained ISO 125 film, such as KODAK PLUS-X Pan Film. And for working in dim light or freezing action KODAK TRI-X Pan Film with a speed of ISO 400 is a logical choice. If necessary, it can be pushed a stop to ISO 800, or even higher.

The special mood created by black-and-white film can be heightened and given more graphic impact by producing images that have either exaggerated grain or ultrafine sharpness and lack of grain. As the picture of the two runners at far right top shows, pronounced grain can greatly enhance the factual, documentary mood of a picture, especially when it shows frozen action or is taken in very dim light. Conversely, extreme sharpness is an element that we associate with many artistic and classic images taken with large studio-type cameras.

These effects are most easily achieved with two specialized films. Highly sensitive KODAK Recording Film 2475 is designed to be used in poor lighting conditions. At its normal rating of ISO 1000, it produces a fairly coarse grain. It can be pushed to ISO 3200 and, at

Neil Montanus

PLUS-X Pan Film negative

To show the differences in grain and sharpness, this same image was taken on three different films. A detail from each type of film is shown below, greatly enlarged. Lighting was the same for all three pictures, and camera settings were adjusted to produce correct exposure with each film.

Technical Pan Film

Shot on Technical Pan Film 2145 at ISO 25 and developed specially, this image has clarity of detail and little grain even in this extreme enlargement. With its slow speed, this film is practical only with fairly static subjects in good light.

TRI-X Pan Film

Shot on TRI-X Pan Film at its normal rating of ISO 400, the greatly enlarged section has pronounced grain but is still quite sharp. In a less extreme enlargement, the overall picture would have a moderately fine grain.

Recording Film 2475

Shot on Recording Film 2475 pushed to ISO 2000, the image has a grain so strong that it obliterates the details. While considered a coarse-grain film, it is ideal for photographing under extremely poor lighting conditions when a fast shutter speed is necessary.

Keith Boas

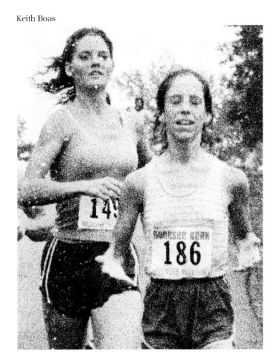

Niki Berg

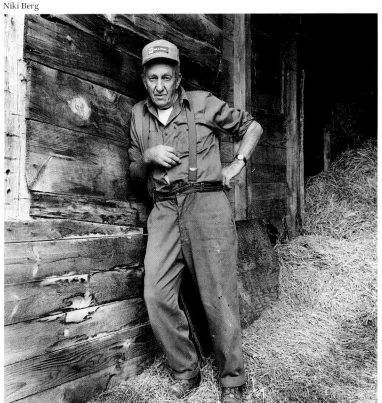

Extremely coarse grain in this dramatic photo of two marathoners passing through a spray of water creates a mood that is at once documentary and impressionistic. It was produced by pushing Recording Film 2475 to ISO 2000. Only a small part of the full image was then enlarged.

higher ratings, will produce a very coarse grain. This is most evident when the image is greatly enlarged and cropped.

The opposite effect can be produced with KODAK Technical Pan Film 2415, a film intended for pictorial photography, photomicrography, and high-resolution copying. This film is extremely sharp and nearly grain-free even in giant enlargements. When used for photographing pictorial work and people, it is rated at ISO 25 and should be processed in a special compensating developer to reduce its contrast. The series of extreme enlargements at left compares the fine grain of Technical Pan Film and the coarse grain of Recording Film with TRI-X Pan Film, a normal ISO 400 film.

A fine-grain black-and-white film produces a sharply detailed image. It is particularly effective in rendering textures such as the weathered wood and tossed straw in this picture.

Filters for Black-and-White Film

General purpose black-and-white films are designed to yield the most natural-looking skin tones when used without filters. But you may want to use filters for effect – to make a subject appear more dramatic, for example, or to accent clothing or surrounding scenery. The principle behind color filters for black-and-white film is simple: colors are recorded on black-and-white film in shades of gray, depending in good part on a color's intensity.

 If a color is seen through a filter of the same color or a closely related one, it becomes lighter in relation to the other colors since the filter transmits its own color and, in varying degrees, absorbs others. If a color is viewed through a filter of its complementary (opposite) color or one close to it, however, the color becomes darker since a color is absorbed by its complement. In the comparison pictures at right, the red blossoms were photographed through a red filter (third picture) and became paler than in life. The same flowers appear dramatically darker than in life, however, when photographed through a green filter (bottom picture) – a color fairly close to red's complement, the greenish blue know as cyan.

 A similar, though subtle, change occurs when skin tones are recorded through a color filter. Most skin is basically reddish in hue. When photographed through a red filter, it appears lighter. This is most noticeable in the more reddish areas, such as the lips. Just the opposite occurs when you photograph skin through a green filter. The skin is darkened slightly overall, and areas like the lips are darkened substantially, as the pictures opposite dramatically illustrate. The filters most often used for lightening skin tones are a No. 25 red or the even more powerful No. 29 deep red. For darkening, try a No. 56 light green or a No. 58 green.

 A red filter can also obscure blemishes and give a subject very pale tones. A deep yellow (No. 15) filter will lighten blond hair; a blue filter (No. 47) will make blue eyes look paler. Filters can also strengthen the contrast between a subject and clothing or background. If you pose a subject against a dappled sky, you can darken the sky and make the clouds stand out by using a yellowish-green (No. 11) or a deep yellow (No. 15) filter. These two filters will not greatly affect the natural rendering of skin tones.

Neil Montanus

KODACHROME 64 Film

This photo shows the backyard scene as it appears to the eye in natural color.

No filter with TRI-X Pan Film

Black-and-white panchromatic film without a filter produces gray tones that correspond closely in lightness and darkness to the colors in the original scene. The red blossoms and green foliage become almost indistinguishable medium grays.

No. 25 red filter with TRI-X Pan Film

With a No. 25 red filter, the red blossoms become light in tone while the green foliage is greatly darkened. The woman's jacket also darkens, but the yellow remains about the same.

No. 58 green filter with TRI-X Pan Film

A No. 58 green filter darkens the red blossoms while lightening the green foliage. It also lightens the woman's blue jacket and, like the red filter, does not greatly affect yellow.

Neil Montanus

EKTACHROME 64 Film

The color photograph shows the natural tones of the skin and clothing of the two subjects.

No. 25 red filter

With a No. 25 red filter, the skin of both subjects lightens considerably, appearing smoother and more delicate. Facial shape predominates over features.

No filter

With no filter, black-and-white film renders skin in gray tones that look natural, closely approximating the lightness and darkness of the actual subjects.

No 58 green filter

With a No. 58 green filter, the skin darkens while the lips deepen dramatically. A heightened contrast makes the features stand out, giving the face more depth.

71

Filters for Special Effects

Ulrike Welsch

Robert Clemens

(Above) A large amount of diffusion creates a misty, romantic atmosphere – an effect enhanced here by the subject's delicate, old-fashioned blouse.

Keith Boas

No filter *Diffusion filter*

Filters can be used to create special effects in photographs of people, just as in scenic pictures. Use them discreetly and subtly so the effect does not look forced, detracting from the subject. The most commonly used special filter for photographing people, a diffusion filter, usually has a finely embossed surface pattern that softly spreads the light entering the lens. The dreamy, misty atmosphere it creates makes this filter a popular lens attachment for portraits, figure studies, fashion shots, and wedding pictures. The blurring of light by diffusion filters also obscures wrinkles, pores, and blemishes – an effect that portraitists have traditionally used to flatter a subject.

You can produce similar effects by placing light-scattering materials ranging from window screening to sheer nylon hose in front of the lens. Or you can spray a plain skylight or UV filter with a fine coat of artist's fixing varnish, stipple it with clear nail polish, or apply a thin layer of petroleum jelly to it. Materials that create natural filtration as part of the scene, such as the window screen in the picture above, can also serve as diffusion filters. Other possibilities include sheer curtains or netting, rippled and etched glass, and frosted or steamy glass. All can be quite effective in creating nude or glamour studies.

(Above) For this portrait of three pensive men, a window screen was a natural element of the scene that acted as a filter, diffusing and softening the image.

A special vignetting diffusion filter, designed specifically for portraits, has a clear center; often it is just a hole in the filter. As the black-and-white picture of the girl at far right shows, this filter allows the face to remain in sharp focus while softly blurring the surrounding edges of the image. You can achieve similar vignetting effects by tearing a hole in a diffusing material placed in front of the lens or by applying a diffusing agent around only the edges of a plain filter. A wide aperture usually enhances the effect of any diffusing device, and it is especially important to use a large lens opening with a clear-center vignetting filter so the edge between sharp and diffuse areas is imperceptibly blurred.

Neutral density filters are sometimes useful in photographing people. By reducing the amount of light entering the camera, these grayish filters allow you to create effects that rely on wide apertures or slow shutter speeds. On a bright day, for example, a neutral density filter lets you open up the lens's aperture so you can blur a cluttered

In these two comparison pictures, the effect of a diffusion filter is clearly seen. The picture on the left was taken without a filter. The one on the right was taken with a filter that produces a moderate amount of diffusion, just enough to soften and flatter the woman's image.

background behind a subject; you can also blur the motion of a runner or an active child. The most useful of these filters have densities of .03, .06, and .09, which reduce light by one, two, and three stops respectively. Two filters can be combined to increase their light-blocking ability.

A polarizing filter is also handy – for removing reflections when a subject is behind a window, for darkening the sky behind a subject, or for intensifying the color of shiny fabric or glistening skin. Filters that adjust the color of light are sometimes needed as well (see pages 94-95).

Other standard special-effects filters add overall or partial color, turn bright points of light into starlike crosses, or break light into a spectrum. But as the pictures of the mountain climber and cave explorer at far right show, such filters usually work only when the subject is a relatively small part of the scene or when the subject's features are silhouetted or otherwise obscured.

Keith Boas

Keith Boas

Allen W. Cull

In this photo of a climber scaling a cliff in the Garden of the Gods in Colorado, the photographer heightened the drama by using a No. 38 blue filter to create a twilight mood.

(Top) A clear-center diffusion filter, which records the face sharply while diffusing the edges, puts emphasis on the young girl's quizzical expression. A wide aperture helped blur the line between sharp and diffused areas.

(Bottom) A starburst filter was used very effectively to enliven this photo of a spelunker in an underground cavern and to reinforce the sparkling, icy atmosphere.

Exposure

You can usually trust your camera's light meter as a reliable judge of correct exposure. Certain situations, however, can mislead your camera and you into producing a poor exposure of your subject, the most common occurrence being a backlighted subject. As the comparison photos of the man in a boat at right show, following a camera's reading when a subject is backlighted almost invariably results in an underexposed picture. The camera's meter, designed for scenes with average light reflectance, sets an exposure for the bright light behind the subject. But that exposure is not sufficient to expose the much dimmer subject properly.

A similar problem occurs when a small subject is set against a bright, light-toned backdrop, such as a beach or snow. The camera again gears its exposure to the background and underexposes the subject. To compensate, take a light reading of your subject up close, then step back and take the picture based on that reading. Your subject will be properly exposed, while the less important background will wash out. Including a bright light source in your picture can also fool a camera into underexposing a scene. This can happen if, for example, you pose a subject next to a lamp. To avoid this problem, simply exclude the light source when composing the scene.

Although less common, a dark background can mislead the camera into overexposing a subject, especially when it is small. If your subject is spotlighted on a dark stage or well lighted in front of a shadowed interior or dark wall, it needs less exposure than indicated by the meter. But the means of achieving the correct exposure are the same as for a bright background: move close to the subject and take a reading of the skin tones.

If you can't get close to a subject, take a reading from a neutral 18 percent grey card by placing it in light of the same intensity as the light on the subject. Or take a reading from the palm of your hand, then increase the exposure by one stop because your palm is about twice as bright as a grey card.

On certain occasions you may want to vary exposure to create a special effect. By increasing the exposure slightly, you can achieve a dreamy, high-key effect, as in the portrait of a little girl at far right below. Or you can decrease exposure substantially to turn a backlighted subject into a silhouette,

Neil Montanus

In this typical backlighted situation, sunlight hitting the subject from above and behind completely shadows his front. The camera's meter, misled by the scene's overall brightness, causes the subject to become badly underexposed.

To get a reading that exposes the subject properly, the photographer moved to within a foot or so of the subject's face and took a close-up reading with the camera's meter. This showed that the overall scene needed to be increased by two stops.

as shown in the lake scene at far right above.

Cameras offer various means for adjusting exposure. If, with a manually operated camera or one that can be switched to manual, a close-up reading of a subject indicates that you need a stop less exposure, then simply set one shutter speed faster or one *f*-stop smaller than the camera's meter reading indicates. More automated cameras often have built-in compensation controls. Many models have a control that lets you make a 1 1/2-stop increase in exposure for a backlighted subject. A few have dials that let you increase or decrease exposure in 1/3-stop increments for up to two stops. Others have lock mechanisms that allow you to keep the camera set on the exposure determined by a close-up reading of the subject after you move back.

If your camera is so automatic that it has none of these controls, you can still adjust exposure by fooling the camera's automatic system. To increase exposure by one stop, set the film-speed dial for an ISO rating that is half the film's actual ISO speed. To decrease exposure by one stop, set double the film's speed. Using the film-speed dial for adjustments is easy once you get used to it, but remember to switch the film's speed back to the normal rating before taking more pictures.

Jon Brenneis

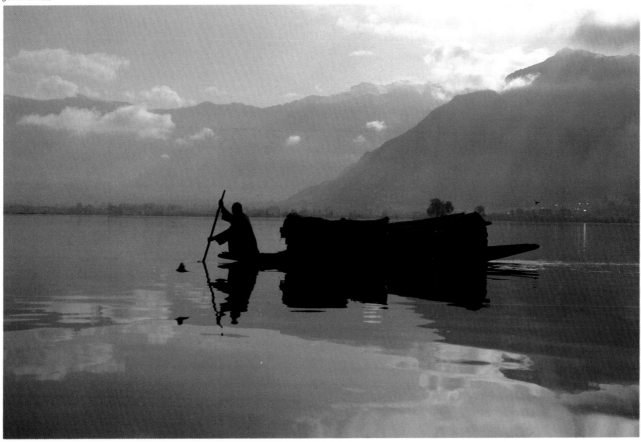

Keith Boas

The evocative mood of this lake scene in Kashmir was greatly enriched by a deliberate underexposure that turned the boatman and his craft into silhouettes and gave the rest of the scene a twilight atmosphere.

A deliberate, slight overexposure heightened the airy high-key effect in this portrait. But this works only when you begin with a light-toned subject and background. Here, the effect was also enhanced by a center-clear diffusion filter.

Composition

Homer Sykes/Woodfin Camp

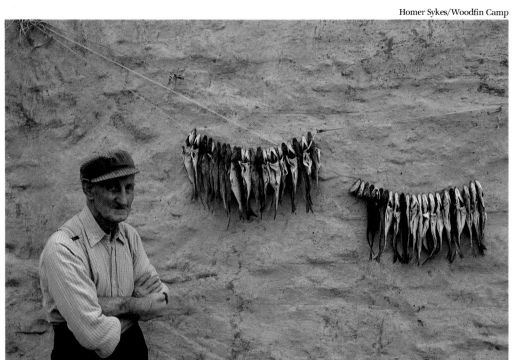

As this Shetland Islands fisherman poses beside his day's catch, he is the immediate center of attention because of his size, bright color, and off-center position against a neutral backdrop. The image gains visual interest from the two strings of fish that form a subtle and telling counterbalance.

At the heart of good photographic composition are a few basic decisions: where to position the subject within the frame, what other elements to include, where to position those elements, and whether to frame the scene horizontally or vertically. The majority of pictures taken are horizontal in format. However, a vertical image can be very effective for pictures ranging from full-length portraits to tight facial close-ups. The unexpectedness of a vertical format can also give an image added impact.

A successful photograph has a strong center of interest. With a single subject, you automatically have a center of interest. But even here you must be careful to exclude elements that distract from the subject; keep only those that help tell a story or convey an idea. Similarly, keep a background unobtrusive by selecting one that is plain and uncluttered or shrouded in shadow. Look for visual elements, such as windows and archways, that direct attention to your subject.

With groups of people, a center of interest isn't immediately apparent. Sometimes you can unify a group portrait with a pronounced diagonal, triangular, or oval arrangement. It also helps to place eye-catching bright colors and light tones in the center of the group.

For a composition to strike the eye of the viewer, it should have a dynamic rather than static composition. It is often a good idea to follow the traditional rule of thirds. Imagine a pair of lines dividing the picture into thirds horizontally and a second pair dividing it into thirds vertically. Place the most important visual element where two lines intersect. A dynamic arrangement can also be achieved by balancing a strong subject against a less important element, as demonstrated in the picture of the fisherman above.

When a subject moves across the camera's field of view, the final image has much more impact when the subject is off-center. And as the pictures of the soccer player at far right show, it is psychologically important to leave the open space in the direction in which the subject is headed. Similarly, if a subject is looking off to the side, it is best to leave space in that direction.

Frank Fournier/Contact

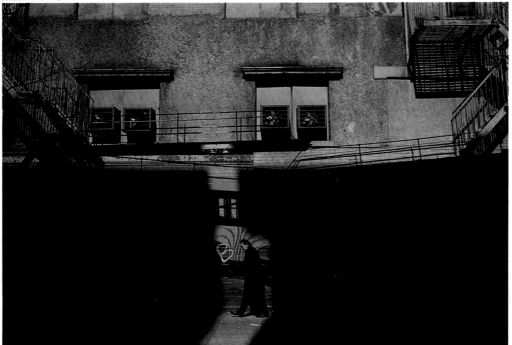

Despite his relatively small size, a passer-by in New York City's East Village instantly catches the viewer's eye as he is dramatically framed in the tiny pocket of light between building shadows.

Neil Montanus

William McBride/The Image Bank

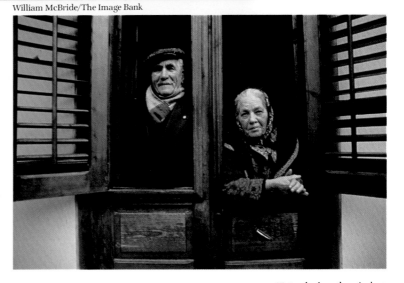

Always leave space in front of a subject moving across the camera's field of view (above). Not only is the subject dynamically off center, but we feel that he has room to continue moving forward. In the center (left), the subject looks static, and at the other side (bottom), he seems to be running out of the picture.

Not only does the window create a beautiful frame for this elderly couple, but the shutters' lines lead the viewer's eyes to the pair. The dynamic diagonal arrangement of the heads gives drama to the scene, enlivening its formal symmetry.

Depth of Field

In photographing people, as in other types of photography, a very important element is depth of field, the near-to-far range in which objects in a scene are reproduced acceptably in focus. The part of the scene beyond this range or closer to the camera appears, in varying degrees, blurred and out of focus. When depth of field is great, it may extend from a few inches in front of the lens to as far away as the eye can see. Such extended depth of field can be used to get pictures in which widely separated subjects are kept in sharp focus, to show a person sharply against an equally sharp scenic backdrop, or to keep both a subject and a foreground in focus, as in the picture of the chef at right.

On the other hand, when depth of field is restricted, it can be used to set off a person or group of people sharply against a blurred background, as in the picture of a man with a pipe at far right below. This is a highly effective technique in people photography. More subtly, limited depth of field can be used literally to focus attention on a specific subject, as in the picture of the children in a car at far right below. Or it can be used to blur a foreground object into a soft, diffuse framing device, as in the picture of the banjo-playing couple at far right above.

The depth of field provided by a lens varies with the aperture you use. The larger the aperture, the shallower the depth of field. Thus, the shallowest depth of field is produced by a lens's widest aperture, typically $f/1.4$ or $f/2$ on an SLR's normal lens. And the greatest depth of field is produced by the lens's smallest aperture, usually $f/16$. Depth of field also varies with the subject's distance from the camera. The closer the subject is to the camera, the shallower the depth of field. Thus, you obtain the most restricted depth of field when you open the lens to its widest aperture and focus on a subject close to the camera. And you get an ever-enlarging zone of sharpness as you stop the lens down to its smallest aperture and focus on subjects that are increasingly farther away. But you will soon reach a point of diminishing returns. Once the growing depth of field behind the subject – which is twice as great as in front – reaches infinity, you begin to lose sharpness in the foreground as you focus on more distant subjects.

Cary Wolinsky/Stock, Boston

In this mouth-watering scene, the zone of sharpness stretches from the front of the table to just beyond the proud chef. Such extensive depth of field can only be obtained with a wide-angle lens set on a small aperture.

Besides aperture and subject distance, depth of field is also affected by a lens's focal length. The shorter the focal length, the greater the depth of field a lens will have at a particular f-stop. Thus, the greatest depth of field is provided by a wide-angle lens and the most restricted by a telephoto lens. A wide-angle lens is ideal when you need to keep both foreground and background subjects sharp or when you must photograph at close range with little time to focus. By contrast, a telephoto lens is ideal when you want to single out a distant person in a crowd by blurring foreground and background elements.

When you change aperture to adjust depth of field, there must also be a corresponding correction in shutter speed to keep the proper exposure. If you open a lens three stops, from $f/5.6$ to $f/2$, for example, then the shutter speed must be increased by three equivalent increments, say, from 1/60 to 1/500 second. Depending on the type of camera, you may have to make this adjustment yourself.

A limited depth of field can be used to blur objects in front of a subject, creating soft, translucent washes of color that help frame the subject. This is easiest to do with a telephoto lens.

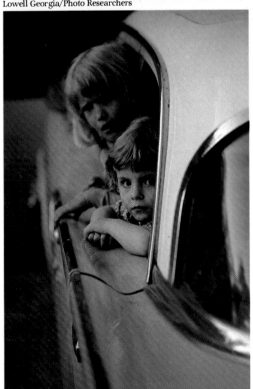

The front child's striking eyes draw your attention immediately because the depth of field has been subtly narrowed to make that child's face sharp and the other's slightly blurred.

In photographing people, the chief use for a shallow depth of field is to blur a background so that a subject stands out sharply against it.

Point of View

When you photograph someone, the selection of a point of view is vitally important. Yet all too often we tend to photograph from our own eye level and from the position where we first saw the subject. Instead, try moving in an arc around your subject. Try high and low vantage points. Move closer and farther away. You will find that there can be amazing shifts in relationships between your subject and other elements in the scene and between your subject and the background. The significance of the subject and the other elements also changes. Viewed from a low angle, a person looks taller and takes on an almost monumental importance. Viewed from a high angle, on the other hand, a person looks shorter and less significant. At an extremely high angle, the subject becomes entirely anonymous, like the couple walking along the sidewalk in the picture at right. High and low camera positions can also be used in portraits to enhance someone's jawline or to downplay a bald head.

When you can't move your subject, changing your viewpoint is the only way to control the background and make a subject stand out. A shift to the side, for example, may be all that is needed to separate one person from a mass of other people on a busy sidewalk. By crouching down you can set off a person against the sky or the plain side of a building, and by climbing a few stairs you can isolate someone against an expanse of pavement, lawn, or floor. And of course, the classic way to eliminate a distracting background element is to hide it behind your subject.

When your point of view shifts, the change in the relationships between a subject and other elements in a scene can be dramatic. If one person stands a few feet in front of another, they may look almost the same size from a distance. But as you move closer, the person in front becomes larger faster than the more distant one. Foreground elements can also be altered by shifting your point of view. Use them to frame a subject or create lines that draw the eye to the subject. A row of hedges, for example, or a sloping roof line can effectively bring attention to a person standing behind or to the side of it.

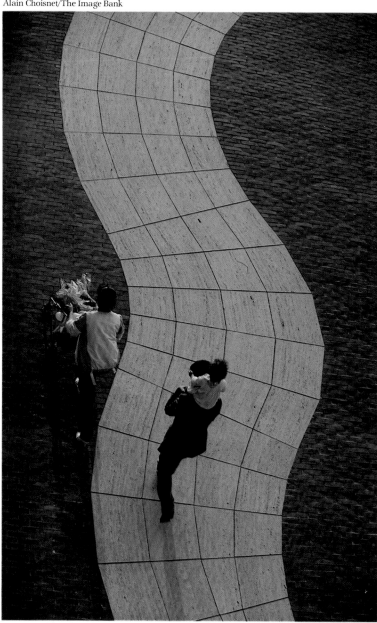

Seen from overhead, the members of this young family lose their individual identities and become graphic elements super-imposed on the pattern of paving stones.

Keith Boas

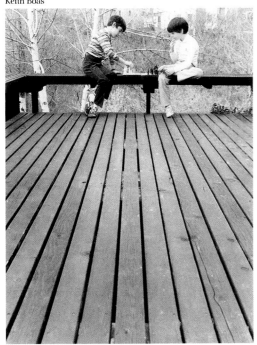

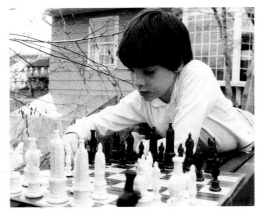

Every situation offers dozens of possible vantage points, each resulting in a unique image. Here, six different angles of two young chess players range from intimate close-ups to more impersonal, distant views. Low-angle views set them off against the sky, while high-angle views show them against the ground. One shot emphasizes the foreground; others reveal background.

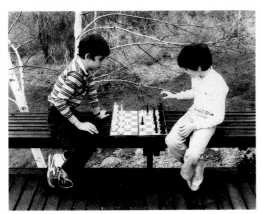

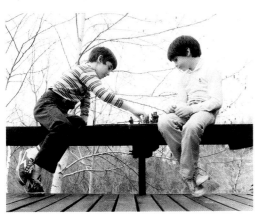

By carefully selecting his vantage point, the photographer was able to isolate this monk in Sri Lanka against a statue of the reclining Buddha – a backdrop that at once reveals his calling and sets off the bright saffron robes.

A low angle of view allowed the photographer to take in the tops of the Art Deco resort hotels, revealing the setting as Miami Beach and explaining why the woman is wearing the nose shield.

A conventional straight-on point of view, or one slightly below eye level, is usually best for close-up portraits like this one of a colorfully clad Herero mother in Botswana.

David Shockey

DeAnn Eddy

A directly overhead view from a high vantage point reduces these sun lovers to tiny, anonymous figures in a pattern on the sand.

It was necessary for the photographer to get down to the subjects' level to capture this dramatic photo of two student wrestlers and their watchful referee.

Planning

The best photographers know that you rarely just happen upon a good photograph. Most often, a successful picture results from the photographer's careful preparations prior to shooting. Some of these preparations are purely technical, such as selecting the appropriate film and lens and determining whether a filter will enhance an effect or if an autowinder is needed for rapid shooting.

Planning, however, should start even before these decisions are made. It usually begins with visualizing the image – finding a location, determining how the subject fits into it, and establishing the best point of view. Then you may have to determine what aperture is needed to get greatest depth of field or which one is needed to blur out a background. Or you may have to calculate what shutter speed is needed to freeze action or to let a moving subject create a blur.

In a portrait, of course, nothing should be left to chance. You determine both subject pose and setting. Every detail should contribute to the knowledge of the subject, as in the picture of the artist at right. Even seemingly casual shots benefit from planning. The picture of the three boys at far right above is a good example, since it was planned to reveal a location. Action shots, like the one of the boy shooting a waterfall at far right below, often require you to stake out a vantage point where you can photograph your subject as it passes.

Even candids require preparation. At a minimum, your camera must be loaded with high-speed film, set for prevailing lighting conditions, and focused at the distances where you expect action to occur. Photographers who specialize in candids frequently search for a setting that is visually interesting or has the potential to be telling or funny. Then they wait, sometimes for hours, watching for people so they can capture an image at just the right moment.

Mark Lyon

This portrait was carefully arranged in a way that not only tells us that the subject is an artist but also shows us some examples of her work.

By posing these three lively Welsh boys behind a wall with a street sign, the photographer created a storytelling image with a definite sense of place.

For this dramatic photo of a daring youngster shooting down a lava rock slide on Kauai, Hawaii, the photographer had to frame the scene, set the focal distance, and determine the exposure, all prior to the instant the boy passed by.

Timing

In photographing people, no skill needs to be more finely honed than your sense of timing. In the great majority of pictures, the exact instant you release the shutter is of enormous importance. You can freeze action at a peak moment or just miss. You can capture the critical instant when changing shapes converge to create a strong composition, or you can end up with a scene that falls short. Even when a picture is mostly a matter of posing and planning, such as a portrait, timing is essential. As the contact strip series below shows, a person's facial expressions are constantly in flux, and capturing the one that expresses the personality of the subject is at the heart of good portraiture.

In most cases, learning to develop good timing is primarily a matter of watching an evolving scene and anticipating the crucial moment when movement peaks or when several elements briefly come together. If you frame a street scene and keep an eye on how the various elements change relative to each other, you will soon develop a knack for judging interesting coincidences or juxtapositions. Remember that the fewer elements you deal with and the slower they move, the easier it will be for you to anticipate and capture the crucial moment. Practice by observing and photographing a single moving subject in a static setting.

In freezing action for a sports photo, for example, good timing is simply a matter of learning through observation when an action reaches a climactic and revealing point. For continuous action, like running, you must determine when a subject coincides with a preselected point where background, lighting, and other elements have been carefully considered.

Furman Baldwin

The humor in this delightful photograph comes from the fleeting expressions on the three youngsters' faces that were captured with proper timing.

In portraiture, you are not likely to take a good photograph if you simply wait for your subject to display the right expression. It is much better to start photographing as soon as all the other elements – pose, setting, and lighting – are in place. As you photograph and encourage your subject, he or she will relax, giving you natural and revealing expressions to catch.

In all cases, remember to click the shutter a split second *before* the critical instant, allowing for the reaction time required by you and the camera. On SLR cameras, this includes the time it takes for the mirror that lets you look through the lens to swing out of the way.

Neil Montanus

The changing expressions of a portrait sitter are dramatically illustrated by this series of images recorded during just part of a session. The photographer was not trying to capture the ultimate revealing image every time; some photos were taken primarily to establish rapport with the subject and relax her.

Len Jenshel

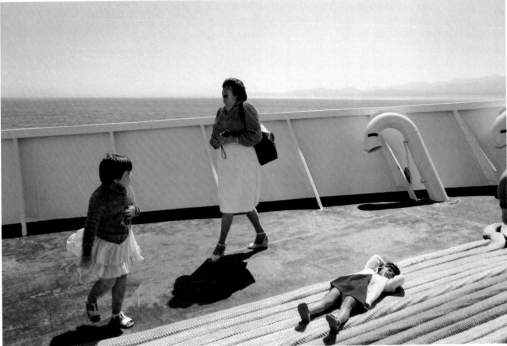

Only good timing permitted the photographer to seize this moment when three subjects showed such different moods. A strong triangular arrangement is emphasized by the eye-catching reddish garments.

Len Jenshel

This intriguing picture of a couple peering intently into a shoreside rivulet is one of those unexpected scenes that the prepared photographer must be ready to capture.

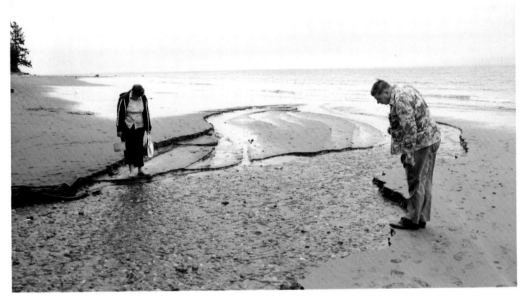

The Direction of Light

Through changes in intensity, direction, or directness, light can dramatically alter the appearance of a subject. The angle at which light hits a subject is particularly important. Lighting direction can emphasize some features and suppress others, or change the way colors and shapes are captured on film.

It was once customary to illuminate a subject frontally with the sun coming from behind the photographer, and many people still automatically position their subjects in this manner. But direct frontlighting tends to flatten a subject, as it doesn't create enough shadows to give the subject a rounded appearance. The subject can look pinned to the background, somewhat like a cardboard cutout against a painted backdrop.

Still, frontlighting does have its uses. In a figure study, for example, frontlighting can reduce the body to a two-dimensional shape for effect. It can also be used when you want a color to be as bright as possible or when you want to ensure that every detail of a subject is clearly visible. And when a scene is fairly complex, frontlighting can help simplify it by eliminating the shadows.

For general picture-taking, however, lighting that strikes a subject from the side is much better. The shadows produced by sidelighting give a subject depth and volume. As the portrait of a young woman at right shows, sidelighting defines a subject's features and brings out the three-dimensional form.

Sidelighting can be varied greatly by changing the position of a subject relative to the light source and camera. If the light comes completely from the side – with the light source at a right angle to the camera side of the subject – the effect can be very dramatic, sometimes shadowing half the face, as in the picture of the elderly woman at far right below. And such extreme sidelighting can also bring out texture, for as the light rakes across skin or fabric it creates a multitude of tiny shadows that reveal fine surface details. But most often you will want to use light that comes from a somewhat more forward position, perhaps at about a 45° angle. You'll find that the sun provides the most effective natural sidelighting at midmorning and midafternoon.

When sidelighting is very directional, pictures often result in which the shadowed areas are too dark, obscuring many of the subject's features. Use a ready-made reflector, such as a sheet of white or silver cardboard, to bounce light into the shadowed areas. Or position your subject near a natural reflector – a white or light, neutral-colored wall or an expanse of sand or pavement.

Diane Cook

In this fine example of a sidelighted portrait, the illumination from a window gives the subject three-dimensionality by creating varying degrees of shadow on her face, arms, and clothing. A weaker light from the opposite direction prevents the shadows from being too harsh.

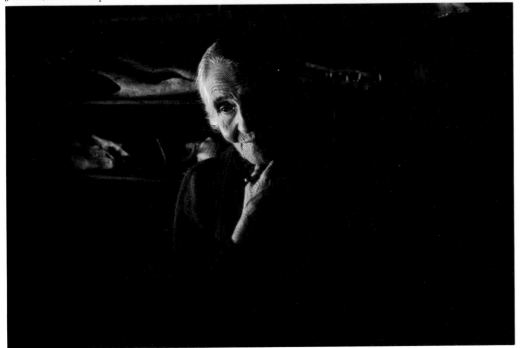

Frontlighting was the safest course for this photograph of two French women. It permitted the photographer to get a clear, unshadowed picture of their elaborate, starched headdresses.

Highly directional lighting that comes completely from the side gives dramatic impact to this portrait of a Georgian woman by shadowing half of her face. It also emphasizes the texture of her skin.

Backlighting

When light hits a subject from behind, it is often difficult to obtain a recognizable image of your subject. Whether the light is directly behind the subject or strikes the subject from behind at an angle, it's usually necessary to increase your exposure substantially over the camera reading to avoid underexposing the subject (see pages 74-75).

Sometimes, however, backlighting can be just the treatment you need to achieve a certain effect, such as a silhouette. And this is easily done by combining a stop or two of underexposure with strong light from the rear. The background may be scenic, as in the picture of the fisherman at far right below. Or it may be urban, as in the picture of the London bobby at right. Backlighting is useful when you want to emphasize a scene or shapes rather than a person. Also, as the picture of the fisherman demonstrates, silhouetting a person against a light background is a good way to give more prominence to a subject that is only a small part of a scene.

Backlighting can also be used to show the translucence of an element, like the water spray in the picture at far right above. Light that hits a subject from behind at an angle creates a halolike rim of light around the subject – a very effective way to set off a subject from a dark or cluttered background. Backlighting can also subdue a distractingly strong color since the color will appear less bright when it is shaded.

Whenever you photograph into the light source, try not to include it in the picture, since this virtually guarantees lens flare, the glaring spread of non- image-forming light created as rays bounce off the lens's optical elements. To avoid this problem, keep the light source outside the frame or hide it behind the subject or some other pictorial element. Even when the light source is outside the frame, shield the lens with a lens hood. If the light is close to the edge of the frame, you may have to shade the lens even more with your hand.

When taking backlighted portraits, consider using a reflector near the camera to bounce light onto the front of the subject. It greatly reduces the differences in contrast between the subject and the background, resulting in a more balanced-looking picture.

Ernst Haas

Reflected light can also be used for backlighting. Here, noted photographer Ernst Haas used public notices to reflect light and silhouette a London bobby. At the same time, they provide a colorful and revealing backdrop.

Keith Boas

In this lively summer scene of backyard play, light coming from behind the subject was picked up and refracted by the fine water droplets, giving the spray a luminous visibility.

David Scott Pyron

Jeff Albertson/Stock, Boston

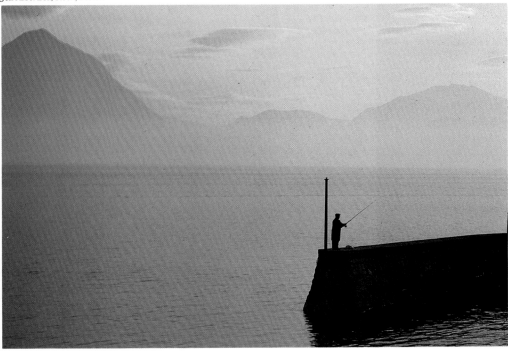

By positioning himself behind these youngsters, the photographer was able to silhouette their figures against the light of the sparklers. To illuminate a large area, a time exposure was needed, during which movement by the children blurred their shapes slightly.

Although only a tiny figure in the overall picture, this northern Italian fisherman stands out against the pale mountain vista because backlighting has created a dark and distinctive silhouette.

91

The Quality of Light

John Launois/Black Star

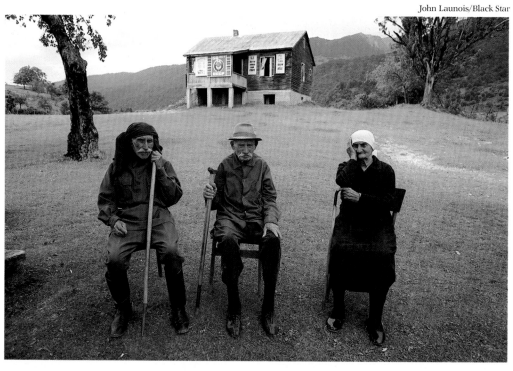

The soft, diffuse light produced by an overcast sky was ideal for photographing this trio of Soviet citizens, allowing their features to be seen distinctly and imparting a sense of tranquillity.

In photographing people, the quality of light – its hardness or softness – is just as important as its direction or intensity. The bright, hard light cast by the sun on a clear day creates distinct, dark shadows with sharp, clearly defined edges. Similar hard light is produced by any direct source of light – a spotlight, the moon, a bare bulb in a ceiling fixture. But if a cloud passes in front of the sun or if a shade is placed over the bare bulb, the light becomes softer – dimmer and more scattered. The shadows created are lighter in tone and have more feathered edges than those produced by hard light. The more overcast a day becomes, the softer the light coming through the clouds, until finally, the light is so scattered and hits the subject from so many directions that there are practically no shadows at all.

Although it need not be shadowless, soft light is by far the best light for photographing people. It provides subtle shadings that reveal the form of the face without obscuring the features. It is flattering to the skin, for it doesn't spotlight wrinkles and blemishes the way that hard light does. Soft light makes posing and photographing easy: you or your subject can shift positions without having to worry how changing shadows will affect the picture. And equally important, a person in soft light is much less likely to squint.

In general, the best outdoor light for photographing people occurs when the sun is covered by haze or thin clouds. The light is soft yet still directional, and it creates just enough of a shadow for three-dimensional modeling.

On bright days, photograph people in areas of open shade – such as the shadowed side of a building – that receive soft, indirect light reflected from the sky. If you find that light too even, use a reflector to bounce sunlight onto one side of the subject, or rig up a large piece of white cloth to diffuse the sun's bright rays before they hit the subject. If you have no choice but to photograph in bright, direct light, backlight your subject (see pages 90-91).

Neil Montanus

Mark Godfrey/Archive Pictures

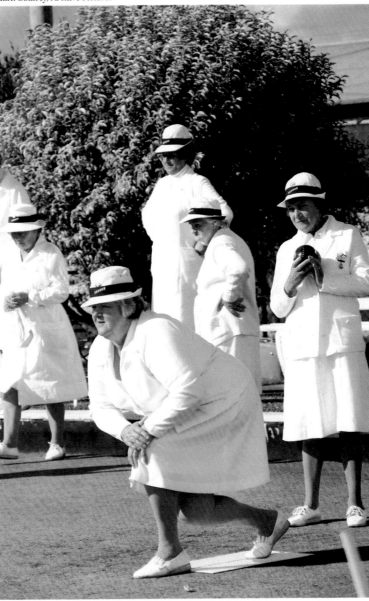

(Above left) In the soft, reflected light of a shaded area, this woman is both relaxed and flattered. There are no noticeable shadows on her face, only subtle differences in shading. (Left) In hard, direct sunlight, not only is the subject squinting uncomfortably, but unattractive shadows extend under the nose and chin.

For this photo of British lawn bowlers, the photographer had no choice but to shoot in hard, direct sunlight. But its harshness was tempered somewhat by the women's white outfits, which acted as natural reflectors, bouncing light into shaded areas.

The Color of Light

Len Jenshel

Soon after the sun sets, a beach is awash in blue because the only remaining source of illumination is light reflected from the sky.

Although we rarely notice it, sunlight has color. It is rosy orange at sunrise and sunset, bluish at twilight and on overcast days. A neutral mix of colors occurs from midmorning to midafternoon on a clear day, and even then shaded areas are likely to be tinged with blue. It is important to recognize the changing color of light in order to compensate for it with filters or film, or to use it to full advantage in establishing the mood of the picture. This is especially necessary in photographing people because unnatural-looking skin tones catch our eye immediately.

Most films are balanced to give natural-looking results when used with daylight or electronic flash. Under incandescent illumination, such daylight-balanced films record the orange bias of the light. If you photograph by incandescent light, you can correct this color imbalance by using a filter with a daylight-balanced film or by using a film balanced specifically for tungsten light. A No. 80A blue filter absorbs many of the excess yellows and reds in incandescent light and enhances the scarce blues.

Indoor tungsten film, balanced for 3200° Kelvin(K) incandescent bulbs, is widely available. For making a portrait or nude study under 3400 K photoflood studio lamps, a special Type A film exists that compensates for the slightly less orange light of these lamps.

When photographing people with color film, try to avoid scenes that *mix* light sources – for example, a person lighted on one side by daylight coming through a window, and on the other by a lamp. In such a case, turn off the lamp and use a reflector to bounce the daylight onto the other side of the subject. Another alternative is to use an electronic flash as a fill light since its color nearly matches that of normal daylight. If you cannot avoid mixing light sources, use daylight-balanced film. The warm golden hues evident in areas lighted by incandescent bulbs will be less objectionable than the eerie blue tones created by tungsten film in daylight-illuminated areas.

If you happen to be outdoors with tungsten-balanced film in your camera, you can adapt it to ordinary daylight with a No. 85B amber filter. Fluorescent light is best avoided altogether when you photograph people. Its almost entire absence of red results in sickly green and blue skin tones. However, filters can help to some extent. Under the widely used cool white fluorescent tubes, use a special FLD filter or a color-compensating filter with a 30 density of magenta (CC30M) with most daylight-balanced films. With tungsten film use an FLT, FLB, or CC60R red filter.

Outdoors, be aware of the changing color of natural light. The warm amber to rose tones of sunrise and sunset are very effective in establishing a mood, as shown in the picture of children at play above. But if you take a close-up portrait of a person in this light, you may find the resulting skin tones excessively warm. For normal-looking results, use a No. 80B or 80C blue filter with daylight film. Since the light is so red, you can switch to tungsten film, correcting very warm light with a No. 82 blue filter.

More often, however, you'll encounter the opposite problem. The skin tones of a subject in the shade or under an overcast sky will look slightly blue; to compensate use a No. 81B or 81C pale yellow filter. On a clear day, when the subject's skin is picking up the reflected blueness of an exceptionally blue sky, you may want to use the slightly stronger No. 81EF yellow filter.

Similarly, if you find that the pictures produced by your flash unit tend to be too blue, you can adjust the color with one of the No. 81 pale yellow filters. Also keep in mind that other factors can affect the color of light. Sunlight filtered through the leafy foliage of a tree can impart a greenish tinge to a subject's skin. A person photographed through plate glass may look blue. And someone standing beside a bright red wall may pick up red overtones from light reflected from the wall.

The golden amber hues of light from a setting sun give added warmth to this lively scene. To achieve the most natural-looking skin tones in this light, a portrait taken at close range would require a blue filter or tungsten-balanced film.

Existing Indoor Light

Taking good indoor pictures is a challenging task, the chief difficulty being the relative dimness of the light. Since natural light is so much brighter than most available artificial light, it's usually best to photograph people using soft, indirect light coming through a window. You can also place a bedsheet over a window to diffuse the incoming light.

Even when softly diffused, however, light from a window is highly directional. The contrast between the window and room sides of a subject's face is often so great that the shaded room side reproduces very darkly on film. One solution is to turn your subject toward the window so you can get a profile or three-quarter view. A more common solution is to use a reflector. If the light is bright, you can pose your subject beside the wall opposite the window so that the wall bounces light into the shaded areas. You can also introduce a natural reflector into the scene; the book held by the little girl in the picture at far right below is a good example. And, of course, you can position a piece of white cardboard just outside the camera's field of view to fill in the shadows.

Photographing just by normal room light is trickier since it is usually dim and uneven. Turn on as many lights as you can for bright and even illumination, and use the most light-sensitive combination of lens and film you can. Also, because of the relatively dim illumination levels, your lens should have a large maximum aperture – $f/2$ or greater. For black-and-white pictures, a high-speed ISO 400 film is a good choice. In dim light it can be pushed to ISO 800 or more with only a slight increase in grain and contrast. In especially dim light, you might consider the highly sensitive but grainy Recording Film 2475 (see pages 68-69). For color pictures, it's easiest to work with a high-speed ISO 400 or 1000 color negative film, correcting the color balance when the prints are made. If you prefer slides, the fastest tungsten-balanced film generally available is rated ISO 160 but can easily be push-processed one stop to ISO 320. If you use a higher-speed daylight-balanced slide film, however, your subject will just have an unusually warm glow, as does the violinist in the picture at right.

Even with a fast lens and high-speed film, you may need to use a slow shutter speed, making it important to support your

Tom Beelman

camera. With shutter speeds of 1/30 second or longer, it is best to use solid support like a tripod or a monopod. But for more informal photographs you can steady the camera by pressing it against a wall, a door jamb, or the back of a chair.

This violinist was lighted primarily by incandescent room light, but he was photographed on daylight film. The resulting flesh tones are more golden than they appear to the eye, but most viewers don't object to the added warmth.

Derek Doeffinger

Susan B. Dickens

Janice Penley Keene

By photographing this tearful toddler in a shadow created by natural window light, the photographer emphasized her sulky mood.

(Above) Soft, indirect light from a window provided the perfect illumination for these two young ballerinas. The side light models their features and reveals the translucence of their costumes. (Below) For this portrait of a young girl, the book is not only a prop; it also serves as a natural reflector that bounces light from the window onto her face.

Electronic Flash

The electronic flash is an enormous boon to today's photographers. Compact and lightweight, this highly portable unit emits a great amount of light that approximates the color of daylight. Its ouput is so quick – typically between 1/1000 and 1/50,000 second – that you can freeze virtually any activity. Yet mounted on the camera, the way such units are normally used, the flash does not always produce the best pictures of people. The light hits your subjects from the front, flattening them and washing out the subtle shadows that reveal form and features. In addition, it is hard and direct, creating dark, hard-edged shadows behind your subjects.

Even so, a direct frontal flash is useful when you want to capture a fleeting expression, as seen in the picture of the two women at far right. However, people usually photograph most attractively when you modify the way the flash illuminates them. Even with a built-in camera flash, you can soften the light delivered by placing a diffuser – a piece of tissue, cloth, or matte acetate – in front of the flash tube. Larger units often come with a plastic panel that you can slip in front of the tube. You can also hold the flash unit up and to the side to give more three-dimensional modeling. The best and easiest way to modify the light, however, is to bounce it.

When light is bounced off a ceiling or wall, it spreads over a wide area and strikes the subject from many different angles, producing soft, even light. Yet it remains directional, coming from the top or side, and produces subtle shadows that give the subject a rounded, three-dimensional form. Bounced from a wall, the light emulates the soft light from a north-facing window. Bounced from the ceiling, it suggests ordinary room light. With many automatic flash units you can angle the flash tube to make bouncing light easy. And depending on how the unit senses light returning from the subject (see pages 100-101), you can hold the unit off-camera or mount it on a special bracket.

The ceiling or wall off which you bounce light should be white or neutral-colored. The reflecting surface imparts its own color to the light, so if you bounce light off a green wall, you will get a greenish subject. Also, ceilings should not be too high. The 8- to 12-foot ceilings in most buildings usually pose no problem, but with the higher ceilings found in such places as churches,

Tom Beelman

A direct flash from a unit mounted on the camera covers the subject with bright, hard light, washing out his features and flattening his form. It also creates dark, sharply defined shadows against the backdrop.

When flash is bounced, the light becomes soft and even, producing faint shadows that give depth to the subject's features and form. The natural effect is also helped by the light's direction, which here simulates room light.

gymnasiums, and auditoriums, the light spreads too much in traveling to the ceiling and back down, making bounce flash ineffective. If you are in a room where the ceiling is too high and the walls the wrong color, look for other possible surfaces, such as doors and window shades. You can also bounce flash off a white cardboard reflector, or off a photographic umbrella, which provides light that is more directional – and predictable – than light bounced off room surfaces.

Another important use for a flash is as fill light for backlighted or shadowed subjects in natural light. If your subjects have a daylighted window behind them, for example, a flash can prevent them from becoming silhouettes, as the picture of football players at far right above demonstrates. Outdoors, a fill flash permits you to photograph someone who would otherwise be silhouetted by sunlight coming from behind or whose face would be streaked by shadows caused by sun directly overhead. Whether you use direct flash for fill or bounce flash from a reflective surface, you will achieve the most natural-looking results if you allow a stop or two less exposure in the filled areas than in the sunlighted ones.

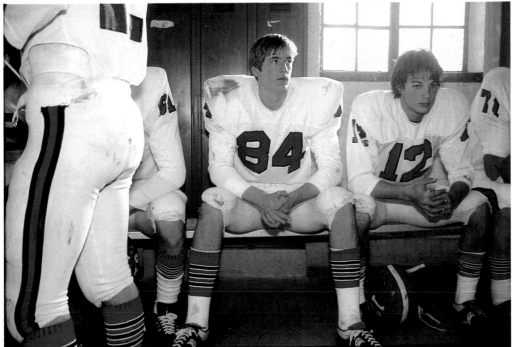

With strong sunlight coming in the window behind them, these football players would ordinarily be silhouetted. But a fill flash hitting them from the front added light to the shadowed areas.

Even though a direct on-camera flash can be harsh and unflattering, it is the fastest and easiest way to capture expressions like these.

In this outdoor photo of a young lady, a fill flash lighted her features, keeping her from being silhouetted against the bright sky.

Flash Exposure

Most modern flash units are automatic. When the flash goes off, a light sensor measures the amount of light reflected from the subject. When the subject has received enough light to be properly exposed, the flash cuts off its light output. On most units, the sensor is built into the unit's base so that it still reads light from the subject when the flash head is tilted upward for bouncing. Some units have a detachable or remote sensor, one that can be mounted on the camera while the flash unit is used off-camera. Since the sensor faces the subject, the flash unit can be held in any position.

The procedure for using a typical flash unit is simple. After mounting the flash on the camera or connecting it by a cord, set the camera to its usual flash synchronization speed – most often 1/60 second but sometimes 1/90 or 1/125 second. (A faster shutter speed with focal-plane shutters results in partly masked images.) Next, set the film's ISO speed on the flash unit's calculator dial, which tells you what flash power mode and lens aperture you need for a subject in a certain distance range.

Small, inexpensive flash units and larger professional units are operated manually. In the manual mode, a flash's output is the same every time; it does not vary as with automatic operation. The amount of light emitted depends entirely on the subject's distance from the camera. To use a manual unit, set the film's ISO speed on the unit's calculator dial, which tells you what aperture to use for a certain flash-to-subject distance.

On either an automatic or manual unit, the distances on the calculator dials are for direct flash. If you want to bounce the flash, you should calculate the flash-to-subject distance by determining the full distance the light travels from flash to bounce surface to subject. Then, to allow for light lost through scattering and absorption, increase that amount by roughly half again. Thus, if your subject stands 6 feet from the camera in a room with an 8-foot ceiling, the light may travel about 4 feet to the ceiling and then 6 feet back down to the subject for a total of about 10 feet. To allow for light loss, you would add another 5 feet, giving an effective flash-to-subject distance of 15 feet. With practice, estimating distance becomes easy. And obviously, you should expect to work at much

Keith Boas

When this sheet-covered Halloween prankster was photographed against a white wall, the large amount of light reflected back from the scene deceived the automatic flash. Designed to respond to light returning from a scene with average tones, the flash cut short the light it sent out, resulting in an underexposed subject (top). The solution is to give the subject one-half to one stop more exposure (bottom).

closer range when you are bouncing a flash than when you are using it directly.

Additional calculations may be necessary when you use fill flash outdoors (see pages 98-99). To spotlight a subject so that it stands out from the background, as in the picture of the girl on a swing at far right above, set the camera's exposure for the bright natural light and then adjust the flash's output or its distance from the subject to give the shadowed areas the equivalent of a stop or two less light. Since the maximum synchronization speed (1/60 to 1/125 second) dictated by the flash is somewhat long for bright sunlight, you must use a slow- or medium-speed film (ISO 25 to 100) so that your lens can provide a small enough aperture.

The most common problem encountered when using fill flash outdoors, however, is putting too much light into shadowed areas, which can occur when the subject is close to the camera. On many automatic units, you can reduce the ouput in fractional increments by switching the unit to manual. You can also make an automatic flash unit produce half as much light as normal by doubling the ISO rating set on the unit. Other ways of reducing the amount of

Henry Katz

Neil Montanus

Confronted with these two men in dark tuxedos at night, the automatic flash sensed so little light reflecting back from the scene that it continued to send out light after the men were properly exposed (left). To correct this problem, the exposure was reduced by one-half to one stop (right).

light include putting tissue over the flash tube and bouncing the light from a reflector. And you can always move the flash farther away from the subject. If you use a fill flash outdoors often, consider buying an inexpensive, low-power manual unit. After a few trial photos, you will soon establish the distance range within which it is effective.

Another situation that may require you to make an adjustment in an automatic flash's output occurs in unusually light or dark scenes. Like a camera's meter, an automatic flash is designed to respond to an average mix of tones. If the scene is overwhelmingly dark, the flash will emit too much light, overexposing the subject, as in the comparison photos of the two men in tuxedos at left. And if the tones are light, the flash will emit too little light, underexposing the subject, as demonstrated by the pictures of the costumed child at far left.

To capture the exuberant spirit of this high-flying youngster, a stronger-than-usual fill flash was used, setting her off brightly against the dappled twilight sky.

101

Studio Lighting

The ultimate control of lighting comes in a studiolike setting. Here, multiple flashes or lamps can be used along with reflectors and diffusers to obtain precise lighting conditions. There are a great many ways to light a subject, but as the typical arrangement shows here, the heart of most lighting setups is a main light. Also called a key light, this source ideally simulates natural sidelighting by the sun at midmorning or midafternoon. By striking the subject from the side – at a 45° angle, for example – such lighting produces the shadows that round a subject naturally. And by shining on a subject from above, it creates an effect that suggests sunlight. When positioning a main light, watch for shadows that may form in the eye sockets and under the nose. If you place the light too high, a person's brow can cast deep shadows over the eyes. And if you place it too far to the side, you can create an unsightly nose shadow that cuts across the cheek.

The next important light is the fill light, which projects light into – or fills – the shadowed areas created by the main light. A common position for this light is on or beside the camera at about the same level or slightly higher. In this position, most of the shadows created by the fill light fall behind the subject, so the light does not create an unnatural-looking second set of shadows. The fill source need not be a second light. For a simple portrait, you can place a reflector near the subject to bounce light from the main light onto the subject's shadowed side.

Other lights have very specific functions. Often, as in the portrait at right, the subject's hair is highlighted by a small, hard light shining directly from above and slightly to the side or back. To make a subject stand out from a background, a light is placed behind the subject and aimed at the background. Sometimes, a backlight is aimed at the subject to create halolike rim lighting around the edges of the subject.

The key to creating natural-looking lighting, however, is to establish a balance between the main and fill lights. A fill light's job is to lessen the difference between highlighted and shadowed areas so that those differences are well within the contrast range that film can accommodate. Generally, these differences are expressed as a lighting ratio. For example, a 2:1 ratio means that the

Stephen Kelly

Studio lighting produces effects that can never be achieved with natural light. But when properly done, the result is subtle and natural-looking.

highlighted areas of the subject are receiving twice as much light as the shadowed areas. For most portraits, a pleasing ratio is 3:1 or 4:1. With a 2:1 ratio, there is little discernible difference between the two sides of the face, making it look flat. With ratios greater than 4:1, the lighting becomes more dramatic and less natural in appearance, an effect that can look especially jarring in a color portrait.

When the main light hits the subject from above and to the side and the fill light is near the camera, a 3:1 ratio is obtained if the main light is twice as bright as the fill light – that is, if the main light produces the equivalent of one stop more light than the fill light. This is a 3:1, rather than 2:1, ratio because the highlighted side of the face receives two units of light from the main light and one unit from the fill light, while the shadowed side receives only one unit. There are a number of ways to achieve a 3:1 ratio. With variable-power flash units of equal output, you simply place both units the same distance from the subject and switch the fill unit to half power. On units that can't vary their output but are of equal power, you can place the fill unit the equivalent of one stop farther away from the subject than the main light. Just increase the distance by about 40 percent.

Clifford Stoltz

Neil Montanus

Hitting the subject from about 45° to the side and a few feet above his head, the main light mimics natural sunlight and emphasizes the subject's three-dimensional form.

Coming from a position near the camera and level with it, the fill light adds illumination about one stop weaker into shadowed areas without creating secondary shadows.

An accent (hair) light coming from above and slightly to the right creates shiny highlights on the subject's hair and the shoulders of his jacket – in effect, outlining him.

A light behind the subject shining on the background gives the portrait a sense of depth and separates the subject from the backdrop by lightening it and making it seem farther away.

Studio Setup

Whether it is a permanent or temporary arrangement, a studio's first requirement is space. For simple head-and-shoulders portraits, the amount of space can be quite modest. But standing full-figure setups usually require a room with generous proportions. Not only must there be room for you to back your camera away from the subject, but there must be space between your subject and the backdrop, especially when you light the backdrop or when you want to keep stray light off it. There must be room on either side of your subject for lights and reflectors, and space above the subject for taking pictures at different levels. Other essential requirements include curtains or shades that block daylight from the room, since daylight can interfere with the lighting you establish. Also, a ceiling and walls that are painted a flat white can be used as reflective surfaces when you light a subject. But when you want a very controlled effect, you must be careful to mask your lights so that stray light doesn't bounce off these surfaces onto your picture.

Because of its convenience, electronic flash has superseded tungsten lighting in most commercial studios. And as the picture of a studio here shows, a professional flash unit consists of large rectangular power packs that plug into normal house current along with flash tubes in metal reflectors on stands. These units recycle very quickly, giving photographers the opportunity to shoot many exposures in rapid succession.

But you don't need such elaborate equipment to take excellent studio portraits. Two or three good amateur flash units with moderate to high outputs and variable power control switches will suffice. You can back them up with tripod-style light stands and photographic umbrellas for bouncing light. Various sizes of white cardboard can serve as reflectors, and black cardboard and fabric can stop stray light. You may want to create a large diffuser by stretching white fabric over a simple rectangular frame.

The final two requirements for a studio are a sturdy tripod and a suitable background. For many shots, a plain white or neutral-colored wall with a flat finish is perfect. And remember, the color of a white or light-toned background can be changed by putting a gelatin filter in front of a flash directed at the background. For more variety,

Carolyn Weatherly

A studio makes it much easier for you to achieve such special effects as the soft, diffuse vignetting in this young lady's portrait.

you may want to purchase the special seamless background paper sold in may photography stores. This paper can be tacked to a wall or suspended on poles or from ropes.

With multiple flashes, exposure calculations are tricky. And automatic flash units must be switched to the manual mode as the special circuitry in each would be confused by the other light sources. Because of this, a highly useful accessory is a flash meter. Because ordinary light meters are designed to read continuous light sources, they can't be used with flash. But a flash meter can record both the intensity and duration of a burst of flash, enabling you to determine exposure quickly. Otherwise, when you use multiple flash, base your exposure on the main light and then bracket.

Steve Labuzetta

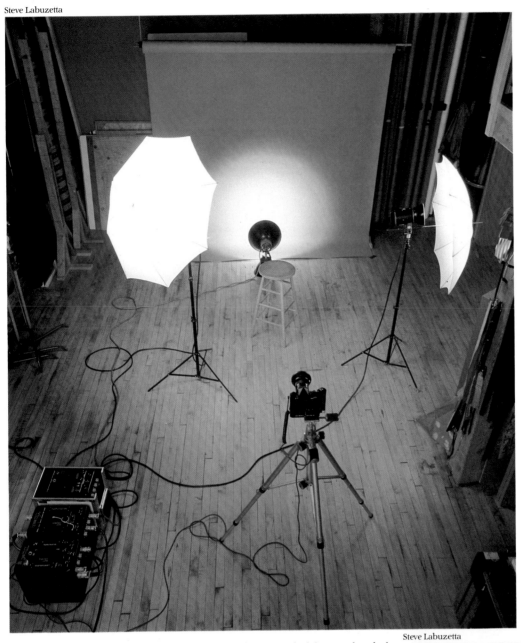

In this typical professional studio, the power packs that fuel the flash tubes lighting the umbrella and backdrop can be seen at lower left. Additional rolls of seamless backdrop paper are stored vertically at upper right.

Steve Labuzetta

Knocked down and packed away, the basic studio lighting and photographic equipment is compact and ready to be easily stored or taken on location.

Photographing People

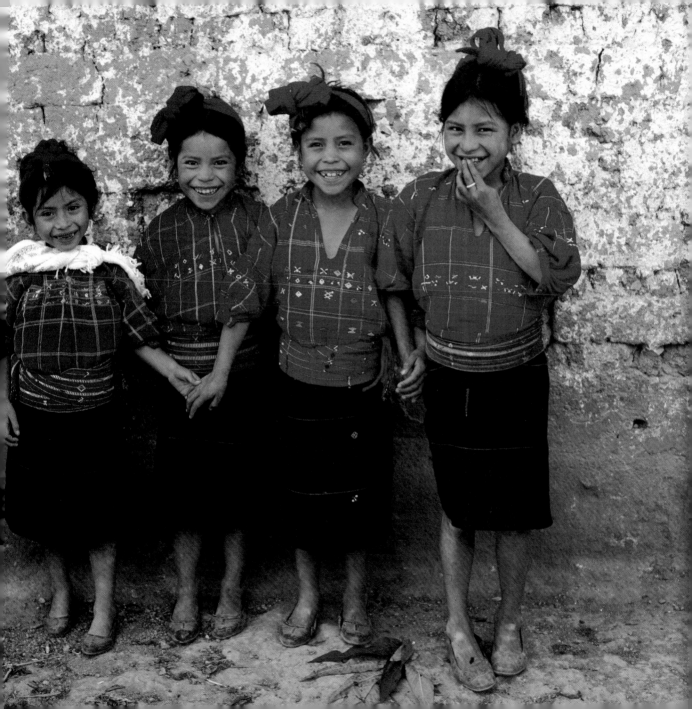

Children

Children are an inexhaustible source of appealing expressions, gestures, and poses. From sleeping to playing, from silliness to sadness, a child's activities and moods are a treasure to record. Children are often playful and clown for the camera, but they are just as appealing when they reveal natural bashfulness at being photographed.

Your best pictures result when a child is either unaware of the camera or accustomed to its presence. If instead of making picture-taking a special occasion you keep your camera handy and use it often, a child is much more likely to consider it a normal part of life. Such familiarity gives you chances to capture a characteristic look or stance.

It is more important with children than with other subjects to experiment with camera angles and levels. From a standing position with the camera at your eye level you can show a child from an adult's perspective. From an even higher angle, perhaps standing on steps or a chair, you can convey beautifully the tiny stature of a toddler in a world designed for adults. But you will discover that the most rewarding pictures occur when you move down to the child's level. Your images will be more intimate and revealing and will show facial expressions and bodily proportions from a more pleasing and natural-looking perspective.

Since children are small, remember as well to move close to them so that their image fills the frame. This is best achieved by using a medium telephoto lens, one between 85 mm and 105 mm (for a 35 mm camera). A lens of this focal length allows you to keep your distance while shooting candids, yet it is not so long that it hampers your mobility in an average-sized room. When you come in for a tight head shot, it gives you natural, undistorted facial features, as in the picture at right above. Using a lens with a relatively wide maximum aperture ($f/2$ or $f/2.8$) and fast film (ISO 400/27° or higher), you should be able to get good indoor photographs with available light if you wait for quiet moments and focus carefully. If your young subject is too energetic to stay put for a pose, a flash is your best choice for lighting. Remember to bounce it off a white surface for the most natural-looking results (see page 98).

Consider using a fast film to photograph children who are playing

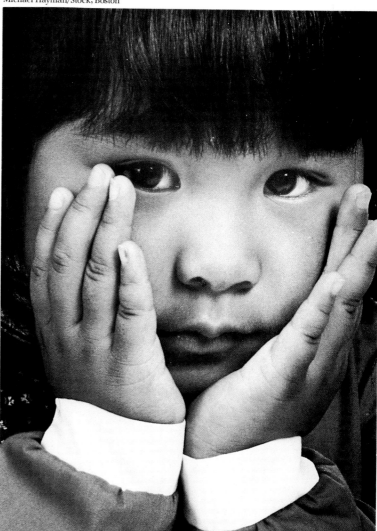

outdoors, even when the light is strong. A high-speed film permits you to set a small aperture for great depth of field and a fast shutter speed for freezing action, a combination that gives you the greatest freedom in capturing on film these fast-moving, unpredictable subjects. A shutter speed of at least 1/125 second is necessary to stop action; 1/250 or 1/500 second is preferable. Use a 135 mm to 200 mm telephoto lens to compensate for generally greater outdoor distances. The most useful lens in this situation, however, is a moderate telephoto zoom model, about 70 mm to 150 mm in focal length. Instead of running to keep up with your agile subjects, you can stay in one place and vary the framing of a scene by zooming in or out.

Even though she is looking directly into the camera, the young girl in this tight portrait reveals becoming shyness — her hands hide much of her face and her eyes betray her uncertainty about facing the camera.

▶

Getting good, unself-conscious photos of a child is not at all difficult when you select an appropriate, uncluttered setting and get the child involved in a favorite activity. Here, the pier and still water combine with the barefoot boy and his toy sailboat to produce an image with timeless appeal.

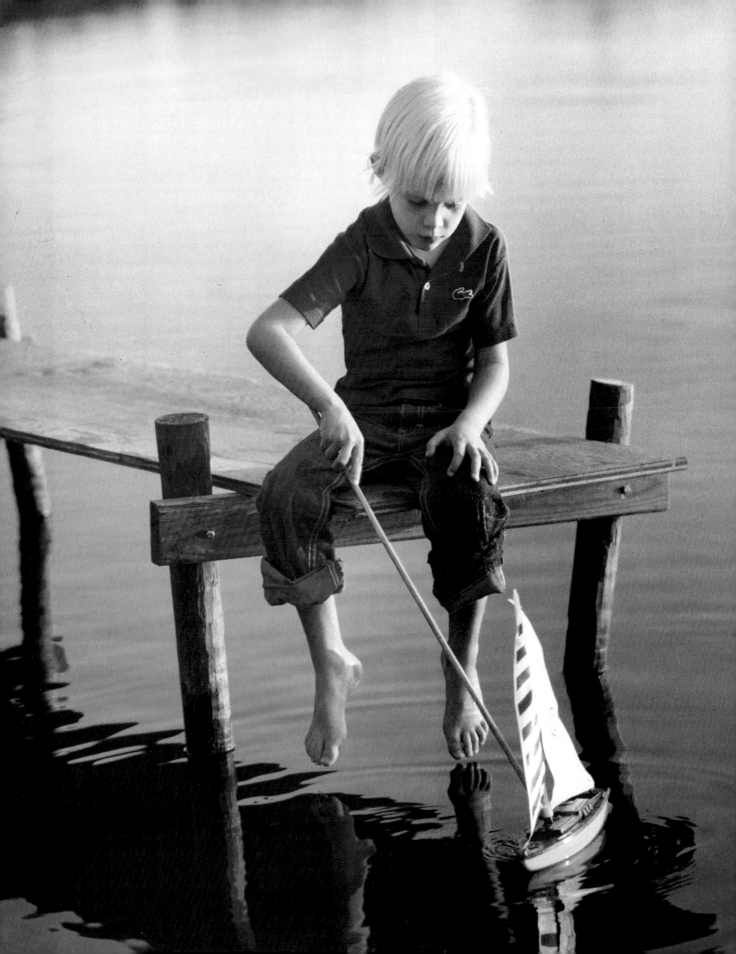

Jim Keating

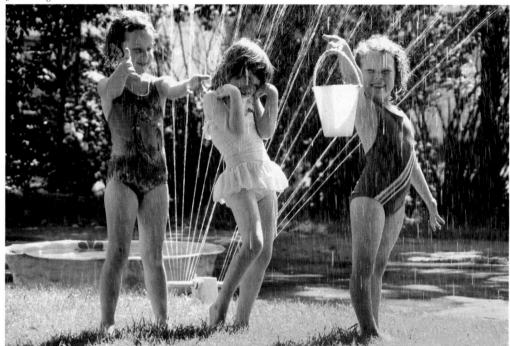

In a photograph appropriately taken at their eye level, three young girls display a range of reactions to being drenched by a lawn sprinkler. For spontaneous responses in such situations, be completely ready to photograph before asking the children to perform.

Jay Freis/The Image Bank

An extremely high, directly overhead point of view produced this eye-catching image. Note how the uniform gridwork of paving stones offsets the exuberant activity of young basketball players. Keeping the subjects well off center gives the image its strong visual impact.

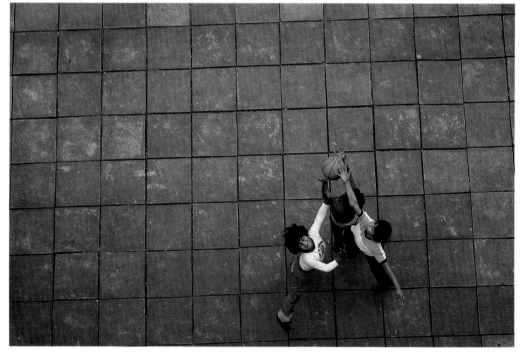

110

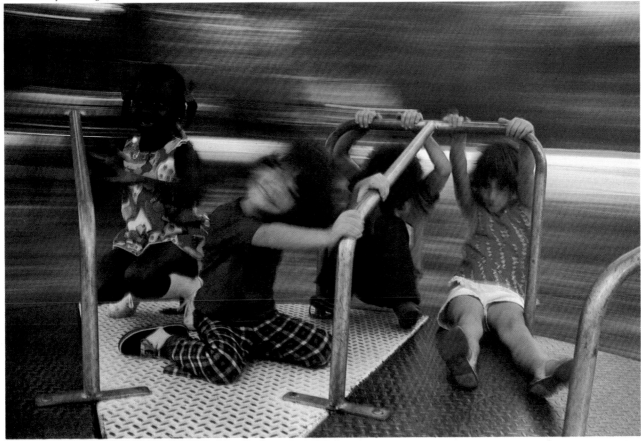

The heady childhood pleasure of careening on a merry-go-round comes across beautifully in this image of blurred subjects and even more blurred background. The photographer achieved this effect by making a slow exposure while riding with the children.

Babies

A child's first two years constitute a period of unparalleled rapid physical growth and intense learning. Each month offers new opportunities for picture-taking, but to make the most of these opportunities, you must use an appropriate approach for the baby's level of development.

Newborns just home from the hospital are most easily photographed close-up, cradled in a parent's arm or lying face-up on a bed or crib. Babies who can hold their heads aloft while lying on their stomachs can be photographed face-on at close range as they hold that position. Infants who can twist and turn over offer you a chance to get interesting pictures of their maneuverings when you put them unclad on a plain blanket and photograph from directly overhead.

Frontal and side portraits can easily be obtained once babies are able to sit up. And when they start to creep or crawl, you'll get the most intimate views when you get down to floor level with them. Once they can pull themselves up and stand or propel themselves about in a walker you'll have a lot more flexibility, taking full-body photographs and then moving in for close-ups of the face. When a child begins to walk you'll have opportunities for endless candids, for a toddler's curiosity and enthusiasm know no limits. (Posed pictures are almost not worth the effort, for toddlers are notoriously uncooperative at this stage.)

With babies of all ages, bath-, meal-, and even naptime present good occasions to get interesting candids while they are preoccupied. When you take more formal pictures, however, try to keep up a steady stream of pleasant, reassuring chatter. Nearly all babies find this diverting; even before they can focus their eyes, very young infants turn their heads toward people who are talking. But don't expect a baby's expression to brighten into a real smile before the infant approaches the end of his or her first month.

For realistic natural lighting, try rolling a baby's crib to a window where soft, diffused light is streaming in, or have a parent hold the baby and sit by the window. Infants can often be photographed in existing light with a combination of fast film (ISO 400/27° or higher) and a wide lens opening (f/2.8 or wider). A baby is rarely still, so use the fastest shutter speed you can. And take several pictures, because a baby's expression is so transitory that it may change without your noticing. With such agile and unpredictable subjects, a flash may sometimes be the only sure way to capture a moment. A bounced flash gives softer, more natural results.

A normal or moderate telephoto lens is fine for most baby pictures. But remember you must move in close to fill the frame. Too often a baby is a small figure in a picture made from an adult's distance. If you want to get a very tight close-up of an infant's face or other features, as in the picture of a baby's neck at far right, you'll get best results with a close-focusing macro lens or a zoom lens with macro capacity. A less expensive alternative is a close-up lens that screws onto the front of your normal lens.

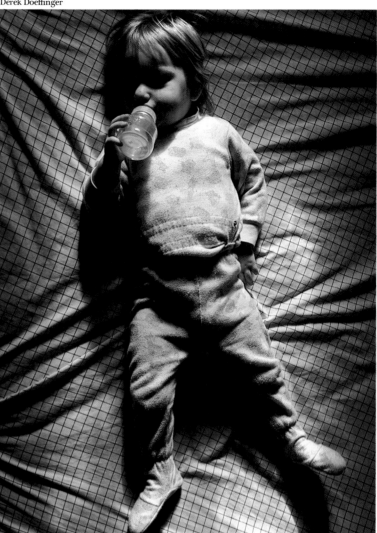

Derek Doeffinger

An air of tranquillity prevails as light filters into a darkened room, framing a baby who's quietly nursing from a bottle. The simple gridded bedsheet provides the kind of large, plain background that gives best results in photographs of infants.

Kasia Gruda

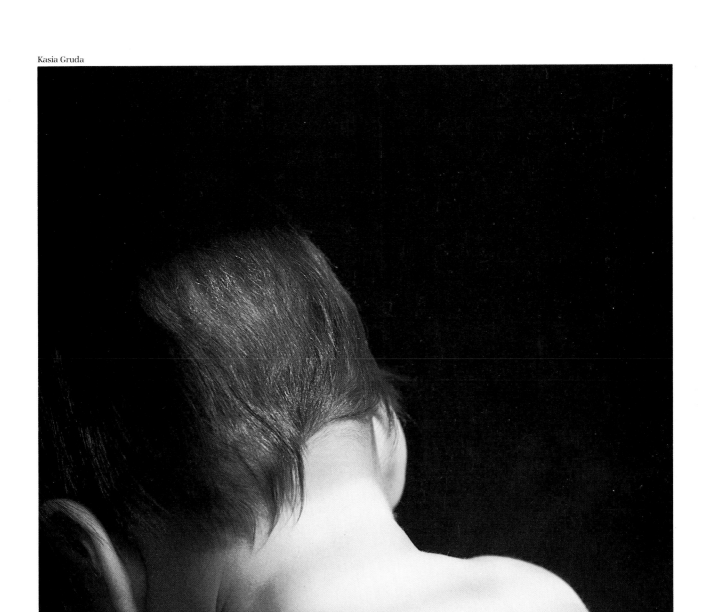

This close-up of a nape of a young baby's neck emphasizes two distinctive characteristics of that age: the fine downy hair and the silky smooth skin. Close-ups that single out an infant's chubby hands, bowed legs, or pudgy stomach can also be interesting.

A Child's World

Donald Dietz/Stock, Boston

The world that children inhabit brims over with imaginative attire, whimsical props, and unexpected poses assumed during uninhibited acting-out of fantasies.

To capture a child's world on film you must refrain from imposing an adult's view on children; keep an eye out for those activities, toys, and locales that convey interesting information about the youngsters. As two of the pictures here demonstrate, photographing children with their artwork can be very effective because their drawings tell us a lot about the skill and imagination of the young artists. But you can capture equally intriguing images by showing how a child sets up dolls for a meal, arranges cars for a race, or decorates a sand castle. Even a child assuming a show-offish stance can result in an engaging, informative photograph, as the picture of the boy in front of the house shows.

When you take pictures of a child's world it is best to use a wide-angle lens with a 35 mm or 28 mm focal length. This lens lets you record more of the scene in a cramped setting where it is impossible to back up. And with its relatively good depth of field, a wide-angle lens tends to keep both near and far picture elements in sharp focus. It can also be used to give exaggerated prominence to elements in the foreground of a picture, as in the picture at right. With a wide-angle lens, however, you must be careful not to distort your young subjects by placing them near the edge of the picture frame or in the extreme foreground close to the camera.

The major difficulty in composing a picture that includes a good deal of setting is avoiding a cluttered, haphazard appearance. One way to rid a picture of extraneous details is to hold your camera at a markedly downward angle so that your subjects and their revealing props are set against a solid background of floor or ground, as in the picture of the young sidewalk artist.

Another, trickier way is demonstrated by the picture of a boy drawing on a stool. Here, the busy distracting furnishings of the room have been cleverly obscured in darkness. Unity in the third picture shown here comes from the imposing solidity of the house. In setting up such photos, remember that children quickly get bored and fidgety. Have your equipment ready and plan the picture before you ask a child to strike a pose.

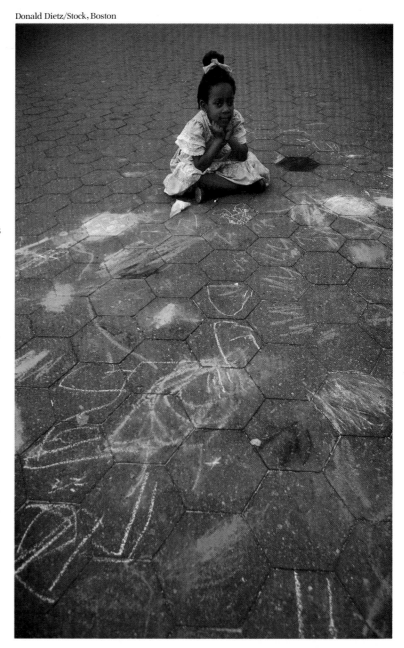

A beribboned and brightly dressed young girl proudly shows off her colorful handiwork. A high camera angle turned the paving stones into a simplifying backdrop, while a wide-angle lens stretched out her chalk markings, making them more prominent.

Mike Mazzaschi/Stock, Boston

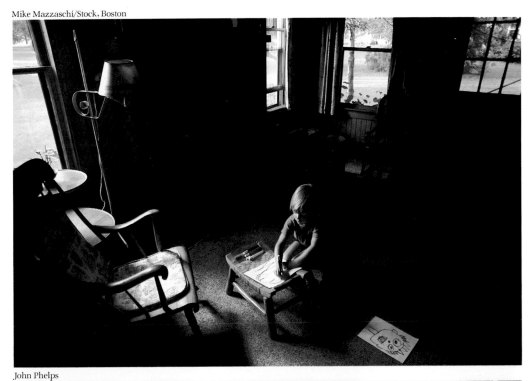

Subject placement and altered exposure were the keys to this remarkable indoor-outdoor view of a young artist's world. By positioning the boy in the strong light from a window and then exposing for the brightly lit subject, the photographer concealed all but a few telling details in the room while giving us a look at the verdant landscape beyond. Had the photographer exposed for the dim interior, the windows would have become washed-out blurs.

John Phelps

A spunky youngster puts on an act for the camera in a scene where everything – from the boy's bare feet to the quality of the light – is evocative of childhood joy. The encroaching shadows of dusk and the dominant shape of the house keep the photo from being cluttered.

Children Alone

Fulvio Roiter/The Image Bank

A porch proved to be a very becoming setting for this portrait of a pensive young girl. Its post and railing frame the subject, and its colors are variations of the colors in her clothing. The large area of shadow created by the porch fits her subdued expression.

As subjects for informal portraits, children are generally more rewarding than adults. Grown-ups approach the camera with a fixed repertoire of behavior patterns, which show in their actions, clothing, bearing, and even the way they respond to the camera. Children, by contrast, are much more natural.

Children are at a stage in life when their individuality is just emerging – often it is being vigorously asserted. They are imaginative, spontaneous, and curious, trying on new roles the way one of their elders might try on a shirt. They are also less restrained in expressing their feelings. They proclaim their emotions more fully and loudly and often experience contradictory feelings at the same time. Not many adults can combine a fierce sense of independence with strong vulnerability the way many children do. Similarly, children can reveal complete naiveté in one area along with enormous sophistication in another.

This variety of moods makes children fascinating subjects, highly gratifying to the parent who takes an inventive but relaxed approach to documenting the stages a youngster passes through. When you take an informal portrait of a child, try to find a setting that reveals something about the child or works with the child to form an interesting visual arrangement. In the picture of a boy with a balloon, for example, the building shows the boy's relative size and combines with him to create a striking composition. Architectural details such as doors, windows, and façades provide elements not only for the important task of revealing a child's height and proportions at a certain age but for eye-controlling frames, like the porch in the picture of the girl above. Buildings can also be the source of vibrant colors that seem more appropriate in pictures of children than adults and can counterpoint strikingly with the brightly colored clothing that children frequently wear. These elements can be as critical in obtaining eye-catching portraits as a child's facial expression. Also important are a child's characteristic stance and ways of holding the head and arms, since these mannerisms are often more unconsciously flamboyant than a grown-up's.

Naturally playful and inquisitive, children can be highly cooperative subjects if you explain what you want them to do and make a game of setting up the photograph. Above all, avoid making picture-taking a stiff, formal event.

▶

A building's strong colors and stark geometrical forms turn this portrait of a happy young balloon carrier into a remarkable composition. Most notable is the repetition of the color in the triangle of sky, the blue of the building's base, and the boy's clothes.

Kasia Gruda

Dick Faust

A rainy day proved to be a good occasion for this portrait of a young boy. The foul weather brought the bold colors of the slicker and door together, and the rain gave them both extra gleam. The overcast sky provided soft, diffuse light.

Kitty Simpson

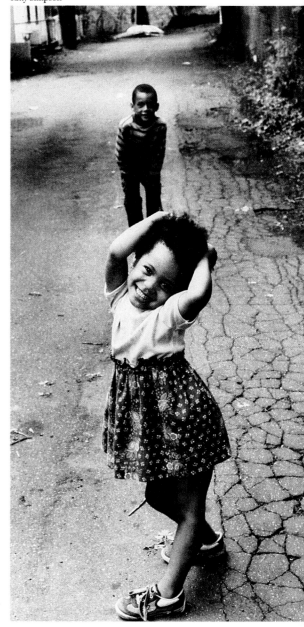

A beaming young girl assumes an awkward, twisting stance, a position that immediately tells the viewer that while delighted to be the center of attention, she is so shy she is ready to run away.

Diane Cook

Morton Beebe/The Image Bank

Daydreaming is as much a part of childhood as energetic play, and it offers a chance for unusual candids. The musing youngster here helps create a striking image as he reaches out to the hand on the vase and the dog eyes his unfinished sandwich.

Handsome large almond-shaped eyes are this boy's most outstanding feature. The photographer made them the central ingredient in the picture by moving in for a close-up and having the boy look directly into the camera.

Families

One of the most common ways to portray a family is to present parents and children together, to photograph the entire family unit. Yet too often such pictures fail to tell the viewer interesting and revealing facts about the family. They might not convey the personality of the family as a whole or disclose what makes this particular family distinctive and different from others. In Evelyn Hofer's picture of a formally posed, well-attired family at right above we immediately sense a lifestyle far removed from that of the gregarious rural family standing in front of a truck in the picture at right below.

In posing a family, try to create an arrangement that ties the members together in a cohesive unit. Most often this can be done by grouping them tightly together. In a more formal arrangement you can also create a sense of unity through compositional elements such as shared textures, shapes, and colors, or lines that direct the viewer's eye from one person to another.

However the group is arranged, the positions of their heads should create an interesting dynamic arrangement, since faces are the first element that catches the viewer's eye. Heads lined up evenly in a row create a static portrait, whereas heads arranged in a staggered pattern or in a strongly triangular design produce a photograph with much more vitality. When a husband and wife are the same height and posing with tall older children, it is more effective to have some members sitting, kneeling, or standing at a higher level, to provide variety.

To light all the family members evenly in any arrangement, photograph on a day when there is soft light from an overcast sky or position your family in an area of open shade next to a building. Indoors, use a bounced flash (see page 98).

If you want to include yourself in the group, it's easiest to have a friend act as a stand-in while you compose the group through the viewfinder of a tripod-mounted camera. Then switch places and have the friend click the shutter for you. This gives you more control than using the camera's self-timer or a wireless remote-control shutter release and trying to guess how you will look. As with all groups, take extra pictures to ensure getting at least one in which no one is frowning or blinking.

Evelyn Hofer

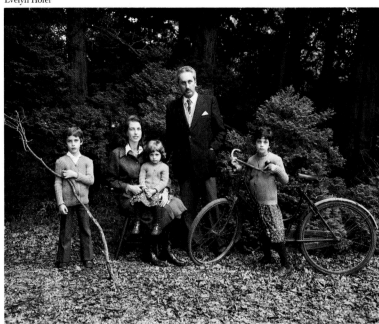

Joan Liftin/Archive Pictures

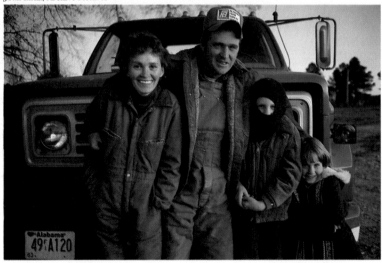

(Top) Noted photographer Evelyn Hofer's formal arrangement accents the restrained character of this upper-class family. The woody background and subdued tailored clothing, which provide a rich, subtle texture, are also dark enough to set off the faces.

(Bottom) The father's embracing arms literally unite this happy family into an attractive, triangular grouping. The truck serves as a bold, revealing frame.

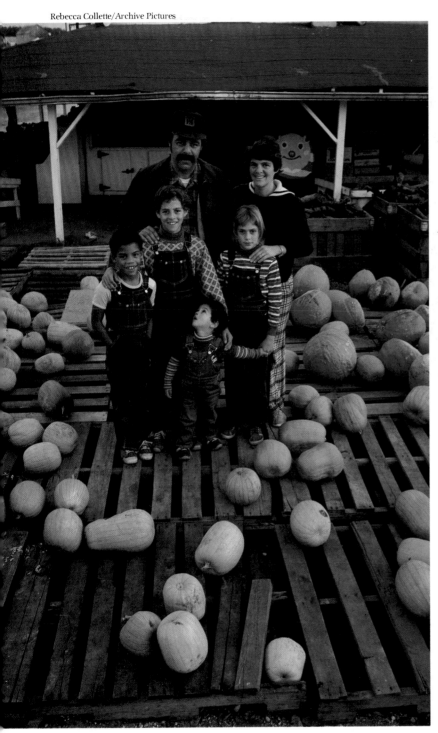

A large family's exotic peasant attire displays pride in their Russian ancestry. The photographer obtained visual variety and unity by a time-honored arrangement: seated parents, with smaller children at the center, some standing behind and others kneeling in front.

A scattered array of pumpkins provides a colorful, unifying frame, telling us that the subjects are a farm family. A high camera angle emphasizes the bright fruit.

121

Joel Meyerowitz's photographs are intimate documents. "I only make a photograph when I feel strongly about something," he claims. His people pictures particularly demonstrate the fullness of his emotional involvement with his subjects, for it is when he feels a deep closeness with people that he "pulls them in" to himself by taking a picture.

Meyerowitz has always watched people carefully. As a youth growing up in the rough-and-tumble environment of the Bronx, New York, he learned to study people's movements and interactions – partly as a way of keeping himself from getting hurt. When he started photographing, the street – and its inhabitants – were natural subjects.

Initially Meyerowitz worked with a handy 35 mm camera. Now, however, he does all his personal work with a heavy, old 8 × 10-inch view camera, taking what he calls, "penetrating pictures of other human beings." Meyerowitz prefers the view camera because the larger negative yields richer texture and color and far more subtle detail. It also changes his relationship with his subjects, allowing them to present themselves formally to a camera that is as big as they are.

Much of Joel Meyerowitz's portrait work has been done on Cape Cod, the place where he and his family spend the summer and the subject of his hauntingly beautiful book, *Cape Light.* This picture of his daughter Ariel, taken on the Cape, is one of the photographer's favorites.

"She's a city girl," he says about his daughter, "and she was into roller skates at the time." She had been roller skating on the lawn when Meyerowitz told her to stop because she was clogging the wheels with grass. When he looked out a few minutes later, there she was sitting on the hood of the car pouting, her wheels humming as she spun them against the metal. "She looked her age," he recalls, "and she looked herself." He grabbed the view camera and made the picture.

Meyerowitz explains that with his pictures he is trying to communicate and explore that depth of human feeling that is so important to him. "Life is interesting and full," he says. "You take pictures because you enjoy life."

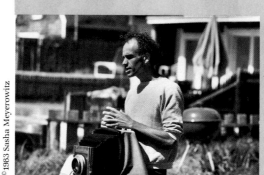

©1983 Sasha Meyerowitz

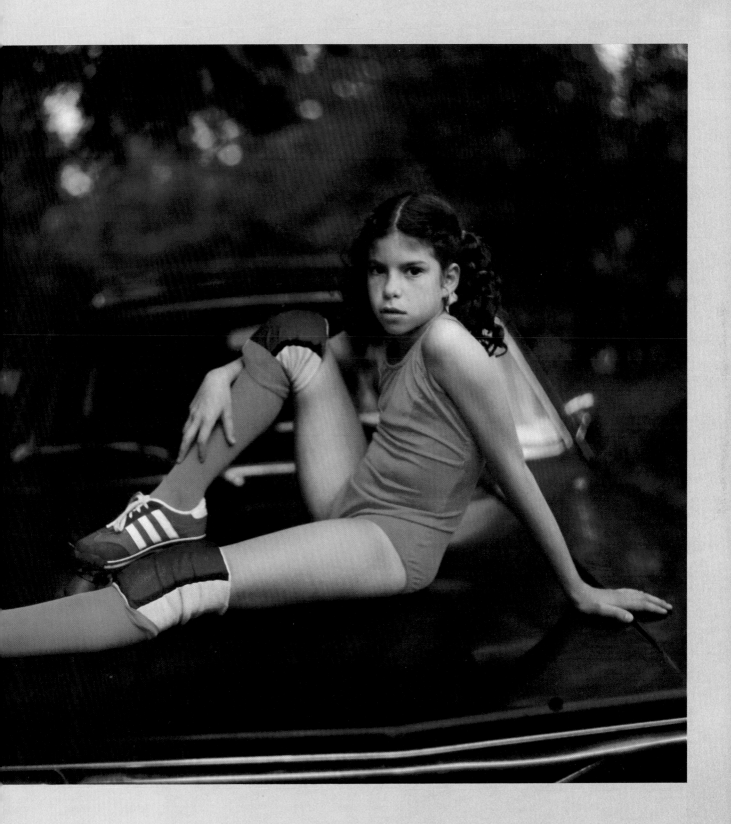

Parent and Child

The relationship between parent and child is unlike any other. Effectively expressing that relationship in a photograph depends on a number of factors, chief among them the child's age.

Infants and toddlers take readily to their parents' arms or laps, which virtually assures a picture with a strong center of interest. The heads of the two subjects are usually staggered, preventing the composition from becoming too static.

Children in their middle years can be coaxed to move close to their parents to form an attractive, unified composition. As the picture of the mother and daughter at far right shows, it's a good idea to have the parent sit or kneel and the child stand alongside. The faces are brought closer together yet are staggered enough to form an interesting arrangement.

As children - especially boys - mature into adolescence and beyond, they generally grow to disdain a parental embrace. As in the picture of the father and son on page 126, the most contact many teenagers tolerate is a hand on the shoulder. Trying to get your adolescent to be more affectionate may only result in an awkward and embarrassed young subject. To obtain compositional unity in such situations, place one subject slightly behind and to the side of the other, overlapping their bodies from the camera's point of view. The parent, who is generally larger, should stand behind the child, but with a six-foot teen and his petite mother you might want to reverse the positions.

Some parent-and-child portraits depend on a visual device. When a parent and child share a strong physical resemblance, it can be emphasized with a close-up of their faces. A full-length picture or perhaps even a silhouette can also stress the similarities in their physiques. A parent and child of the same sex might dress alike or fix their hair in the same style. The work clothes in the picture of father and son and the hairdos in the picture of mother and daughter tie the subjects together and contribute greatly to our immediate recognition that they are indeed parent and offspring.

William Rivelli/The Image Bank

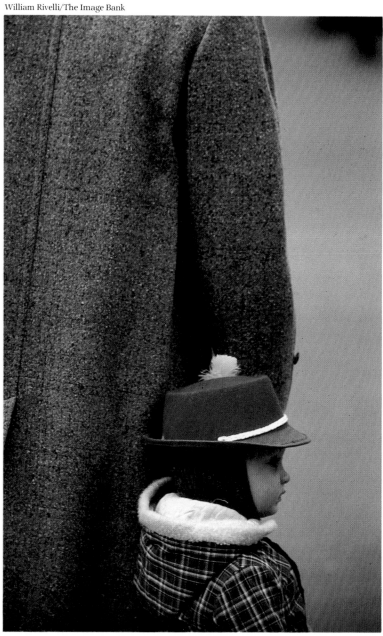

Not all revealing parent-and-child pictures are full frontal portraits. This street candid of a young boy and his father shows how towering and overwhelming an adult is from the child's perspective.

Niki Berg

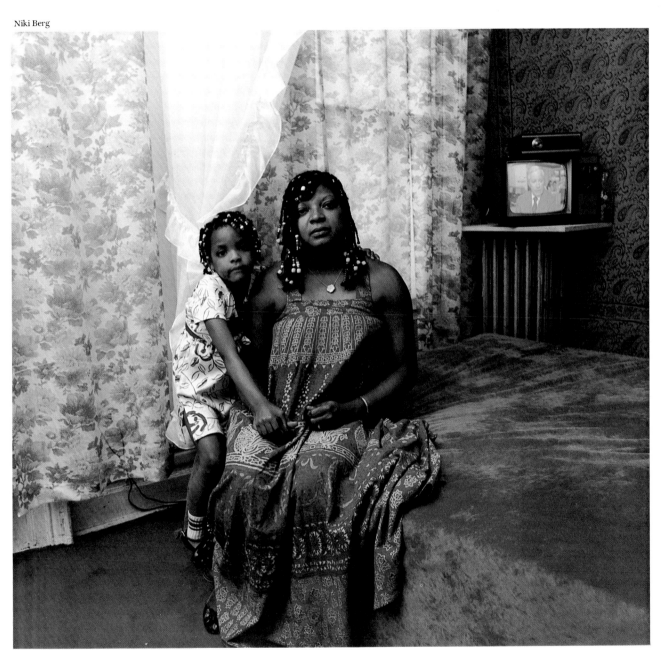

The casual yet affectionate
way a daughter holds her
mother results in an
attractive triangular
composition that empha-
sizes their strong facial
resemblance as well as
their matching cornrow
hairstyles. The black-and-
white television set in the
background adds an
interesting off-beat note
while pointing up the
colorful patterns.

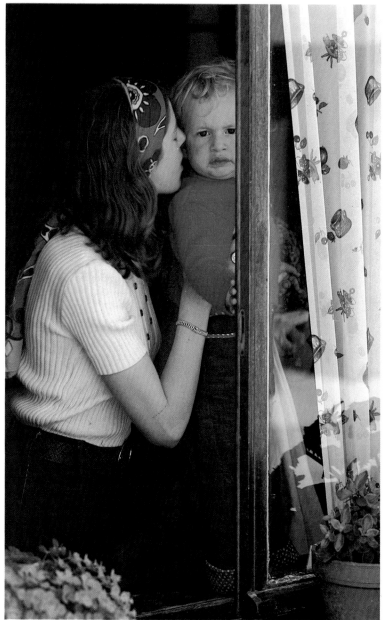

By photographing from outside through an open window, the photographer created a cozy frame for this appealing candid of a young mother consoling her disgruntled toddler. The red in her scarf and in the child's sweater helps to unify the image.

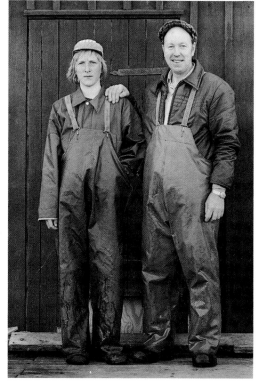

Striking similarities in build and facial features reveal that these two are father and son, while their identical overalls indicate that they share farm chores. The father's proud, protective grip on his son's shoulder contrasts tellingly with the boy's stand-offish attitude.

Michael Skott/The Image Bank

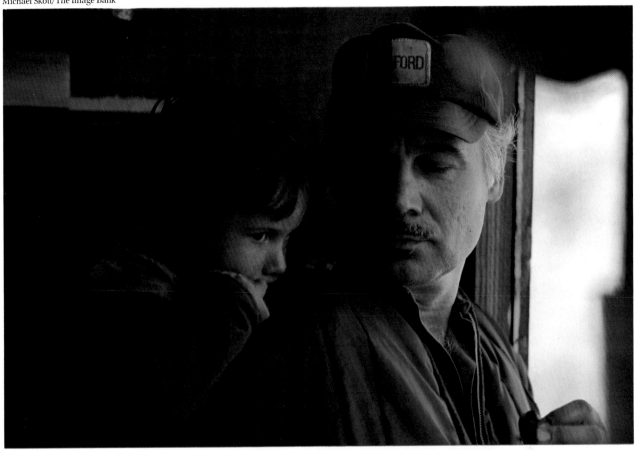

Marcia Lippman

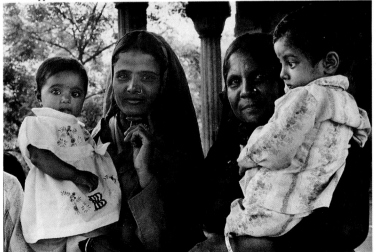

In this father-and-child portrait, our attention is immediately drawn to the face of the shyly pensive youngster. Dark clothes and a dark background combine effectively with sidelighting from a window to isolate both faces, and the father's downward glance leads our eyes to the child.

With primly dressed children in opposite arms, two Indian mothers create a composition that might normally be too symmetrical to be visually pleasing. The image derives vitality and interest, however, from the great difference in height and position of the two children's heads.

Children Together

Lisl Dennis/The Image Bank

It's natural to find children in groups – whether brothers and sisters, neighborhood kids at play, or more formal groups such as school classes and athletic teams. And it's usually much easier to photograph them because they are more comfortable and unself-conscious about being in a group.

Even in more formal studies, it is best to let children arrange themselves. If there is a great deal of difference in their heights, try to find a setting – such as chairs or steps – that allows the subjects to sit and stand, or let them arrange themselves on different levels, to bring their faces closer together.

Look also for settings that provide a simple and unifying backdrop and tell why the children are a group. A chalkboard, for example, shows that they are classmates, a lawn with a set of swings that they are playmates. Props and clothing can also disclose a lot about a group. A single football among a group of casually dressed boys may be all that is needed to reveal that they are a neighborhood pickup team.

Children in groups constantly react to one another, which can be a mixed blessing for the photographer. Sometimes children kidding around with each other and acting for the camera produce marvelously spontaneous pictures that reveal their characters. Other times you'll face a line of self-conscious smirks. In such cases, an approach that sometimes works is to take a couple of photographs, then act as if you have to adjust the camera. You can snap candids as they begin to interact with one another and ignore the camera. Take more than a single picture of a grouping. You can't keep your eye on all their faces at once, and there is always a chance that one of them has looked away at the last moment.

Outdoors, diffuse light of an overcast day or in the shade cast by a house is best; your subjects won't squint and their faces won't be streaked with unflattering shadows. Indoors, a bounced flash can give soft, even lighting on a group while freezing the action.

A quartet of rosy-cheeked girls forms a strong diagonal composition as they smile broadly for the camera. The photographer included just enough of the picturesque row houses and grassy downs to tell us that the girls are in a small Irish village.

As one boy mugs for the camera, another looks less certain about having three on a rope. Although the third boy's face is hidden, it doesn't matter. In such candids, capturing the spirit of the occasion is more important than having everyone's face clearly visible.

Teenagers

Poised between childhood and adulthood, teenagers swing easily between the energy and enthusiasm of youth and the more pensive outlook of maturity. Sometimes they are filled with joyous animation, like the girls in the picture above. Other times they sprawl moodily as if weighted down by enormous lethargy. At the same time, the teen years are the period when most youngsters achieve peak physical strength, skill, and grace and engage in the most vigorous activities. All these characteristics – along with a penchant for fads and copycat dressing – make them prime candidates for candids and other informal photographs. But as a group teenagers are probably the most sensitive about their physical appearance, and they can be the most uncomfortable about being photographed.

Around the house, one way to get beyond camera shyness is to keep your camera handy and take pictures when a teenager is engrossed in an absorbing activity such as studying, sewing a garment, assembling a model, sketching a picture, or even watching television or playing a video game. A photo of a boy shaving or a girl putting on makeup can foretell nicely the coming adult years. A moderate telephoto lens, with a focal length of 85 mm to 110 mm,

(Above) The extraordinary ebullience of youth comes through clearly as a group of lively teenagers, trying to get themselves included in the picture, crowd around the girls being photographed. This type of photograph is usually obtained by using a wide-angle lens at close range.

lets you frame the subject closely and blur distracting background details, yet allows you to maintain sufficient distance to keep the click of the shutter unnoticeable. Another approach is to work closer using a small compact rangefinder camera with a quiet shutter. Either way, you have to compensate for the generally low level of light by using high-speed film and large apertures and by focusing carefully.

When you want to take more formal portraits of teenagers, ask them to act as if they are engaged in one of their regular activities. Although they are just pretending, they will feel much more comfortable and less self-conscious. At the same time, you will be able to control the lighting, background, and camera angle more fully for the best result. The real bonus, however, is that you may very well get a portrait that accurately reflects their interests at that point in their lives.

Since teenagers spend most of their time outside of the home with their friends,

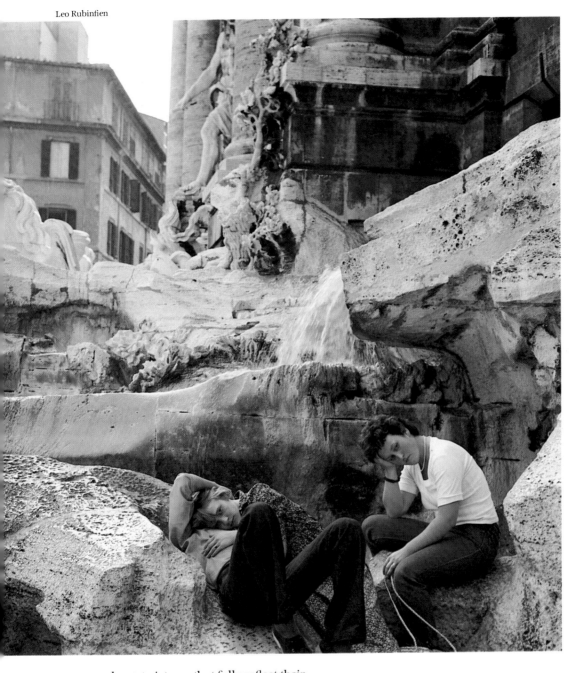

Leo Rubinfien

In the typically casual manner of teenagers, a trio of young people slumps on the rocky base of Rome's famed Trevi Fountain. Especially notable are the two girls' almost identical melancholy expressions.

you can also get pictures that fully reflect their lifestyle by going to the places they go. It can be a place where they simply hang out together. Or better yet is a place where you can get a nice mix of photographs of them, in action and relaxed: a local park or playing field, or in summer a beach or pool. The best approach is usually to take candid pictures from a distance with a telephoto lens.

Couples

Whether in a street candid or a more carefully posed portrait, your most important objective in photographing two people is to convey the strong relationship between them. This is most easily done by capturing a moment when a revealing physical gesture or look passes between them. As the picture of the Eskimo couple illustrates, snapping a moment of revealing interchange can be much more striking than getting clear images of faces.

When taking candid pictures of couples, the moments you want to capture are usually those when your subjects are most involved with one another. Their rapport can make it possible for you to photograph them at close range, especially if you use an unobtrusive rangefinder camera with a quiet shutter. To increase your chances of documenting those special, fleeting moments, be ready with your camera. Use high-speed film and a fast shutter speed, and preset your camera's distance and exposure settings.

Posed pictures of couples can also be very rewarding, but you must make a special effort to arrange the subjects so they create a dynamic composition. Having two faces right next to each other or two people standing side by side generally results in a static image. A good solution is to have one subject slightly higher than the other so their heads form a strong diagonal arrangement. You can, for example, have the man stand on a step just behind the woman, or have her sit on the arm of a chair in which he is sitting. In a full-length picture you might have one person stand and one sit. In a tight close-up of their heads, arrange them so the mouth of one and the eyes of the other are even along an imaginary line.

Whatever their positions, it's best for your subjects to overlap slightly to form a strong, unified image for the camera. You can also add interest by making one person more prominent than the other – have one closer to the camera or show one full-face with the other in three-quarter profile. Similarly, if one person looks at the other, the recipient of the gaze becomes the focus of the picture.

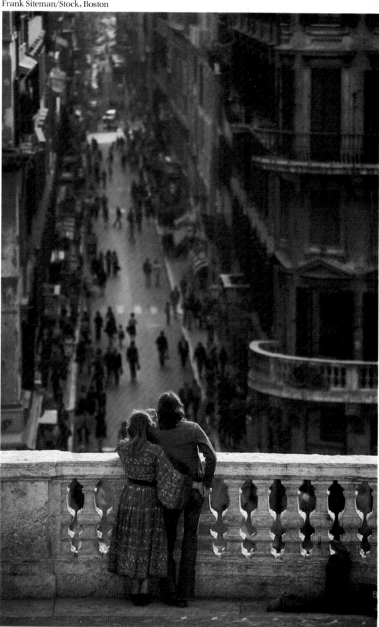

Frank Siteman/Stock, Boston

It's best to use soft, diffuse lighting with couples because it's tricky to light two people well with strong directional lighting. A north-facing window with a reflector opposite it, an area of open shade outdoors, or a bounced flash indoors lights both faces fairly evenly. It also gives you much more flexibility in arranging your subjects.

Atop Rome's famed Spanish Steps, a young couple reveals the closeness of their relationship by the way she stands beside him with her hand on his hip and by his response in placing his hand over hers. Angled side lighting creates a rim of light that nicely separates the pair from the picturesque street scene below.

Mary Ellen Mark/Archive Pictures

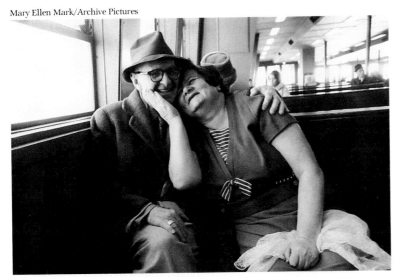

In noted photojournalist
Mary Ellen Mark's delight-
ful candid, an older cou-
ple's good-humored and
warm display of affection
contrasts strikingly with
the stark setting of the
Staten Island Ferry's
benches.

Even though the woman's
face is almost completely
concealed, we can imme-
diately discern the strong
bond between this Eskimo
couple. In a late after-
noon's golden glow, the
photographer captured the
intimacy of the action and
the quizzical expression on
the man's face.

Eva Momatiuk and John Eastcott/Woodfin Camp

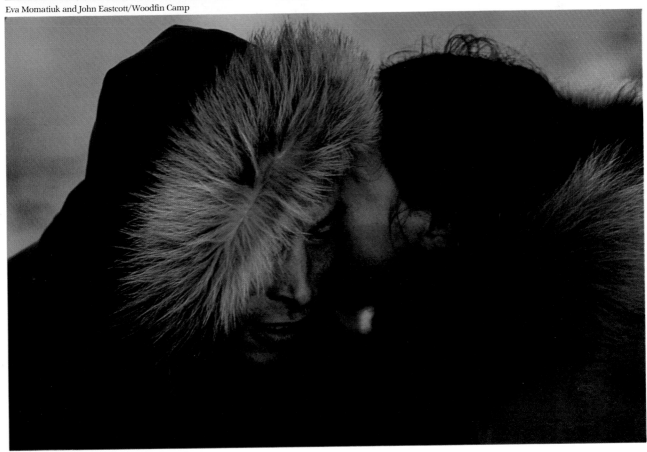

Older People

The key ingredient in taking a successful picture of an elderly person is the quality of the light. Direct light from the sun or a flash tends to bring every age spot and wrinkle to the fore. Soft, diffuse light, on the other hand, gently fills in all but the deepest furrows and tends to lessen the contrast between facial marks and surrounding skin. Since it is a light that is flattering to the subject without concealing the effects of age that are so much a part of an older person's character, diffuse light is ideal for most portraits.

To obtain such lighting, take your subject outdoors on an overcast day when the sun's rays are filtered through clouds. Or pose your subject in the open shade next to a building. Indoors, use a bounce flash or, for more natural results, indirect daylight coming through a window. But remember that window light, even when soft, is highly directional. You will usually need a reflector to fill in the side of the face away from the window.

In posing an older person for a portrait, you will find that a full frontal shot of the face is generally more becoming than a three-quarter view or a profile. Also, choose an eye-level or higher camera angle to avoid emphasizing your subject's chin and neck. A moderate (85 mm to 110 mm) telephoto lens is also a good choice as it does not distort the nose and make it appear larger.

If you want to flatter your subject even more, use a diffusion filter or other material, like sheer nylon, over the front of the lens (see page 72). These devices cause the light to spread as it enters the camera, obscuring the subject's facial details. A slight amount of diffusion can be very effective, especially in a formal portrait or in a picture with a nostalgic setting. But too much diffusion produces a portrait that looks unnatural and old-fashioned.

At the other extreme, you may want to stress the deep, weathered creases of a colorful field hand or the shriveled, papery skin of a fragile ninety-year-old. In this case, use strongly directional lighting that hits the subject from the side and rakes across the skin, revealing its texture. Even here, however, the light should not be too strong because it can create an uneven, contrasty picture with pronounced highlights and shadows.

Niki Berg

Arms set determinedly on her hips, an obviously vigorous elderly woman boldly faces the camera as if trying to stare down the photographer who has the temerity to take her picture.

▶
In this gentle portrait of an older man, the impressionistic landscape painting behind him serves as more than a strong compositional element. Its presence suggests that he is a man with sophisticated taste.

Kasia Gruda

134

Generations

A picture that includes several generations is virtually a photographic genealogical chart and ranks among a family's most treasured images. The most effective way to create a picture that emphasizes generational relationships is to gather all the descendants of one person or a couple for a group portrait. When you arrange such a photograph, be sure to place the senior person or pair in the center of the front row or in some other position that makes them the focal point of the picture. Place members of the next oldest generation toward the center of the group to give them more prominence.

Do not arrange the members rigidly by generation levels or family subunits. Instead, try to achieve an attractive, natural-looking composition. It is uninteresting to have all the subjects standing abreast, for example, forming a static row. Instead, position them according to height or on different levels. Have their heads form a staggered pattern to add visual interest. Or introduce variety by having one sit, another lean on the arm of a chair, and another stand or perhaps kneel.

For photos of other groups, place the members close together to weld them into a cohesive unit. Also, consider using a setting like the staircase in the picture at far right to frame the subjects and tie them together visually. With a large group, be especially sure that everyone's face can be seen clearly. The larger the group, the more pictures you should take to ensure that you have at least one or two photos in which everyone's expression is pleasant. If the group is unusually large, some of the suggestions about handling sizable groups may help (see pages 170-171).

Another way to portray generations is to show one person from each generation; the image, in effect, traces the line of descent from great-grandparent or grandparent to great-grandchild or grandchild. As the two black-and-white pictures at right demonstrate, this approach works especially well when the subjects bear a strong resemblance to each other. The similarities in the subjects create a compelling underlying unity, which you can underscore with tight grouping and careful composition. In any photograph of several generations, you'll get the best results with the soft, diffuse light of an overcast day or open shade.

H. Sylvester/Rapho

Peter Simon/Stock, Boston

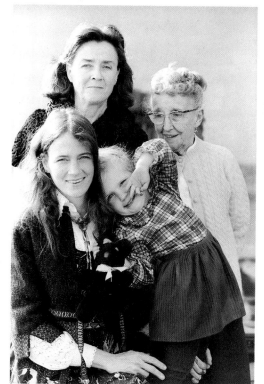

The faces of a southern Italian son, father, and grandfather form a striking diagonal arrangement from light to dark, which emphasizes the progression from vigorous, bushy-haired youth to aging elder.

The similarities between members of different generations create a visually intriguing image. These American women of four generations bear such a strong resemblance to each other that their group portrait looks almost as if it were a composite of photos taken at different stages in the life of one person.

▶

A staircase provided the ideal setting for this portrait of an elderly matriarch with her children and grand-children. The outdoor structure's distinctive styling enhances the pic-ture's Mediterranean flavor; the two strong lines formed by the balustrades frame the group beauti-fully and lead the viewer's eyes toward the youngest children in the rear.

136

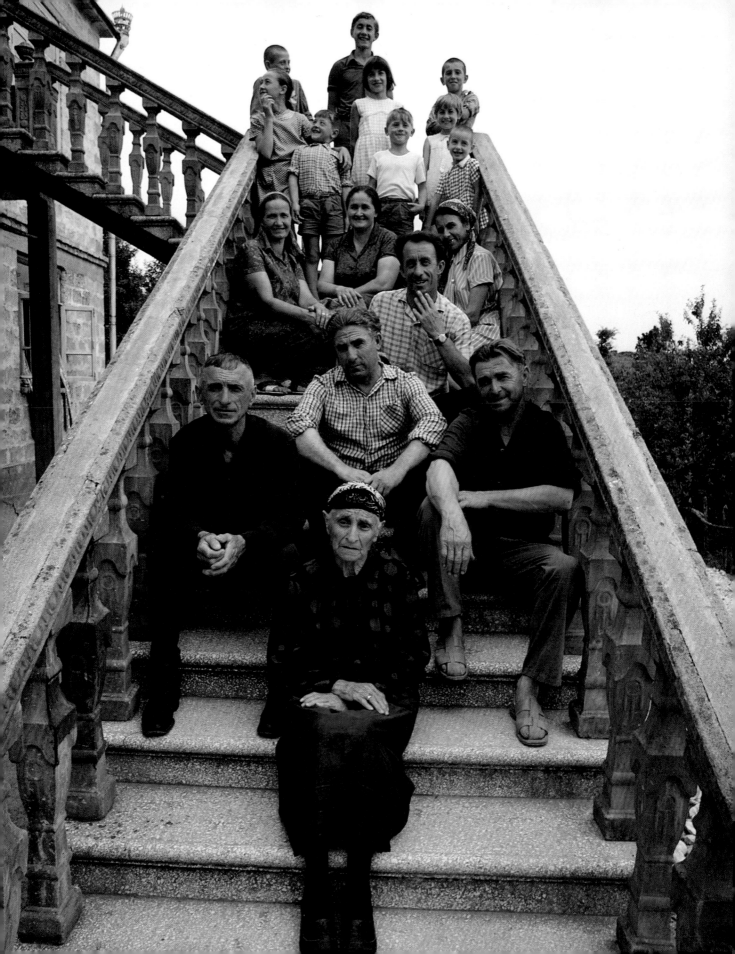

Family Events

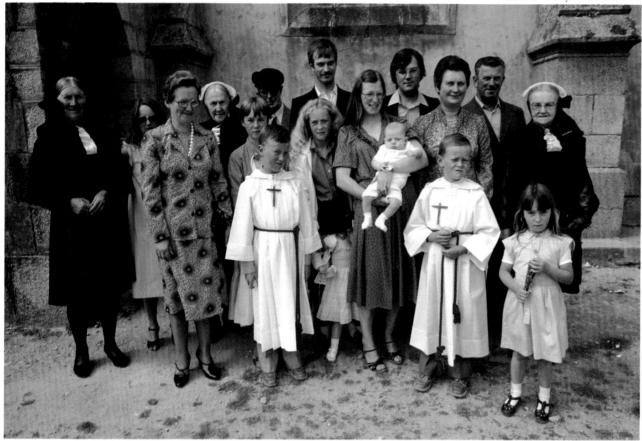

To produce pictures that record cherished memories, nothing compares with the special occasions that mark milestones in the life of a family. These may be events that regularly bring several generations of family members together, such as holiday gatherings. Or they may be once-in-a-lifetime happenings – a christening or a fiftieth wedding anniversary. Any out-of-the-ordinary – and sometimes even ordinary – family event can provide many opportunities for the photographer who is interested in capturing a slice of time and, with it, a bit of family history.

 A group portrait is often a priority on such occasions. Use the difference in people's heights or a setting of several levels to get an arrangement in which everyone's face can be seen clearly. For visual unity and to keep faces as large as possible in the final image, have everyone stand or sit close together. For a visually interesting grouping, position people so that their heads form an uneven, staggered pattern. Soft, diffuse lighting conditions are best for these pictures. When the sky is not overcast, pose the group in the shade.

 Another good time to photograph a family is when it assembles at the table for a meal. Everyone feels more comfortable, and the table supplies a strong unifying element, both visually and symbolically, telling the viewer that the people gathered together are closely related. For such a photo you may have to stand on a chair to get a high angle to include everyone's face. It is a good idea to take pictures before the meal, when the table is relatively uncluttered. And the best images sometimes result when everyone thinks you're still setting up the camera.

 You'll probably need a wide-angle lens to include everyone in a large group around a table. It is easiest to work with a camera supported by a tripod. For more intimate shots of family events, you may want to use a moderate telephoto lens (85 mm to 135 mm), or a zoom in the same range, supplementing it indoors with a flash.

The charm of this portrait of a French family gathered for the christening of a new baby derives partly from details that would ordinarily be considered mistakes – the robed boy in the front, squinting, and the little girl at center, hiding behind her mother's skirt.

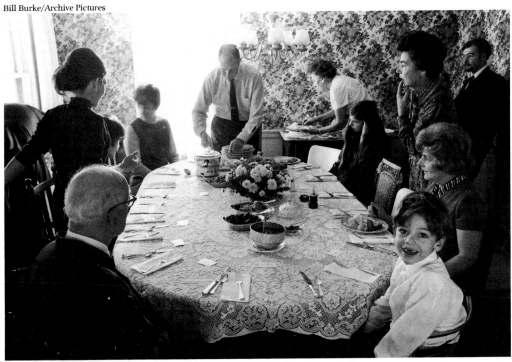

By snapping the shutter release before everyone had sat down and assumed a pose, the photographer captured a candid glimpse of a family's holiday meal.

Although the members of this large clan have obviously gathered for a group portrait, only a few seem to be aware that a picture is being taken. The photograph is therefore casual and revealing despite its formal organization.

Twilight proved to be the perfect time to photograph two young family members about to set out on a round of trick-or-treating. The light was bright enough to show the subjects clearly, yet dim enough to create a nocturnal mood and emphasize the light from the pumpkins.

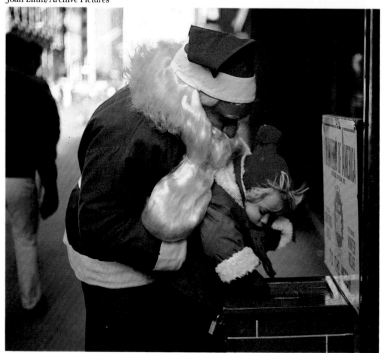

A novel variation of the traditional visit-to-Santa portrait resulted when this youngster was photographed with a sidewalk Saint Nick.

Brian Hill

Backstage just before showtime proved to be an excellent time to capture the last-minute adjustments to these ballerinas' costumes – as telling and memorable a record of the event as a photograph of the performance itself.

Norman Kerr

The warm glow of flames gives a strong sense of intimacy to the traditional family ceremony of lighting candles each evening during the eight days of Hanukkah, the Jewish festival of lights. When you take such photographs in similar light, be sure to take a close-up reading of the subject's face, excluding the bright light source. To preserve the warmth of the candlelight, this photographer used KODACOLOR VR 1000 Film.

Weddings

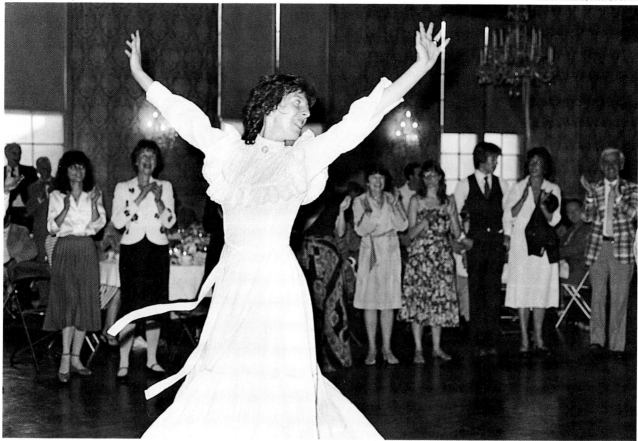

As joyous occasions that often bring together large numbers of family members and friends, weddings offer good opportunities for taking pictures. One way to capture the festiveness of the event is to take a journalistic approach by taking candids or casually posed portraits.

To capture the most effective images, ask about the sequence of events in advance. Then scout the locations where they will occur so you can plan potential photos and determine what film or special equipment you may need. You may find, for example, that you can get a clear view of the ceremony from the choir loft, but to get a good-sized image of the subjects you will need a long lens. To compensate for the relatively dim lighting you may also need high-speed film and a camera support so you can use a slow shutter speed; a flash would be too obtrusive. Similarly, you may find that the ceiling in the reception hall is too high to bounce a flash; if you want softly lighted flash photos, you will need to put a light-reflecting card on your flash unit.

Before taking photos of the ceremony – especially with flash – seek the permission of the minister, priest, or whoever is conducting the ceremony, then respect any limitations or special requirements given. The bride or her family may not wish to have flash photos interrupt the ceremony – all the more reason to use a high-speed film and a tripod.

Weddings are events at which everyone is preoccupied – watching the ceremony, congratulating the couple and their parents, greeting other family members and friends, eating, and partying. This range of activity not only provides you with many marvelous scenes to photograph but also makes it easy for you to work unnoticed. At the reception you may be able to photograph unobserved with a normal or a medium telephoto lens – although a long lens may be in order if the festivities are held outdoors or in a large hall. You might also consider a zoom lens for its flexibility, but only if you will be working outdoors or with a flash so there

Although it is usually best to avoid direct flash, it was employed very effectively in this picture to freeze the exuberant dancing of the bride and make her stand out from the guests in the background.

Earl Dibble/Photo Researchers

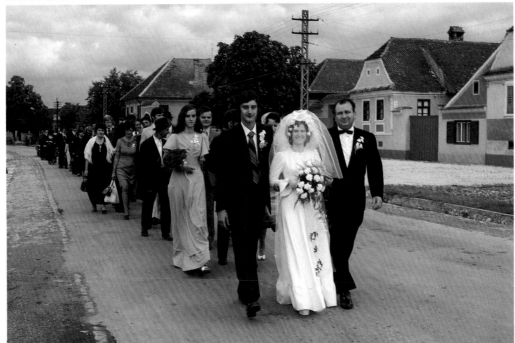

Even in this casual-looking photo of a wedding procession, everything works together to make the happy bride the focus of attention. She is beautifully framed by her two dark-suited escorts, and her off-center position in the picture is pleasing to the eye.

Jeff Dunn

A casually posed portrait of two newlyweds taken by the light of a window appropriately underscores their informal approach to their wedding.

will be enough light to compensate for the lens's relatively small maximum aperture.

A camera with automatic exposure control may make it easier for you to work quickly, but keep in mind that backlighting, strong light sources, and other conditions can mislead the camera's meter. Color negative film is your best choice. It has slightly more exposure latitude than slide film, and if you take pictures under different types of artificial light, the resulting color imbalances can usually be adjusted when prints are made.

Always stay out of the way of the professional photographer hired by the family for the occasion. Take your pictures of each event after the hired photographer is finished.

Wedding Portraits

Neil Montanus

A wedding symbolizes the start of a new branch of a family, so it is a traditional time to take carefully posed portraits of everyone involved, from the couple's parents to the youngest attendants. The main subject, of course, is the couple – especially the bride. Some photographers prefer to capture the bride's likeness in a formal portrait by photographing her just before or after the ceremony. But to accomplish this, you have to do a good bit of advance preparation and work quickly, since time is short on the wedding day. Other photographers prefer to take a bride's portrait a few days, or even weeks, before the wedding, when they can work at a leisurely pace.

Either way, photographing a formally attired bride is usually a two-person job. You will need someone else, like the bride's mother or a friend, to help drape the gown or tame that last wisp of hair. If you photograph while the gown is fitted, be sure no pins or basting stitches are visible. Also keep in mind that a white dress can mislead your camera's meter, especially if you pose the bride against a light background. When possible, take your reading from an 18 percent grey card or from the bride's face at close range. You can sometimes add interest by taking the portrait outdoors, but you must take extra pains to keep the dress from getting soiled or torn.

If you take the bridal portrait in advance, you may at the same time get pictures of the bride with her mother or both parents; pictures of other participants usually have to be taken on the day of the wedding. The best time to get a portrait of everyone in the wedding party is just after the ceremony. Professionals also take series of pictures of relatives and attendants with the couple. It is easiest to start with the largest groups and narrow them down as you work, ending with just the couple.

As the picture of four young members of a wedding party at right shows, steps are an excellent setting, for they allow you to arrange the group on different levels. When you photograph groups, be sure to place the members close together to create a visually coherent unit.

The difference in the subjects' heights and a step permitted the photographer to get this simple group arrangement in which the faces form a pleasing diamond shape.

William Ziegler

With a quick eye and a ready camera, the photographer was able to capture the joy a mother and daughter share on this special day.

Sam Campanaro

For this formal portrait of a bride, the photographer used a classic pose: her body in profile with her head turned for a three-quarter view. A white background, relatively soft and even lighting, and a lens attachment that diffused the image along the lower edge all helped to enhance the romantic mood.

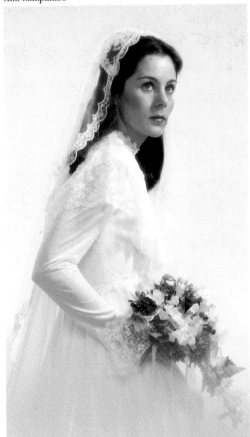

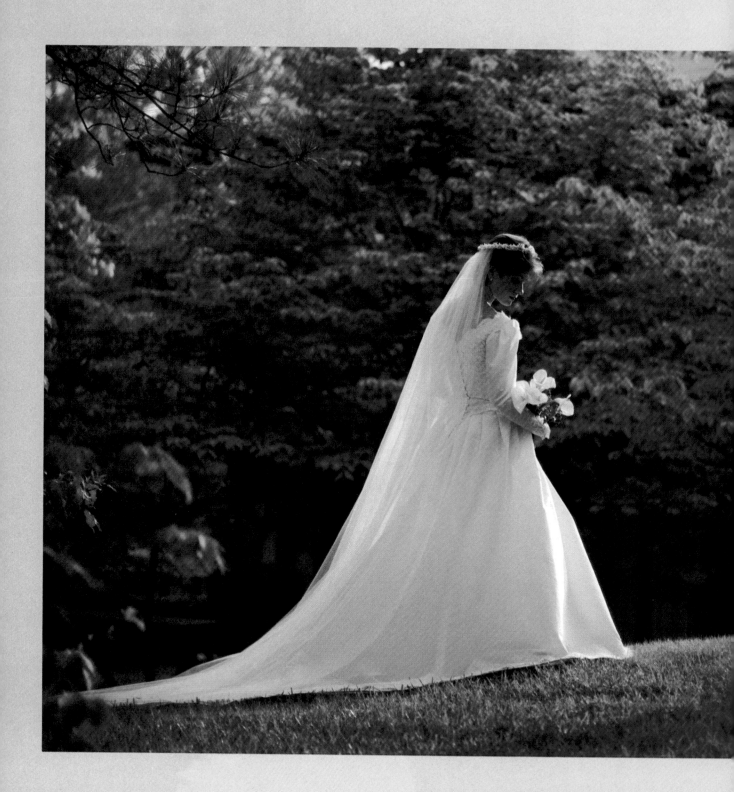

David Smith

In Focus

David Smith's career as a wedding photographer started with a happy accident. Although he had enjoyed taking pictures as a youngster, he hadn't kept up with it until, at a friend's wedding, the official wedding photographer's camera broke and David offered his own 35 mm as a substitute. As he followed the man around that day, he became intrigued with the work, and soon he was started on the path that would lead him to be a successful wedding and portrait photographer. Today Smith and his wife, Linda, serve mostly the Atlanta, Georgia, area, working for a diverse clientele, from ordinary people to former governors of the state.

David Smith thinks of his wedding photographs as true portraits. "Personality is the priority," he says. "Working with each couple is different, and you have to adjust your approach to make each picture truly reflective of that couple. According to Smith, the best wedding pictures occur when the photographer can inspire the couple to express the love they feel toward each other. "As professional photographers," he describes, "we have to share in the tremendous emotion we are capturing on film – we have to love not only our work but the people we are photographing."

Smith cautions against traditional wedding poses because they can make the pictures look too contrived. This picture of a bride is a good example of Smith's own creative approach. "It's simple and true to life," he says, "and it's not contrived. The lighting is very delicately done." Working in a limited area, Smith positioned the bride and chose a camera angle to give the illusion of a larger space. He took advantage of the late afternoon sun, letting it backlight his subject for soft, romantic illumination.

David Smith believes that mastery of technique and understanding of natural and artificial light are essential tools of the wedding photographer. He also recognizes the importance of good preparation: he usually arrives at the wedding an hour and a half early. And he *always* carries a backup camera!

Jason Smith

147

Planned Portraits

A successful portrait does much more than present a good likeness of a person. It also gives us insight into the subject's personality. To get such an image you must first observe your subject closely and objectively, releasing the shutter only at the moment when the posture of the body, the tilt of the head, the set of the mouth, and most important, the look of the eyes all combine to reveal the subject's character. Fortunately, one of the great advantages of a planned formal portrait is the enormous control you have over many of these elements.

One of the chief tools you have for controlling your subject's appearance is the pose. The angle of the head is particularly important. A full-face view tends to be formal and visually static. It also makes a broad nose look wider and points up any unsymmetrical features. At the same time, however, a direct frontal view can be used effectively to make a thin face look fuller and a long nose shorter. By staring boldly and directly out from the picture, the sitter's eyes immediately lock the eyes of the viewer. There are also times when the formality a full-face view imparts is just the touch needed to make a portrait work, as in the picture of the young girl at far right.

With its strong emphasis on the lines of the chin, nose, and brow, a profile seldom flatters anyone who does not have very regular features. A profile also conveys a certain air of remoteness and detachment because the subject's eyes do not engage the viewer's. Yet posing someone in profile is a most effective way to instill an evocative sense of drama in a portrait.

The most pleasing camera-to-head angle is a three-quarter view. Visually, with the face divided into uneven portions, the image is more dynamic and less formal. The subject looks more natural, as the angle tends to flatter most people. The up-and-down tilt of your subject's head can also be important. A slightly lowered head makes the eyes more prominent and plays down a jutting jaw or flaring nostrils, while a slightly raised head makes the sitter seem more alert.

If you include your subject's hands in a portrait, you must position them carefully to avoid their looking awkward and distracting. Whether the hands touch the face, make a gesture, or rest in the lap, they should seem

William Coupon

The unexpectedly prominent presence of a hand in this portrait of a cowboy creates an effective counterbalance to the face; like his unkempt appearance, the hand contrasts noticeably with the otherwise classic formal composition.

natural and graceful from both the subject's and the camera's point of view. You can pose a subject's hands to accent the face by framing it, thus leading the viewer's eye to it, or to serve as a compositional counterbalance. If the hands are strong elements in the image, it is preferable to show them from the side, with the fingers casually flexed and spread. But as the picture of the cowboy shows, this is far from a primary rule.

The overall position of the body in a portrait should look natural and relaxed. But keep in mind that a subject leaning forward seems more at ease, whereas one leaning back appears more reserved and distant. It may also be a good idea to angle a subject's shoulders to create a more dynamic and less symmetrical image. As a general rule, the arrangement of the subject within the camera's frame should also be made visually interesting by keeping the chief element (usually the face in a close-up portrait) off center.

In this portrait of a young Soviet girl, noted photographer Pete Turner found good reason to ignore the usual rule about not posing a subject in a static, evenly balanced manner. The picture works so well precisely because almost every element is uncommonly symmetrical. Even so, the eye loses little time in spotting the off-center breast pin that proclaims her proud membership in a youth group.

Planned Portraits

Many other factors besides posing and framing go into the creation of a good portrait. Lighting is especially important. Like pose, it can be used to emphasize or subdue certain of your subject's physical characteristics. In addition, lighting controls the appearance of shapes and forms. Lighting arrangements can be as simple or elaborate as you feel necessary (see pages 88 – 103), but the quality and direction of the light are always crucial.

Soft, evenly diffused light from an overcast sky gives equal emphasis to most of a subject's features. Although this reduces your control over which features to stress, the light's gentleness helps play down wrinkles, blemishes, and other imperfections.

More directional but still soft lighting can be obtained from a north-facing window or a flash bounced into an umbrella. When you use a reflector opposite the light source to fill in the shadows it creates, the result is also soft, flattering illumination with subtle modeling of the subject's face. This style of lighting works especially well with color film and is a favorite with many portrait photographers. In a color picture, harsh shadows can obscure features and tend to look unnatural. Shadows can also be filled in with a lighting unit that produces a weaker diffuse light. You can supplement the basic arrangement with more specialized lights to illuminate the backdrop, accent the hair, or create rim lighting.

Using direct light from the sun or flash creates a more dramatic, hard-edged effect. It allows you to highlight the features you want to emphasize and cast shadows on those you wish to diminish. But hard, direct lighting requires you to take much more care both in positioning your subject relative to the light and in using reflectors and fill lights to control the amount of shadow.

When you set up the main light keep in mind that illumination from the front tends to flatten the face and make it look rounder, while illumination from a side angle creates shadows that bring out the features and the bone structure, making the face look longer. The farther the light is to the side, however, the more it reveals the skin's texture, bringing wrinkles and lines to the fore. Pay special attention to ensure that the shadows that form under the brow, the nose, and the chin look natural. When setting up a reflector or light to fill in shadows, you have to experiment to get a satisfactory ratio between highlights and shadows. And remember that the contrast is likely to appear much stronger on film than it does to the eye. This style of lighting lends itself especially well to supplementary lights that add sheen to the hair. But with the strong dramatic emphasis created by the main light, be careful that added lights don't create effects that look too contrived.

Normal camera height for a head-and-shoulders portrait is the sitter's eye level. You might want to try a higher viewpoint to make a double chin less noticeable or a lower one to diminish the appearance of a bald head. Many photographers prefer to place a camera on a tripod when taking a portrait. This limits your flexibility somewhat, but it frees you to stand aside and talk directly with the subject while taking pictures with a cable release attached to the shutter.

The best backdrop for a portrait is a simple and uncluttered one. A plain wall, a panel of curtains, or a quickly hung bedsheet often work as well as the professional seamless background paper sold by photography and art supply shops. It is best to avoid strong colors that detract from the subject. Except when you want to create a deliberately low-key or high-key effect, don't use a solid black or a very light shade of white. To make a plain background more interesting, many portrait photographers put a light on part of it. Sometimes they position it to light the area just behind the subject, creating a halo around the sitter. At other times, they use it as a counterbalance, lighting the side of the backdrop opposite the more brightly lighted side of the subject's face. In most cases, it is best to keep your subject's body support as unobtrusive as possible. A simple stool is less noticeable than a chair with a back.

With its capacity to render facial features so well, a medium (75 to 135 mm) telephoto lens is by far the first choice for a formal portrait. And with all the effort you put into arranging a portrait, be sure to use a medium- or slow-speed (ISO 125/22° or less), fine-grained film to get the sharpest, most subtle results.

▶

A tight close-up enabled photographer Jean-Paul Debattice to emphasize this youngster's delicate coloring and the fine sprinkling of freckles on his face as well as the subtle auburn hue of his hair. Because they have ultrasmooth skin, children generally look better in close-ups than adults.

Jean-Paul Debattice

A bright red vest and pink shirt contribute unusual warmth and vividness to this subject. Belgian portraitist Jean-Paul Debattice brought out the richness of the colors by placing the subject against a completely dark background. And by having the subject lean forward and smile, the photographer made him appear friendly and accessible.

Jean-Paul Debattice

Evelyn Hofer

A slightly wary expression and crossed wrists suggest that photographer Bill Brandt was not entirely comfortable facing the camera, even though he himself is one of the grand masters of the medium. The three-quarter view of his face and the angle of the chair lend an informal feeling to the picture, while the chair creates a striking frame.

Marc Hauser

Marc Hauser has built a successful career as a portrait photographer by taking honest, true-to-life pictures.

"When most people get in front of a camera," he explains, "they give the photographer the expression they want to give or think they ought to give. What I want is the expression that's truly and naturally them."

Hauser has been interested in photography since he was very young. As a high school student in Chicago, he'd avidly take portraits of all his friends and acquaintances, just because he liked taking pictures. As a professional, his enthusiasm is still high. "I like working," he declares. "If it were my choice, I'd work every minute of the day."

Subjects entering Hauser's studio are in for a treat. They find a room full of toys and a photographer who jumps around, makes noises, and occasionally even grabs his subjects by the arm. "When they walk in here," he declares, "I make them feel like the most important people in the world. They're in *my* place." Of course, the method is not madness. It is simply Hauser's way of getting through people's outer layers to uncover the real person inside.

This picture of composer Aaron Copland captures that special quality of the inner being. "Even if someone didn't know who Aaron Copland was," says Hauser, "he'd know this guy was somebody."

Hauser talks of entering Copland's hotel room, where the composer sat on a couch in the shadowless light of a north-facing window. Ignoring his studio lights, Hauser set up his tripod and camera and started shooting, while the two of them talked about music, from classical to rock. As Copland relaxed, Hauser watched. When the eyes came alive and Copland's personality seemed most true, Hauser made sure he got the picture.

What does it take to be a good portraitist? "Mainly," Marc Hauser suggests, "a photographer must enjoy people." He is dedicated to his work not only to show what people look like, but to capture that moment when people unveil themselves.

"*That's* what I'm going for," he sums up. "When I see it, I know it!"

Interpretive Portraits

William Coupon

A portrait can tell a story about its subject. The way a person is dressed or a photograph's background can tell us where the person came from, perhaps, or what his or her world is like. Most often photographers choose to include a revealing prop to indicate the interests or talents of a subject. In the three pictures shown here, for example, we are immediately aware that music plays an important part in the lives of the subjects.

Similar revealing props could be an easel and paints, a shelf of legal books, a weaving loom, or even a football. The weekend gardener might be shown with a plant and trowel, the proud parrot owner with the bird. Costumes and uniforms also disclose a great deal about a person's interests. Intriguing results can be achieved by taking portraits of people with pictures of themselves, as shown on the following pages. Although the emphasis in these portraits is on offering more information about the subject's lives, they reveal attitudes and temperaments better than a straight portrait.

Using a prop also has a practical advantage. Your subjects are much more likely to feel relaxed when they hold a familiar object. A prop solves the problem of how to position a subject's hands. It is important, however, that the object give true insight into the individual. A photogenic gadget thrust into your subject's hands may help create an interesting picture, but a picture is not a real portrait if it gives a false impression about the person. Whether or not you know your subjects well, it pays to spend some time learning what their chief interests are and devising the most appropriate way to represent them.

In planning such portraits, keep the image as simple as possible. Pictures that work best are those that convey their message directly and unequivocally. Avoid using two unrelated props in the same image - you want to get across a single idea about the subject, an idea that the viewer grasps immediately. If the prop is a complicated one, try to find a way to make it less distracting. Frame the scene so only part of the prop shows, as seen here in the pictures of the woman at the piano and the man with a bagpipe. To show both subject and prop to best advantage, the background should be plain.

To create this impressionistic portrait of a jazz saxophonist, the photographer used the horn as a prop and underscored it with trick exposure. A flash produced the solid image of the musician while the camera's shutter, set for a long exposure, recorded the man's movements as ghostly trails that suggest the rhythm of his playing.

Thomas Nebbia/Woodfin Camp

In this portrait of a Scotsman proudly posing with his bagpipe, the diagonal position of the instrument's longest pipe and the man's upraised arm draw the viewer's eye directly to the subject's face.

John Phelps

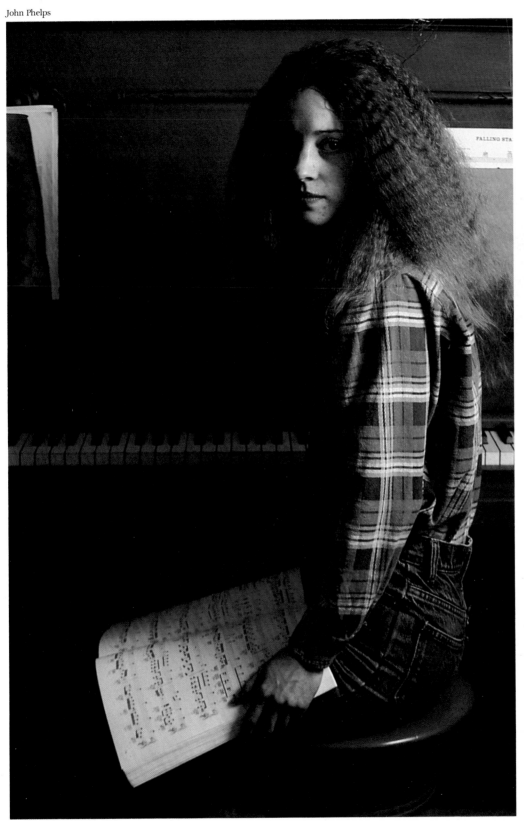

This young woman's interest in music is revealed immediately by the piano keyboard behind her and the open score on her lap. Tight framing of the piano keeps the portrait simple, and strong side lighting directs attention to the subject's most striking feature, her luxuriant crop of crimped hair.

Evelyn Hofer

To create this time-looped portrait of noted artist Saul Steinberg, photographer Evelyn Hofer had him hold the hand of a life-sized cutout of himself as a boy. Although the two resemble father and son, the stark room and doorways suggest a confrontation with the past.

The subdued lighting, the dark painting, the clock, and the old photograph convey a sense of time passed. Yet the young woman, in a similar pose and outfit, stands in front of a portrait of herself.

Here the passage of time is emphasized by both the old photograph the woman is holding and the weatherworn condition of the couple's home.

Informal Portraits

Not all good portraits are made in controlled settings. An observant photographer can snap a portrait almost anywhere. What you lose in control you often make up for by the spontaneity of a subject who feels more relaxed than someone surrounded by lights and reflectors. You can concentrate more directly on capturing fleeting expressions than when you are concerned with all the subtle details of lighting and posing.

Be especially concerned with using available light as effectively as possible. If you can photograph on days when the sky is overcast or pose your subject in the shade of a building, you will get soft, diffuse light that illuminates your subject's features evenly. Even when the light is more directional, look for soft illumination, such as that from a north-facing window or filtered through a curtain. This quality of light is less likely to produce harsh, washed-out highlights. Search for backgrounds in which you can use light-colored walls or stretches of white sand or pavement as natural reflectors to fill in shadowed areas of the face. Even without them, however, you can get a striking portrait in strongly directional light if you want dramatic emphasis. For lighting, you can also use flash, bouncing it off the ceiling or a wall or using it to fill in shadows.

Be careful not to get involved with equipment, however. You can lose many of the advantages of taking an informal portrait if your subject has to wait while you determine the correct flash output for the situation. In low light conditions, it's better to use high-speed (ISO 400/27° or higher) film, and even to push the film if necessary (see pages 66-69).

Eliminating extraneous background details is the other chief problem in taking an informal portrait. Find locations or camera angles that give you a plain, uncluttered background. This includes not only walls but also the sky and large areas of deep shadow that often reproduce as solid black. Another approach is to blur background detail by using a large aperture to limit your depth of field, as in the picture of the Nepalese man. In either case, exclude as much background as possible by moving in for a tight composition. The best tool for this is a medium (75 mm to 135 mm) telephoto lens because it renders facial features without distortion and has a relatively shallow depth of field, letting you blur the background with ease.

Fiona Entwistle

Nancy Edwards

(Top) Soft, even light, a dark background, and a rest for her arm combine to make this informal portrait of a young woman virtually indistinguishable from a more elaborately planned studio picture.

(Bottom) Not all informal portraits need to be close head studies. This picture, which so perfectly conveys a child's innocent curiosity, proves you can say a lot about people without even showing their faces.

Stuart Cohen

Anestis Diakopoulos/Stock, Boston

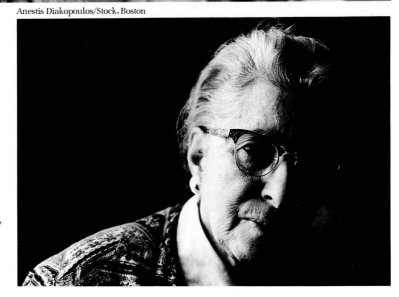

In this delightful portrait of a Nepalese man, the limited depth of field produced by a relatively large aperture on a telephoto lens works effectively to blur out distracting background details. The close-up view of the man's smiling, crinkled face, his side-glancing eyes, and his long, pointy mustache suggest a warm personality.

Portrait photographers normally avoid using light that hits the face from only one direction. But here the deep shadows created by the light add a dramatic touch, while the angle of illumination reveals the subtle texture of the subject's finely wrinkled skin.

Environmental Portraits

Linda Benedict-Jones

When you select the place a person lives, works, studies, or plays as the setting for a portrait, the image gains an added dimension. The setting adds to our knowledge of that individual and gives us a feeling for the person's life. You are much more likely to notice this phenomenon when you travel abroad and encounter subjects in colorful and unexpected settings. In the picture of young Asian men at the far right, for example, the unusual storefront is an immediate eye-catcher that reveals a good deal about the youths' lifestyle. Through careful observation, you will find that equally interesting and informative settings abound in everyone's life. An ordinary school chalkboard proved to be most revealing in the case of the two young women pictured here.

Many people who would look quite ordinary against a plain backdrop become intriguing when they are photographed in a revealing setting. A good setting for an elderly woman might be her living room, for example, if it shows her taste in furnishings or her lifelong collection of family mementos.

Another advantage of photographing people in their homes or workplaces is that they feel more comfortable in familiar surroundings, making it much easier for you to get natural, relaxed poses. For a setting to be effective in a portrait, however, it must also contribute visually to the final image. Choose settings that complement and help set off your subject. A background of contrasting tone or color can help make a subject stand out, as can an element in the scene that frames the subject, such as a door or a window.

Once you find a promising setting, consider it from different viewpoints and camera heights. A slightly elevated camera angle, for example, might be used to make the papers on a person's desk a more prominent part of a portrait. Frame the scene carefully, excluding unnecessary and distracting details. Don't bring into the picture anything that does not contribute to the overall effect you want to achieve. Most humans' habitations are far too cluttered to look good in a portrait. Feel free, with your subject's permission, to remove the unwanted ashtray or vase and to reposition the side chair. Conversely, you may find that your subject has other interesting objects you want to include.

You can also carefully arrange side lighting to single out your subject against a darker, more subdued background, as in the pictures of the farm wife and winemaker on page 165. Diffuse light from a window or a flash bounced into an umbrella can be shaded with cardboard to reduce the amount of light spilling onto the background. Or use reflectors to lighten the shadows on the subject. The important consideration in lighting such a portrait is to make the illumination appear natural for the setting. A wide-angle lens is sometimes necessary to take in as much of the scene as you want. When you use one, avoid distortion by keeping the camera relatively parallel to the subject, not tilting it dramatically up or down. Also, keep your subject's face away from the edges of the frame and don't allow a part of your subject - such as a hand or a foot - to extend far into the foreground.

Since your subject's face forms only a small part of the image in an interpretive portrait, use a slow, fine-grained film whenever the light permits.

With its combination of schoolwork and graffiti, the blackboard behind these casually posed girls sums up the conflicts many students encounter during their high school years. The contrast between the busyness of the chalk markings and the plainness of the girls' clothing makes the pair stand out.

Stuart Cohen

A flamboyant and deliberately out-of-date boutique façade provides an appropriate setting for a group of Japanese teenagers whose appearance reveals their surprising nostalgia for another time and place.

In this candid portrait, the frame of the window directs our attention to the humorous moment captured by master photographer Henri Cartier-Bresson. The hairdresser and his window model look almost like twins, with the model eyeing him suspiciously as he tries to cover his baldness.

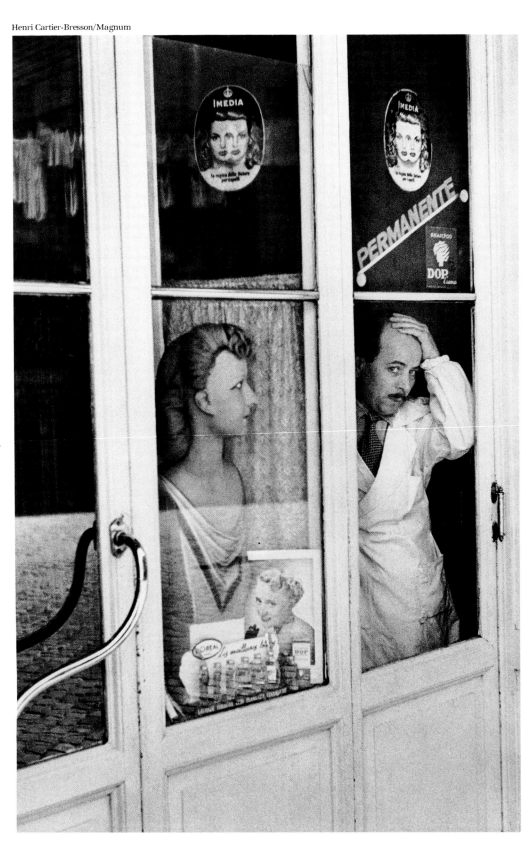

Neal Slavin

Cary Wolinsky/Stock, Boston

In this dramatically side-lighted portrait, photographer Neal Slavin effectively uses the wine casks to inform us that the subject is a vintner. But he also uses the casks in a more tongue-in-cheek fashion to echo the subject's rotund shape.

Against a plain backdrop, the woman in this pose might have looked simply toughly determined. But in her own home, she reveals a gentler side of her nature. The flowers and floral patterns on her apron, wallpaper, and hanging plates all attest to a delicate sensitivity.

William Albert Allard

Sam Abell

"Photography is a way of introducing people to other people," declares William Albert Allard. A photographer whose work has been acclaimed for its sensitivity, Allard has spent the last two decades introducing viewers to cowboys, circus folk, and other slices of an almost lost civilization. His photographs, taken mostly of one or two people in their home or at work, show more than mere faces and physical surroundings. Environmental portraits at their very best, they reveal whole human lives.

This picture is of Tom Robertson of Wisdom, Montana. Allard had visited the man several times while researching a magazine story. The photographer speaks of the man and his life: "He was a man in his eighties and had a wealth of experiences. In this photograph, the place says as much about Tom as the actual image of him does – the soiled dishrags, the little mirror, the chipped enamel wash basin. He's a solitary man, a man who lives by himself, a man in his last years."

William Albert Allard grew up in Minnesota. Studying to be a writer, he became intrigued with combining words with photographs to produce something more powerful. His photographic training at the University of Minnesota included both art and journalism courses, a mixture of influences he retains to this day.

"My goal has always been," Allard reflects, "to make pictures that could be published in a magazine as part of a story, but that could also carry their weight on the walls of a gallery or museum." His work as a staff photographer, then freelancer, for *National Geographic* and his book, *Vanishing Breed: Photographs of the Cowboy and the West*, accomplish that dual purpose eloquently.

Allard most enjoys working spontaneously, photographing people and places that he encounters. He is a great believer in serendipity, trusting that he will be prepared when the scene in front of him comes together for a photograph.

"In so many cases the photograph is a momentary thing that is soon going to change," he asserts. "Once it's gone, it's gone. We have to put it in the box when it happens."

People at Work

Among the most intriguing portraits are those that reveal a subject's occupation. They answer directly the question that often arises when we look at portraits: What does that person do for a living? Almost every occupation has a distinctive tool, attire, or setting that can be used effectively.

The jobs of people who work with their hands frequently offer the most striking environments and dramatic possibilities. For example, the picture of the man with the tank of compressed gas at far right presents a variety of unusual shapes with a strong visual impact that surpasses almost anything you would find in a typical office. This does not mean you can't take a good portrait in an office; it just might be less eye-catching.

It is also easier to photograph people who work outdoors. Except for occasional harsh sunlight, you'll encounter few constraints on your picture-taking, and you can concentrate on finding the best combination of lens and camera position.

Indoors, however, you can almost always expect to run into a lighting problem.

The level of light in many industrial settings is too low or uneven, requiring you to use a tripod, high-speed film, and perhaps a reflector. In stores and offices, the light source is usually fluorescent tubes, which give a greenish cast to subjects and require the use of a pale red filter with outdoor film. If the artificial light is mixed with natural light coming from windows, the best solution is to turn off the lights and photograph with a combination of flash and natural light, using the flash as a fill when the subject is near a window or as the main light when the window is farther away.

Many times you will want to use a wide-angle lens to include the surroundings. In potentially hazardous settings, such as construction sites, you may find it best to use a long lens. It allows you to keep your distance, and, by compressing space, makes a subject look closer to background objects that can help tell the story. In such settings, remember that you nearly always have to obtain permission before you can enter and start photographing.

When noted photographer Ernst Haas took this charming portrait of a vegetable vendor, he added color to the otherwise muted scene by standing back far enough to include the bright beets.

Ernst Haas

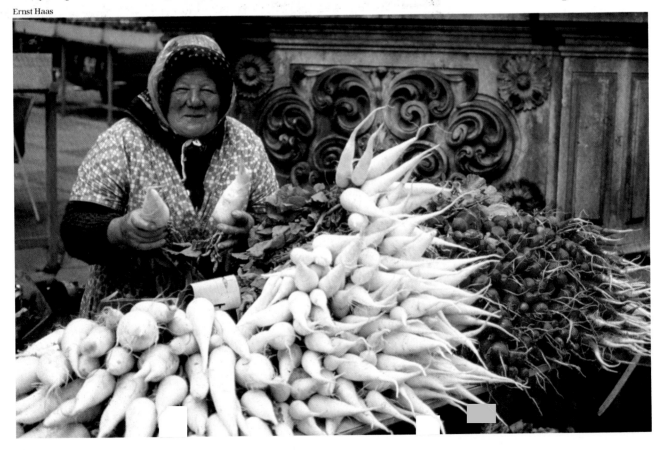

The simple, almost formal composition of this portrait of a welder conveys a strong sense of dignity. The tilted tank directs the viewer's attention to his face.

For this portrait of a Welsh postman, photojournalist Dennis Stock used a telephoto lens to compress the row houses behind him. The large number of hill-climbing structures, together with the snow and his cold-weather attire, reveal the arduousness of the man's work, but his smile shows his good-natured approach to it.

Large Groups

Taking a picture of a large group of people is a genuine test of a photographer's ability. For a posed group picture, the most important task is to arrange the members so they form an attractive composition in which everyone's face can be clearly seen. If the group is not overwhelmingly large you can have members in the front kneel, the ones in the middle sit on chairs, and the ones in the back stand. To add visual variety, don't put the same number of people in each row, and place people of different heights next to one another so the heads in each row are pleasantly staggered. Some photographers find it helps to curve the ends of the rows forward slightly.

For very large groups, you can use people's height differences to get two, and sometimes three, standing rows by placing the taller members in the rear so their heads rise between the shorter members standing in front. Another row can be added at the rear by having members stand on benches, but make sure such supports are stable, or you may end up with some very uneasy expressions.

Soft, even lighting is crucial for photographing large groups. The smallness of the faces in the final image makes it imperative that none of them be disfigured by the harsh shadows that bright, direct sunlight creates. If you can't take your pictures on an overcast day, pose the group in a large area of shade next to a building. Indoors, you may need two or more flash units, each set up to provide diffuse light (see pages 98-105).

You may want to use a wide-angle lens to encompass all of a large group. To prevent distortion, try not to have faces at the edges of the frame, and keep your camera level with your subjects' eyes, not angled up or down. It isn't necessary to tilt your camera up to take in people high in the back if you have the camera in a head-level position on a tall tripod. A long cable release allows you to stand away from the camera, surveying expressions and clicking away when your subjects' minds are not on the camera. An autowinder lets you take several pictures in a row, but check the viewfinder regularly to make sure that one person's change in pose hasn't resulted in someone else's face being cropped out of the picture.

It's essential to take many pictures of a group portrait to reduce the odds that someone has blinked or turned away just as the shutter was clicked. If the light permits, use a fine-grained, slow-speed film to record everyone's face as sharply as possible. But be sure you can use an aperture small enough to keep the nearest and farthest subjects in focus.

With its surprising diagonal lines, an outdoor staircase produces a distinctive and eye-catching arrangement for this group of older musicians. The photographer added interest and anchored the picture by forming the horizontal front row with the bass player at center.

Eve Arnold/Magnum

Craig Aurness/Woodfin Camp

In this photograph of English schoolboys crushed against a crowd barrier, their dark uniforms give the image cohesion and help set off the boys' faces and bright Union Jacks. By photographing from a low level, photojournalist Eve Arnold turned a complex scene into a series of individual portraits of the boys whose faces are framed between bars.

An old weather-beaten barn proved to be the perfect setting for this large family group at a reunion. The building's shape frames and holds the group together and its dark color sets off the relatively small-scaled faces. Equipment outside the barn provides unusual perches for the younger members.

171

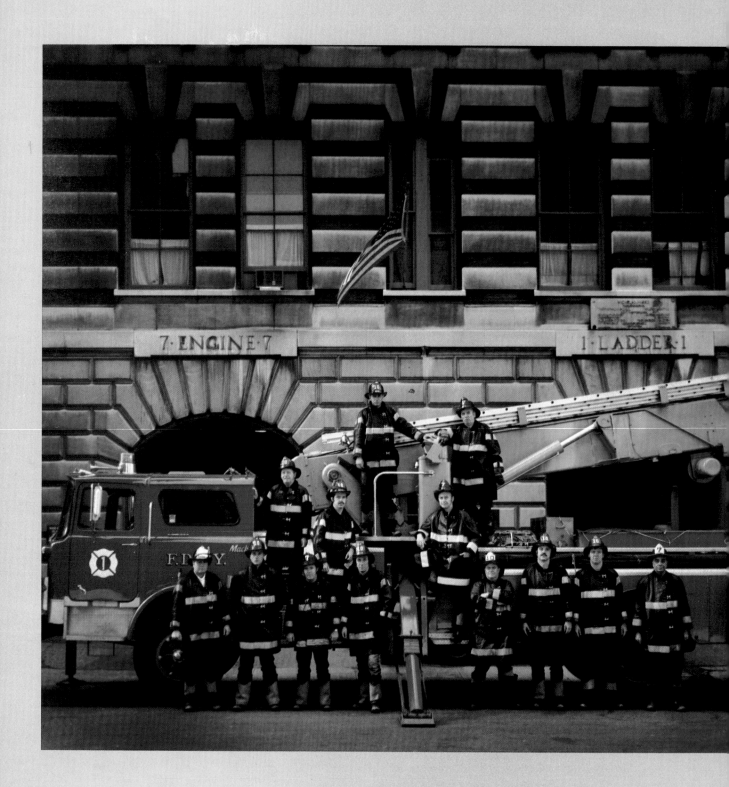

Neal Slavin

Neal Slavin is part artist, part philosopher, and a people watcher of the first order. He is also a successful New York commercial photographer. Although his assignments are primarily for magazines, advertising, and annual reports, his intrigue with how people see themselves has always spurred him to work on personal projects. "I've always been interested in identity," says Slavin. "I want to photograph who we are trying to be in order to discover who we are."

Slavin is perhaps best known for his photographs of groups of people, photographs that often make people smile and always make them look twice – the staff of Tiffany's on the floor of their opulent store, a bowling team congregated in front of the local lanes. There is an incongruity between the location and the subjects' formal poses that makes a humorous point. His work has a serious side, too, though. For Slavin, the group photograph expresses "the conflict of individuality and belonging," a subject that Slavin has explored at length by photographing groups of all sorts. This picture of a company of the New York City Fire Department was part of a series of group pictures published in his book, *When Two or More Are Gathered Together*.

"To me, this picture says 'Firemen,'" Slavin says. "The men seem timeless in their simple black slickers." But after initially seeing them only as a group, "you start looking into their faces, and their body positions, and you begin to sense who these people are. You begin to understand individuals based on their relationships to the others in the picture."

Neal Slavin claims that the way people congregate in a group photograph is more revealing than pictures of individuals by themselves. "If you isolated a person, you would never get that relationship. You remove so many layers of identities that that person puts on in our society."

Slavin's explorations into human subtlety continue in other areas. One is a study of people and their pets. Throughout his work he probes the intricacies of people's sense of themselves. "All of us are conscious of some image of ourselves, and that's what we call identity. The basic question is, who do we think we are? I'm interested in knowing – and photographing – who we think we are."

Self-Portraits

There is a long-established tradition of self-portraiture in photography. The undertaking is not only challenging but an excellent way to learn about creating pictures. One of the simplest ways to take a straightforward portrait of yourself is to photograph your reflection in a mirror. The trouble with doing that is the camera will appear in the scene. With most cameras you won't be able to frame accurately because you have to take the camera away from your eye to avoid hiding your face, although it is sometimes possible to get the camera close enough to the edge of the image area so it can be cropped out later.

By placing the camera on a tripod and shooting at an angled mirror you can exclude the camera altogether. This approach, however, requires very careful planning, and you need another person or a prop to act as a stand-in while you set up. You also need someone else to click the shutter, a long cable release, a self-timer on the camera, or a wireless remote-control shutter release. The latter, which operates via infrared waves, is more convenient and dependable than a long cable release, and it obviates having a friend take the picture.

When you photograph into a mirror be sure to focus on the reflection - not on the mirror frame. The distance for which the camera should be focused is the measurement from the camera to the mirror plus the measurement from the mirror to you, the subject. If you use a split-image focusing device you can sometimes be misled into focusing on the sharp edge of the mirror. Another problem with photographing your reflection is that the image is reversed. But you can solve that easily with transparencies by flopping the slides before viewing them. Negatives can also be flopped before being printed by a custom processor.

Another way to take a self-portrait is to put your camera on a tripod and frame and focus with a stand-in, then place a mirror just behind the camera, and do the final posing of yourself in the mirror. This procedure also requires a wireless remote or cable release, a self-timer, or another person to snap the shutter. If you can keep it out of the picture, the wireless remote or cable release is usually better than the self-timer because it's often hard to resume your pose in the ten seconds or so that most camera timers allow.

Linda Benedict-Jones

Self-portraiture lends itself to interpretive studies. In these pictures photographer Linda Benedict-Jones presents intriguingly different visions of herself. Here, as gigantic legs taper into tiny feet in a bathtub, we know immediately that this study was taken by the photographer herself. The image's humor is tempered by the rigid symmetry of the legs and the starkness of the setting.

Linda Benedict-Jones

In this self-portrait, the photographer seems to be confronting herself, since we sense her presence twice: in the foreground where her hands can be seen and in the mirrored reflection.

Linda Benedict-Jones

The shadows created on walls by a bright late-afternoon sun can produce striking self-portraits in silhouette. Here the photographer, using the stucco wall to set off her profile, found a strong diagonal arrangement.

Linda Benedict-Jones

This somber mirror portrait owes its effectiveness to a low camera angle. Such an angle keeps the camera out of view and brings in the dark ceiling and the massive arch to create a bold composition.

Street Photography

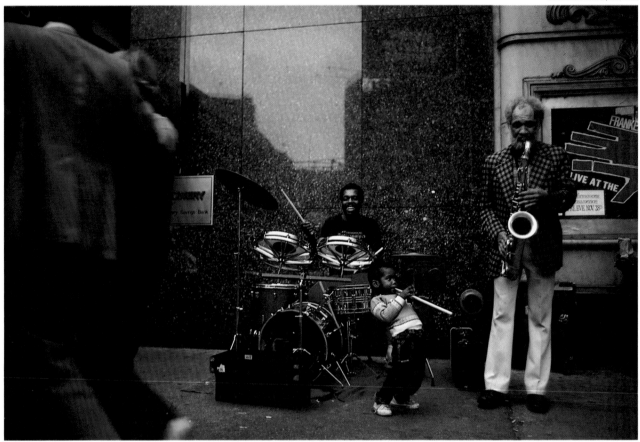

Public places are excellent sites for taking the spontaneous photographs of strangers known as candid photographs. Photographers have devised many ways to keep from tipping off a subject. A classic approach, pioneered by the famous French master Henri Cartier-Bresson, among others, is to work at fairly close range with a compact, quiet-shuttered rangefinder camera with a normal lens or even one with a slightly wide angle. Use an automatic camera, or preset your camera aperture and shutter speed, making adjustments for subjects in unusual lighting by taking readings from a similar scene. Carry the camera cupped inconspicuously in your hand; when the subject is distracted or the scene is right, raise the camera to your eye and trip the shutter release. It takes practice to do this rapidly and smoothly. You should also learn to visualize the scene in the lens before you lift the camera for final framing. You don't have to hide the fact that you're taking pictures if you can make your subject think you're aiming at

something else. If the subject turns to see what you're doing, you may be able to pivot quickly and get a picture. Or keep the camera to your eye, pretending to make adjustments; the subject may soon get bored and look away. It is generally easier to capture a subject unaware from the side or back or from an elevated position. Sometimes you can make your presence less obvious by photographing from a shadowy entryway or from behind a corner of a building.

A more popular approach to candids today is to use a telephoto lens. With it you can use an SLR camera more easily since you will be far enough away that the subject can't hear the click of the shutter. Any lens with a focal length of about 135 mm to a practical maximum of 300 mm can be used, including zooms, which give more flexibility in framing. Some stealth is still necessary, however, since an SLR camera with a long lens is fairly bulky and noticeable.

Street performers like these three generations of New York City street musicians make good subjects because they are too busy to notice the camera.

Even though this young French woman is looking directly into the camera, the picture qualifies as a candid. Her casual pose suggests that she became aware of the photographer only at the instant the picture was being taken.

With a telephoto lens's shallow depth of field, it is very important to focus carefully. If you set a normal lens for about 10 feet, everything in the zone ranging from about 8 to 13 feet will be sharp at an aperture of $f/5.6$; from about 6 to 30 feet, at $f/16$.

Give yourself maximum flexibility by using high-speed film. A shutter speed of 1/250 second is often best, since it can stop most normal action, although a faster speed is needed with a longer lens. One technique professionals use is to find a likely setting and wait patiently for interesting subjects to appear. Using a camera with a telephoto lens mounted on a tripod, a long cable or remote-control release, and an autowinder, they can shoot a whole roll of film without touching the camera.

Someone's momentary distraction offers a good opportunity to raise your preset camera to your eye and press the shutter release. Had this organ-grinder been aware he was being photographed, he might have worn a much less revealing expression.

Street Events

One of the best times to take candids and other revealing photographs of people is during a street event like a parade or fair. The festivity and colorful costumes offer intriguing picture possibilities, and, compared to an everyday street scene, you have more freedom to take pictures even at close range.

Amid all the excitement and activity, most people are too preoccupied to care that you are taking their picture. Even if people see a camera pointed in their direction, they tend to assume that you are aiming at something in front of or behind them or getting an overall view of a scene that happens to include them. Also, with the general convivial feeling that abounds on such occasions, it is often not at all necessary to conceal the fact that you are photographing someone. In a carnival atmosphere, with everyone in costume, for example, a photo of someone clowning for the camera may convey the mood just as well as – or even better than – a candid.

The major problem in photographing street events is getting an unobstructed view. One solution is to arrive early and stake out a good location. At a parade, for instance, you might find a front-row spot on the outside of a bend in the road that gives you clear head-on views of the participants as well as side views when they pass directly in front of you. From that position you could also get good photos of the crowds opposite.

At street events where people mill about, the best way to get unobstructed views is to use a wide-angle lens and photograph at fairly close range. You may get some distortion, but that is better than having someone walk in front of the camera just as you press the shutter release. You can reduce

Before the parade began was the best time to photograph a cross-section of the local citizenry, camped out in the fanciful world created by the muralist.

the amount of distortion by crouching and
photographing the subject straight on rather
than from eye level and tilting the camera
downward. If you prefer to zero in on people
with a telephoto lens, find something to stand
on that will raise you above the heads of the
people in the crowd, like the steps of a
building, a low wall, the fender of a car, or the
boxy base of a streetlamp.

*An unusually low camera
position, together with
an unobstructed view, al-
lowed the photographer
to capture this striking
pattern of marching
majorettes' legs.*

Ulrike Welsch's photographs depict many of the simple details of life – children at play, animals, the seashore near her Marblehead, Massachusetts, home. And although she has also photographed the royal family of Thailand, she prefers taking pictures of the way average people live. Her sensitive, often humorous pictures of people reflect her attitude toward life and are an expression of her affinity with everyday people and events.

A native of Germany, Uli Welsch has been living and working in the Boston area since she came to the United States in 1964. She has served as a newspaper photographer for the Boston *Herald* and more recently the *Boston Globe,* where she was voted Boston Press Photographer of the Year in 1974.

When photographing people, Welsch considers it important to establish a relationship with her subjects. "I like talking to them, seeing how they live," she says. "I like to know what makes them tick." Not only is that relationship more personally satisfying to Welsch, but it puts her subjects at ease and gives her time to wait for the best moment to take the picture.

The scene here is one she happened on while walking around a city, looking for images to "collect." She recounts the meeting: "This man pressed against the glass door. He was looking out... staring as though he was somewhere else. I wondered how I could convince him to be photographed." Her uncertainty disappeared when he waved her over and they started a conversation. As they talked, she studied him. Finally, she felt comfortable enough to ask him to return to his familiar pose by the door. "We had gotten acquainted enough," she says. And she got the picture.

Uli Welsch's advice about the nervousness we all sometimes feel when approaching someone with a camera is simply, "Skip feeling uncomfortable! I feel uncomfortable at times, too, but you have to get yourself out of this spell." Her other recommendation about street photography is to keep looking. When the shot appears, when the light is good and the moment is right, then, "You *have* to take it."

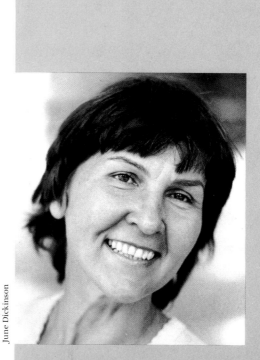

June Dickinson

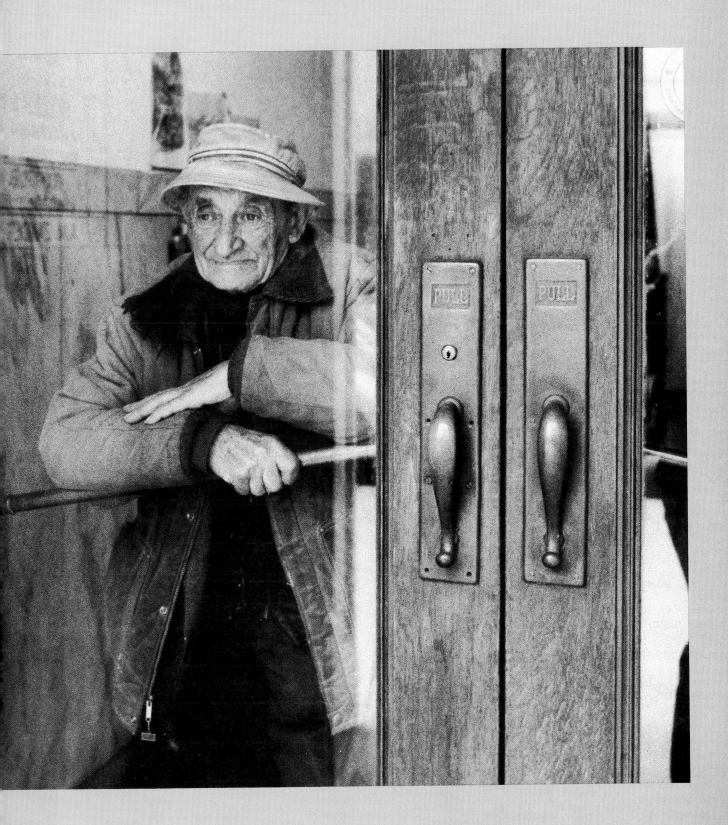

Photojournalism

Whether covering a riot or a ribbon cutting, news photographers are reporters with cameras. They are always on the lookout for the picture that tells a story, and they rely on the immediacy of photography to convey the story in a way that words can't match.

Each picture here exemplifies photojournalism at its best. Great news photographers have keen eyes, a sure instinct for the interaction of people and events, and quick reflexes. If they don't get the picture at the peak moment of action, it is gone forever. Their sense of timing and their eye for telling compositions are their only means for controlling the images they get.

In order to react quickly, each photojournalist must be prepared for any situation and completely familiar with their equipment. Most carry a minimum of two cameras, so they will always have a camera loaded with film. With two cameras they can also have cameras with lenses of different focal lengths, or cameras loaded with different types of film. At least one camera is usually equipped with some type of motorized drive for taking several pictures in rapid succession.

In confined indoor situations, many photojournalists favor a moderately wide-angle lens, such as a 35 mm, because its broader scope and relatively greater depth of field nearly guarantee a sharp picture. The image may have to be cropped before publication, but it will almost certainly be in the range of acceptable focus.

Outdoors, photojournalists are also likely to use a telephoto lens, especially in a dangerous situation or when it is impossible to get close to the subject. For flexibility, some photojournalists prefer a zoom lens with a wide-angle to moderate telephoto range.

A relatively powerful electronic flash is handy for dim or even relatively subdued lighting. Film selection depends on the lighting and personal preference, but most photojournalists favor high-speed film and are ready to click the shutter release when the situation demands it.

Sal Veder/Wide World Photos

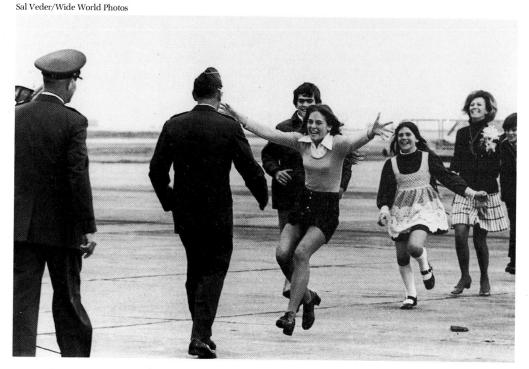

With the perfect sense of timing that earned him a Pulitzer Prize, photographer Sal Veder captured the exuberant joy of a family welcoming the husband and father who has just been released from a prisoner of war camp in Vietnam. The image is so effective in part because of Veder's unconventional vantage point: behind the returning officer rather than to his front or side.

The startling juxtaposition of a bicycling boy with a burning bombed truck vividly demonstrates a child's numbed reaction to violence that years of strife in Northern Ireland have created. The boy seems to be scowling at the photographer for blocking his way.

A soldier running in a crouched position conveys a sense of the danger he faces as he moves forward into the thick, smoky haze. The graphic graininess of the image greatly heightens its impact.

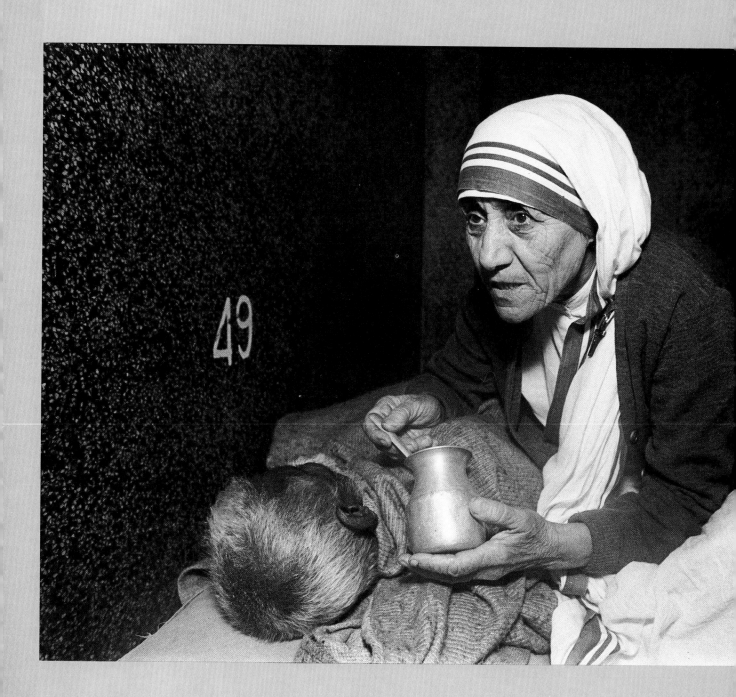

Mary Ellen Mark

In Focus

"I take pictures that I feel people should see and look at."

This is the simple, honest approach of Mary Ellen Mark, one of America's top photojournalists. Mark is a member of the exclusive Magnum organization and photographs regularly for *Life, People,* and other major magazines around the world. She has published three books of her work, the most recent of which, *Falkland Road,* is about the life of prostitutes in Bombay, India.

Mary Ellen Mark attended the University of Pennsylvania and spent a year in a city planning office before she became interested in photography while doing graduate work at the Annenberg School in Philadelphia. She immediately took to the journalistic side of photography and has concentrated in that area ever since.

Although today she lives in New York, Mark's work has taken her all over the world. Of all the places she has been, she is especially drawn to India. "I love the country," she says. "It's the most fascinating place I've ever been. It's full of every kind of contradiction you can imagine." It was while she was in India, for *Life* magazine, that she took this photograph of Mother Theresa feeding a dying man.

"I made two trips to Calcutta. I felt I had to go back because I had to make more pictures, not so much about Mother Theresa but about the world she created with her missionaries of charity."

For Mary Ellen Mark, photography is also her artistic expression. Unlike many photojournalists, who produce photo essays using multiple images, she tries to make each photograph complete in itself. "I've always aimed to get the one best individual picture," she says. "Each picture has to stand alone and be understood alone." The power of much of her work comes from this commitment to quality.

Not surprisingly, Mary Ellen Mark finds working tremendously fulfilling. "What is great about it are the times in your life when you get to do the projects or stories that really interest you. You get involved in the lives of other people. You witness the intimate aspects of their lives, and record them. It's an incredible experience."

Photo by Laurent Wiame

185

Feature Photography

David Burnett/Contact

Photographers who take pictures for feature stories and documentary aspects of the news tend to concentrate on more enduring questions about human nature and how people live, play, and survive. As a result, they usually have a good deal more preparation time than photographers who cover breaking news. They have the freedom to get to know their subjects and to develop more creative approaches to photographing them. They can dramatize an idea by selecting a certain lens and camera angle, as in the picture of the mass wedding at far right. Or they can pay more attention to an individual's personality, bringing out an unexpected character trait or a deep feeling, as in the pictures here of a soldier and an African woman.

Photojournalists who specialize in such pictures sometimes have to get one picture that sums up a situation, since many publications want a single image to stand alone with a caption or to accompany an article. At other times, these photographers are called on to get many pictures covering diverse aspects of a topic, some giving overviews, some concentrating on details. From these, individual images are selected to run as part of a picture essay, a series of photographs that tells a more complex story than a single image can. Occasionally, documentary photographers cover a subject thoroughly over a long period of time with the object of producing a book or an exhibition.

Photographers who work on feature stories, like newspaper photographers, are usually well equipped with extra cameras and lenses. But their job often calls for them to be less obtrusive. They may start to work with only a single camera until the subjects begin to accept their presence. And to get the most natural-looking results, they generally try to use existing daylight or artificial light, saving flash for situations that absolutely demand it. In many cases they are also free to use slow-speed film to get sharp, richly detailed images.

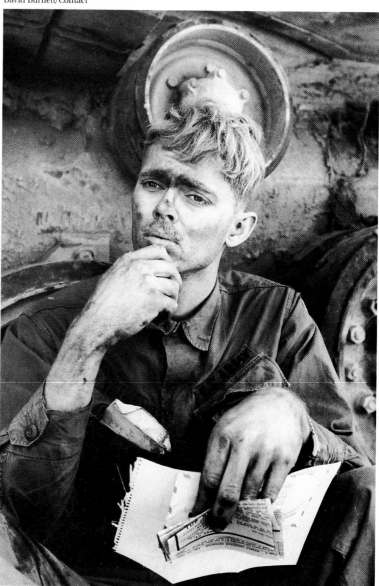

The contrast between this soldier's grimy condition and his contemplative expression as he ponders the contents of a letter poignantly underscores the enormous gulf between life on the battlefield and life at home.

186

Frank Fournier/Contact

At a mass wedding of thousands of members of the Unification Church, the photographer used a high camera angle to give a clear view of the couples' faces and a space-compressing telephoto lens to convey the sheer density of the group. The tight framing also suggests that their numbers extend without bounds.

David Burnett/Contact

The effects of the struggle to subsist from day to day can be seen in the tired, drawn expression of this Nigerian mother as she prepares to nurse her youngest while two older children press around her.

187

Vacation Trips

Most people keep a camera handy on vacation trips. These breaks in normal routine give you the opportunity to see and do a variety of enjoyable, out-of-the-ordinary things. You'll want to capture the events on film for a visual souvenir – something you can show others and look at later to rekindle memories of your experiences.

Vacations are among the few times you can be together with a spouse, family, or friends for long, uninterrupted periods, which makes it easy to get informal portraits. You also tend to engage in water sports and other special activities that can produce exciting action shots. When you take any type of vacation pictures, however, try to find a setting that will remind you of the experience. The photograph of the woman canoeing at far right below is a good example.

If you are going to concentrate your vacation pictures on people and their activities, you'll find it easiest to use a high-speed film. For candids, try to keep your camera exposure preset for the prevailing light, with a shutter speed of at least 1/125 second – or even faster for an action picture. It's also advisable to have the camera prefocused on a set distance, from 7 to 10 feet or so. Be aware of the near and far limits of the depth of field provided by the aperture you are using. This will enable you to release the shutter quickly when the occasion arises. A zoom lens with a wide-angle to moderate telephoto range can also be helpful. With action photos, you can get the best image by planning ahead and looking for a vantage point that lets you capture the action as it passes by, as the photographer did for the picture of the boy on the water slide at right.

Outdoors, with all the sun, water, and sand, it is essential that you protect your film and equipment. Be careful not to leave your camera and film in hot, direct sunlight or locked in an overheated car or its trunk; keep them in a cool, shaded place until you are ready to use them.

If you go to a locale that has a lot of fine grit or water spray, it's a good idea to store your camera and spare lenses in sealable plastic bags. Placing a protective UV filter on your lens is also a sensible precaution. If you plan to wade into water or engage in any other activity in which your camera might

Keith Boas

Robert Clemens

The speed and excitement of an amusement park ride was captured by panning — following a moving subject with a camera (see pages 200-201). This blurs the background while keeping the subject relatively sharp.

Finding a strategic vantage point was as important as timing in getting this action candid. By positioning himself along an outside curve of the water slide, the photographer got a picture of a boy headed straight for the camera.

get dunked or splashed, it's best to use a waterproof camera. Or place your camera in a lightweight watertight housing made from flexible plastic. These relatively inexpensive housings look like sturdy plastic bags with two glass ports – for the lens and the viewfinder – along with finger inserts for operating the controls.

A family outing amid the dramatically grass-tuffed dunes of an east Australian beach produced this memorable group portrait with a strong sense of place and a feel for the activities the family members like to engage in.

In this photo taken in Georgia's Okefenokee swamp, the boat in the background tells us that this excursion involves more than just the young woman and the photographer, while the water plants, long, thin trees, and the still water reveal the marshy setting.

People in Other Lands

In conveying the characteristic flavor of another land, the appearance of its people is just as important as its landscape and architecture. Distinctive national costumes can be highly photogenic. Parades, festivals, and other special occasions still bring out traditional attire, but the everyday garb of shopkeepers and workers or the uniforms worn by police, rail, and postal employees can be equally interesting.

The physical characteristics of the people and their mannerisms are as important as dress in forming a portrait of people from other lands. One way to capture this special quality is to take a casual approach, photographing them unaware or at least taking them by surprise, as exemplified by three of the pictures here. The easiest way to do this is to stand at a distance and use a telephoto lens. A moderately long lens – 85 mm to 135 mm — is sufficient for many street scenes. Many photographers prefer a zoom lens in the 80 mm range because it permits them to zero in on or pull back from subjects quickly, without having to move.

You can also photograph candids at closer range with a normal or even a wide-angle lens if you use one of the standard ruses of the street photographer (see page 176). If your subjects become aware of you, your best recourse is simply to smile and murmur something that sounds mildly apologetic. Also, engage them in conversation, get their cooperation, and even offer to send them prints later. Then live up to your word – be sure to send the promised prints.

It nearly always helps to have your camera set for a predetermined distance – 10 feet for a normal lens and proportionately farther away for a telephoto lens. It also helps if you preset the exposure for the prevailing light conditions. Even better, use an automatic camera. For a normal lens, 1/125 second is a good working shutter speed; for a moderately long lens, try 1/250 second.

While taking candid photos in public places is both popular and allowed in most areas of the world, you might encounter a culture where this activity is frowned upon or even forbidden. The traveling photographer should do his or her homework well and be sensitive to any governmental, religious, or ethnic concerns.

John Coletti/Stock, Boston

In this overhead view, the boat's long, pointed shape neatly frames the gondolier, and the diagonal line of the oar leads the eye directly to him.

Douglas Kirkland/The Image Bank

In this photograph by veteran photojournalist Douglas Kirkland, the huge Japanese character on the poster tells us immediately where the picture was taken. At the same time it provides a stark setting for the two young subjects. Appropriately, the character stands for the word east.

The looming presence of a medieval cathedral in the background gives a strong sense of place to this photograph of a woman who has taken a baby out for air in a French park.

In this photograph of a group of young Polish women, the photographer captured two appealing elements: the delighted smiles of surprise on their fresh faces and the colorful sequins and beadwork on the bodices of their traditional costumes.

191

Faces in Other Lands

Ernst Haas

A more direct way to capture the distinctiveness of people in other lands is to move in close and take intimate portraits. Professionals most often take this approach because it gives them more control and permits them to capture the subtlety of facial features and expressions as well as clothing and posture.

To do this, of course, you will nearly always have to ask the subject's permission, but obtaining it is usually not as difficult as you might think. Indeed, in an area frequented by tourists, a particularly colorful subject may even expect to be photographed – and perhaps to receive a small fee in return. Almost everywhere, you will find that most people are flattered by the request, although this is less true on a bustling, impersonal city street than on a country lane. Some refusals are inevitable, but don't let them discourage you from asking someone else. If you don't speak the language, smiling politely and pointing to your camera will usually convey your message.

Even if it's entirely in pantomime, a friendly, enthusiastic approach is essential to getting your subject into the setting and lighting you want and for making posing adjustments. Otherwise, taking close views of people in other lands is the same as taking any other informal portrait. You'll get the best results if you work in the soft, diffuse light produced by an overcast day or the shade of a building. When that is not possible, consider using a fill flash to light up harshly shadowed areas. A moderate (85 mm to 135 mm) telephoto lens will produce the most natural-looking, undistorted rendering of facial features and also let you take a tight close-up of your subject without stepping on toes. Don't forget to photograph several views from different angles.

Before photographing people in foreign countries it is always wise to ask a hotel clerk or guide whether any groups of people object to having their pictures taken on religious or superstitious grounds. Some governments ban or discourage photographs of subjects they feel might misrepresent their national image, such as beggars or primitive tribes. Again, a hotel clerk or guide can tell you if it is customary to tip a subject and, if it is, how much the tip should be.

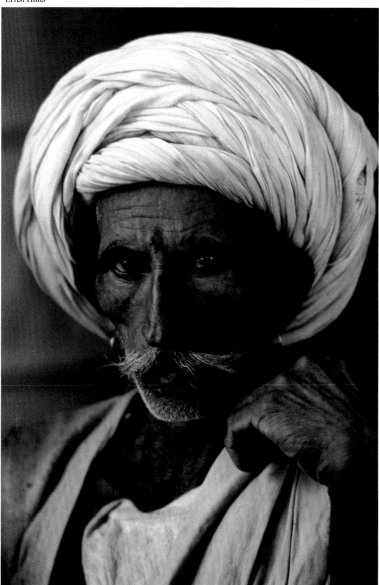

In this portrait of an Indian by Ernst Haas, the coils of an enormous turban frame his face in a formal, balanced way that reinforces the strong sense of dignity the man conveys.

Norman Kerr

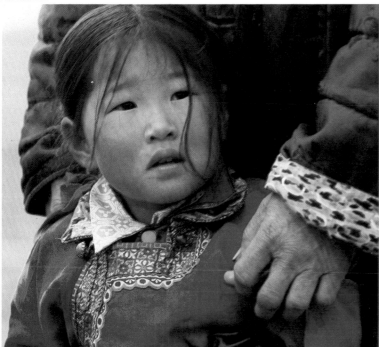

In this close-up of a young Mongolian girl, the photographer emphasized her richly colored costume and delicate features. Yet just enough of her parent shows to suggest the girl's small size as well as her timidity and need for protection.

Ted Spiegel/Black Star

Charles Lederman

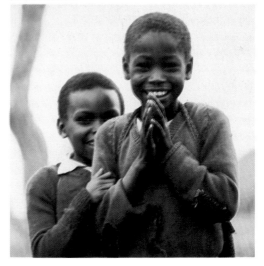

Even people who respond directly to the camera make good pictures. These two young boys seem to be filled with equal parts of delight and shyness at the photographer's attention.

In a highly evocative father-and-son portrait, a man wearing the distinctive garb of an Orthodox Jewish sect stands near Jerusalem's Western Wall. The background helps set the scene as a location – and way of life — far away.

Tom Kelly and Gail Mooney started their photography business about six months before they were married. They had met at the well-known Brooks Institute in Santa Barbara, California, where each of them was studying commercial photography. Today they do chiefly travel-related photography in the United States and overseas for editorial and commercial clients.

"It's great when we can work together and share our experiences," says Mooney about their unique team approach. "It actually works better because we're married." Although they each take individual assignments, when working together on a project they plan the shots together, discussing beforehand how to photograph a given subject. They feel that they always benefit from having two inputs. "And because there are two of us," Kelly adds, "one can set up the shot and the other can do the distracting, which means constantly talking and joking with subjects to make them feel comfortable. We try to design each photograph so that it is aesthetically pleasing and tells a story, without looking designed."

The Kelly/Mooney approach to general travel photography tends to be more spontaneous than when they are assigned to take photographs of specific people. Sometimes when they drive through a place, a good photo situation appears. This particular photograph, taken near Interlaken, Switzerland, happened this way.

"This was one of those times when we were driving along and saw Switzerland – right there," Mooney says. "There were two neat people involved in a neighborly conversation in front of a tidy house with flowers. Even their wagon full of hay was very orderly."

Kelly adds, "That picture sums up what we continually encountered in Switzerland: the cleanliness and the tidiness; everything was just perfectly so."

When asked for advice about getting the best travel photos, Kelly and Mooney agree: "The most important thing is to respect the people in the place for what they are. Also, don't see a shot and say, 'I really should have stopped back there,' which is easy to do. Make yourself take it. You'll be glad you did."

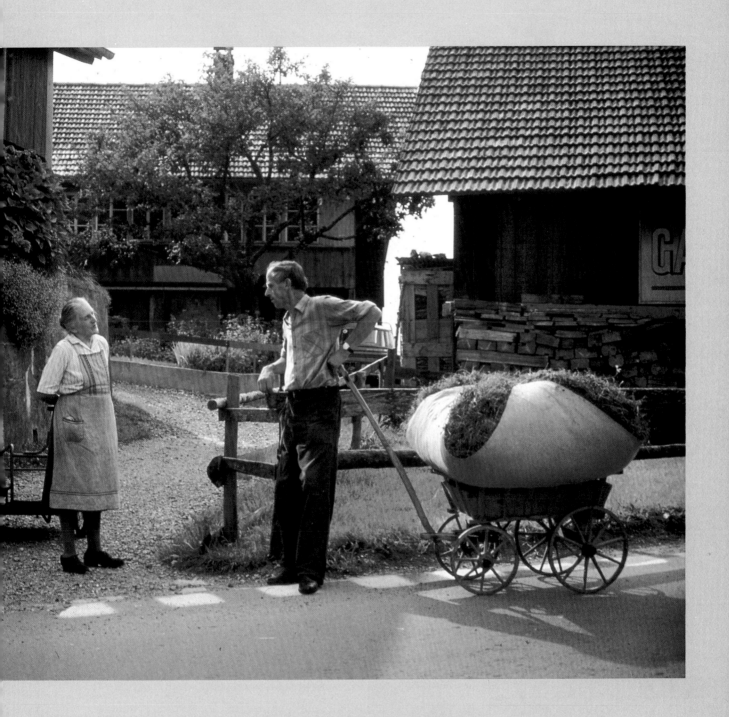

Sports

The drama and excitement of competition, the colorful attire, and above all the grace and beauty of the human form in action can make photographing athletes a highly rewarding undertaking. If you pay attention to the details of technique, timing, and equipment, your still photographs can capture the poetry of a moment in a way that no moving image can.

For most sports, you need a camera with a fast top shutter speed. A 1/500-second setting is sufficient for many sports, but 1/1000 second or faster may be necessary for such swift activities as downhill skiing. A camera with a shutter speed priority exposure mode (see pages 58-59) is most handy for sports photography.

Another basic requirement for most sports photography is a telephoto lens; one with a focal length of 180 mm or 200 mm is probably the most useful. A lens with a focal length over 200 mm can be a help for zeroing in on action or faces, or for capturing a distant scene. But a lens over 200 mm, which nearly always requires tripod support, is awkward for action photography; shorter telephotos often need to be supported to prevent camera shake. The best solution is to use a tripod or at least a monopod – a single-legged version of the tripod that you steady by placing downward pressure on the camera.

The relatively shallow depth of field on all telephoto lenses requires that you focus with extreme accuracy. This can be a problem in dim indoor light; many photographers prefocus on a spot such as a floor marking and take the picture when the athlete reaches it. The limited depth of field of telephoto lenses, however, is often a blessing, since it lets you isolate a subject in a crowded setting. Wide-angle lenses also have their place in sports photography for overviews, crowd shots, and dramatically close, low-angle views of athletes – high jumpers sailing through the air, for example.

Although you can use a slow, fine-grained film on a bright, sunny day, you will usually find it easier to use a high-speed (ISO 400 or more) film. The amount of light reaching the film can be dramatically reduced by the relatively small maximum apertures on telephoto and zoom lenses and by the fast shutter speeds required to stop action. Fading evening light or the dim illumination of indoor auditoriums and stadiums at night can

Martin Czamanske

make the situation even worse; you may find it necessary to push your film to a higher exposure index (see pages 66-67).

Under artificial light, you should also pay attention to the color balance of the film. If the light comes from ordinary incandescent bulbs or floodlights, you can use tungsten film or a No. 80A filter with daylight film. If the source is high-intensity lamps or fluorescent tubes, however, you will have to use special filters to get natural-looking results. Since filters reduce the amount of light that reaches the film in a setting that is normally low in light, a better alternative is to use color negative film. Its color balance can be adjusted when prints are made.

There is nothing new about arranging a team with their victory trophy on bleachers for a group portrait. But by having this gang of young baseball players wave and shout, the photographer captured their exuberant spirit on film.

Stephen Kelly

At most races one of the best vantage points is the outside of a curve. As this photograph shows, a head-on picture of cyclists rounding a curve presented a tight, unified image.

This dramatically close view of a runner as he hits the finish line was captured using a telephoto lens. With its shallow depth of field, the lens simplified the cluttered background, throwing everything behind the subjects out of focus. Such photos are best attained by prefocusing on the finish line and pressing the shutter release a split second before the lead runner reaches the tape.

Neil Montanus

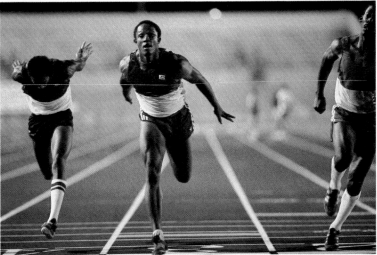

Sports: Freezing Action

John Menihan

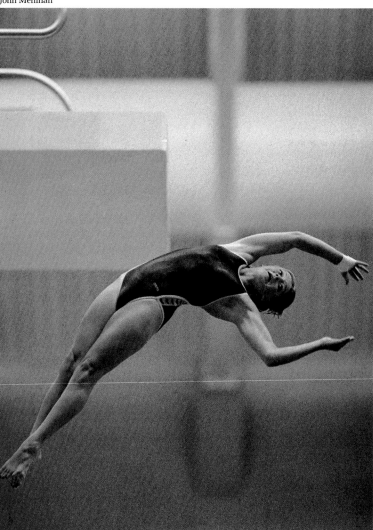

The remarkable ability of a photograph to freeze a moment of fast-moving action and render it with exceptional clarity is the basis for most sports photography. Although the action often occurs too quickly for the human eye to perceive details clearly, the sports photographer endeavors, through timing and planning, to capture an instant that tells a story about the event and perhaps even distills its essential spirit.

The shutter speed required to freeze action depends not just on the speed of your subjects but also on their direction and distance from the camera. Because the image size of close subjects is so large, you need a faster shutter speed to freeze their movements than those for subjects who are farther away from the camera. A cyclist going about 30 miles per hour might be stopped with 1/250 second at 100 feet from the camera, whereas one 20 feet away might need 1/1000 second. Of course, if you use a telephoto lens, a subject at a great distance may be equivalent in image size to one only a few feet away, requiring the faster shutter speed.

The direction in which a subject is moving similarly affects the shutter speed required to stop action. A subject going from side to side across the camera's field of view requires a faster shutter speed than one moving straight toward or away from the camera. You might stop marathoners running 13 miles per hour with 1/125 second if you photograph them head on, but 1/500 second might be necessary to photograph them from the side as they pass in front of you. Subjects crossing diagonally at a 45° angle to the camera call for a shutter speed somewhere between these two.

When the prevailing light and the lens's maximum aperture dictate that you use a slower shutter speed than you'd like, you'll find you can work with that shutter speed if you change your position. At a race, for example, you might move to a bend to get the contestants straight on; you might also aim from a greater distance. If repositioning is not possible, switch to a higher speed film. For example, KODACOLOR VR 1000 Film nearly always lets you use a fast shutter speed, even under very dim illumination, as it is more than eight times faster than medium-speed (ISO 100) film.

There are times in many sports when momentary hesitation in the action allows you to use a slower shutter speed. This is often literally and dramatically at a high point, when an athlete reaches the top of an ascent and pauses before coming down. Examples include a pole-vaulter going over the bar and a baseball outfielder leaping up to snag a high ball. Pauses also occur when a tennis player or golfer finishes a stroke and when a pitcher releases a ball.

Whatever the action you want to freeze, try to anticipate the instant you want to capture and press the shutter release a split second before that point is reached. This allows for the time it takes for your body and the camera mechanism to respond.

A diver suspended in mid-flip was frozen with a very fast shutter speed at a moment that reveals her facial expression as well as her graceful form.

Peter Gales

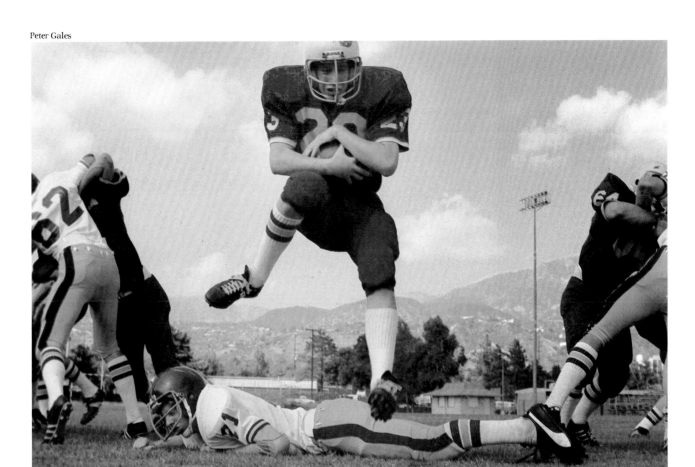

Gregory LaMotta

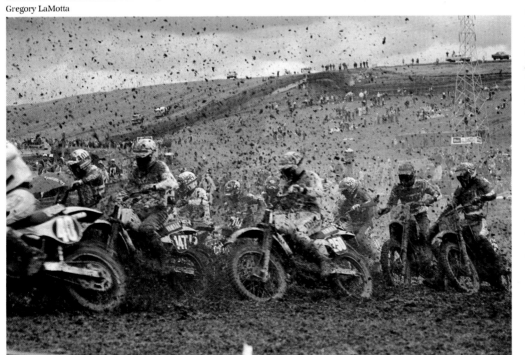

The dramatic impact of this photograph results both from a fast shutter speed that stopped the football player in midair and from a low camera angle that set him off as a looming figure against a simple backdrop of sky.

The mud-tossing vigor of motocross racing was captured with a fast shutter speed that froze the bikes and riders as well as the spray of particles kicked up by their wheels.

Blurring Motion in Sports

By deliberately blurring the image of an athlete you can create an impressionistic interpretation of movement that conveys the atmosphere of the sport better than a completely sharp image. The chief way to blur an image is to use a slow shutter speed. In general, the slower the shutter speed, the greater the amount of blur you will get. If you use a shutter speed just slightly slower than the one necessary to freeze an action completely, you are likely to get an image in which only the fastest-moving parts of the subject are blurred just enough to give a hint of motion to an otherwise sharp picture. At the other extreme, a fairly slow shutter speed combined with a bit of camera movement can produce a rendering of a sports scene in which nothing is fully sharp, as in the picture of the baseball player below. In between are varying mixtures of blurring and sharpness.

Camera movement is apt to cause blurring of stationary objects at shutter speeds under 1/30 second – or at even faster speeds with a telephoto lens. Mounting your camera on a tripod ensures that you have sharp stationary objects in your plane of focus. The speed, direction, and distance of your subject also affect the degree of blur. A subject going from side to side across the camera's field of view will blur more than one coming head on

or obliquely. A near subject will blur more than a far one.

Also keep in mind that a subject in light-colored attire against a dark background will become more noticeably blurred because the highlights tend to spread. With the relatively long exposure times involved in blurring, use slow-speed film to prevent overexposure. It may even be necessary to use a neutral density filter to cut down on the amount of light entering the camera.

One striking technique used in action photography is panning, which you do by following the subject with your camera as it passes from side to side across your field of view. Prefocus on the area where you want to take the picture and, taking a firm stance, swing your entire upper body smoothly,

Jeff Dunn

As he panned the camera to follow the runner, the photographer created an impression of enormous speed by dramatically streaking the background while holding the subject in sharp focus. The effect is heightened because the runner's legs are also blurred.

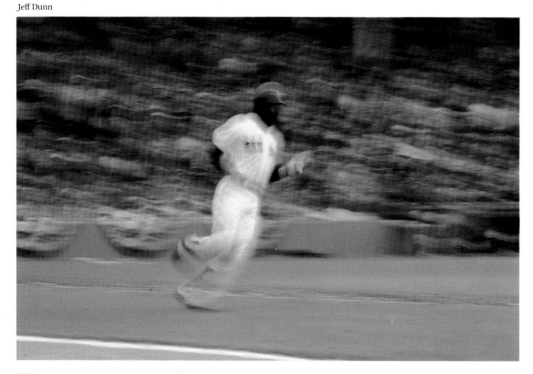

The blurring that makes this image an atmospheric impression of baseball comes from both the player's running during a long exposure and the movement of the camera. Very little camera movement creates a lot of blur; a slight jar of a tripod-mounted camera is often sufficient.

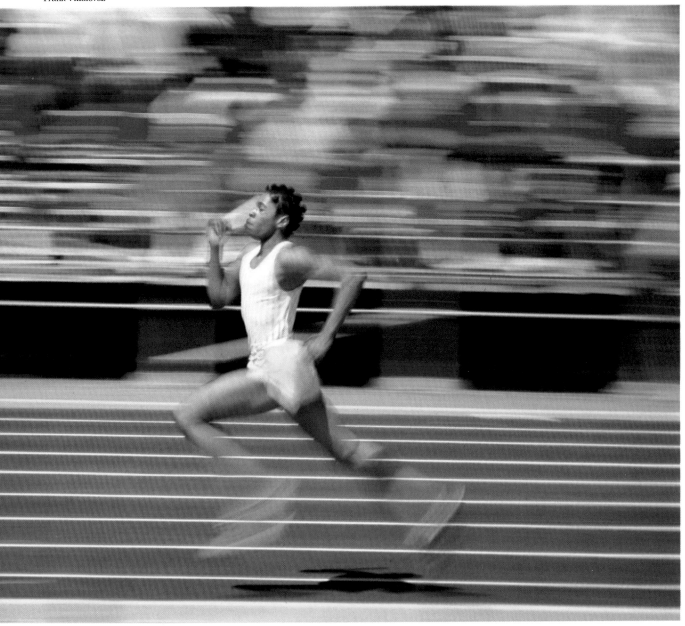

Frank Villalovoz

following the subject well in advance. Keep the subject centered in the viewfinder as you turn; after releasing the shutter at the desired spot, follow through on your swing. Your shutter speed will depend on your subject's speed. A jogger might require 1/30 second, whereas a downhill skier could take only 1/125 second. Also, the farther away the subject, the slower the shutter speed you need. In panning, always look for backgrounds with a contrasting mix of colors or highlights and

shadows to produce the pattern of streaks that conveys the idea of motion. If possible, use a rangefinder camera because the viewfinder of an SLR camera is blocked during exposure, making it impossible to continue following the subject. Another alternative is to use an auxiliary sports finder, a simple framing device that fits atop some SLR models.

Sports: Faces

In attempting to record an athlete's fast-moving body at its most revealing moment of physical effort, many photographers of sporting events tend to overlook the face. But the element that makes many great sports shots so memorable is the participant's expression, for the face conveys the person's exertion and concentration along with the tension, joy, relief, or other emotions experienced at the time. Indeed, an otherwise ordinary sports picture can become strongly compelling if the athlete's face is evocative. At the same time, a sports shot that emphasizes the face can be an insightful portrait, showing a person at a moment of great effort.

Like freezing action at a decisive moment, getting a good photograph that features a contestant's face is a matter of observation and timing. If you watch athletes perform, you will be able to determine when their faces are most expressive. As the picture of the tennis player at far right below shows, for example, the face conveys the most intense exertion in sports that require hitting a ball not only during the stroke itself but also for a brief moment afterward. This period is frequently a good time to photograph because the head is held relatively still as the player watches to see where the ball goes. In foot races, the expression is often more intense when the runner begins to make the final push about three-quarters of the way through than at the finish line. Each sport, and each position on a team, has similar moments. And, of course, most athletes have their own distinctive style.

To make a good photograph of an athlete's face, you should try to get a larger than normal image of the subject in your viewfinder. For most sports, this requires a long telephoto lens: 200 mm, 300 mm, or even longer. But there are exceptions. A carefully planned picture like the one of the basketball player at right below can be taken with a normal or even wide-angle lens. The camera can be clamped in position over the net and operated by a remote-control release.

Stan Pantovic/Photo Researchers

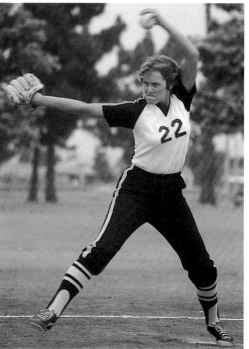

Biting her lip as she winds up to throw, a pitcher on a softball team shows a look of fierce determination. Good timing by the photographer transformed what could have been an ordinary snapshot into a compelling portrait of concentration.

A high overhead camera position permitted the photographer to get this striking close-up of the strained expression on a young man's face as he dunks a basketball into the net.

Todd Jayson Howell

Eastman Kodak Company

By blurring the background and framing to cut off the contestant's body, the photographer focused on the tension in the athlete's face. Yet there is more than enough detail to tell us that the man is a javelin thrower.

Gerry Cranhams/Photo Researchers

As she finishes a shot, British tennis star Virginia Wade displays an expression of intensity that contrasts markedly with the impassiveness of the official behind her. The compression of space by a telephoto lens made the two look closer than they actually were.

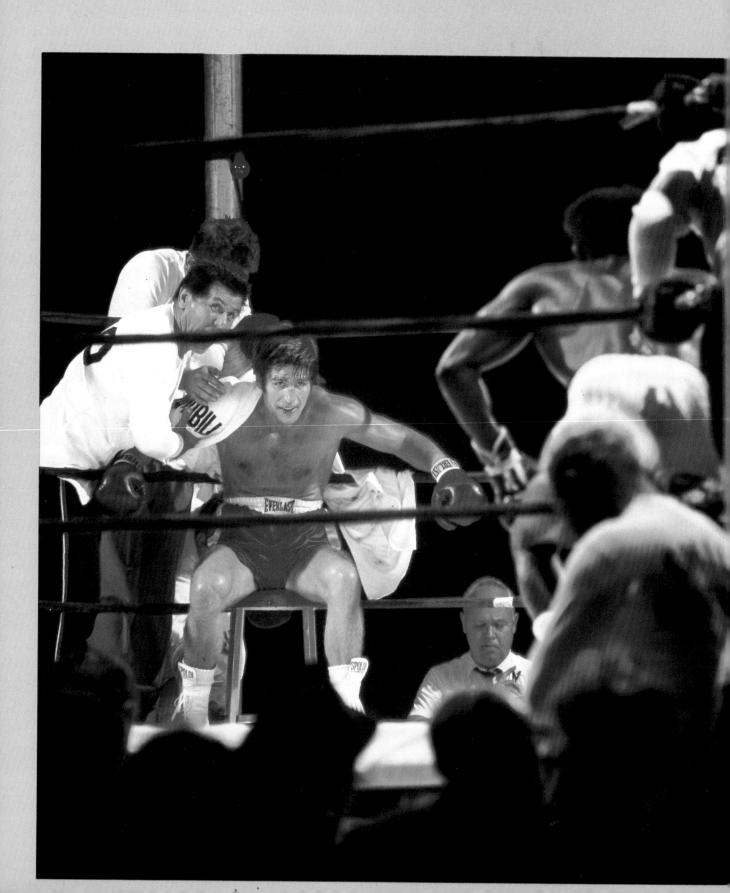

In Focus

Like many kids growing up on the Lower East Side of Manhattan, Neil Leifer was a sports fanatic. But Leifer was able to turn his childhood interest into his business, emerging as one of America's top sports photographers.

"To me, this has always been a profession," says Leifer, whose pictures were first published in *Sports Illustrated* when he was still a teenager. "My whole way of thinking has always been geared directly to the assignment I was on." He has obviously done his assignments well. For years he traveled the globe to cover the world of sports for *Sports Illustrated.* Today he is a staff photographer for *Time.*

While acknowledging that it takes talent and a certain instinct to photograph sports, Leifer attributes much of his success to preparation. "My strength comes from being well prepared and understanding what I'm going to do," he says. This means arriving at the stadium, arena, or other location hours or even days in advance. He checks the angle of the sun, looks for shadows that might mar his pictures, and selects appropriate camera positions. He also follows the sport he is photographing and studies the personal characteristics of key participants.

Wherever possible, Leifer looks for a unique approach that presents the sport in a different and exciting way. This photo of boxer Nino Benvenuti is unusual because the physical characteristics of the arena allowed Leifer to shoot through the ropes, instead of from the usual ringside or balcony positions. "The minute I saw the setup," he recalls, "I said, 'I want to shoot from there.'" Leifer chose a camera position behind the opponent so he would be looking into Benvenuti's eyes, and grabbed the picture right at the beginning of a round. A red gel over the background light intensified the color, making the scene even more dramatic.

Reflecting on his career so far, Neil Leifer is very happy with the life his photographic expertise has made possible. Among his greatest thrills have been the major Ali fights in Zaire and Manila, the Summer and Winter Olympics in Japan, and skiing in Colorado with President Ford.

"The camera was always my ticket," he says. "Coming from my background, that isn't something one could expect to do in a lifetime."

Photo by George Hiotas

Stage Performers

Like athletes, performers at such events as dances, plays, concerts, and circuses offer photographic opportunities filled with grace, color, and action. But the ease with which you can get good pictures depends on a number of circumstances.

Taking pictures during a performance in most theaters is usually prohibited. Professionals who cover stage performances try to stay to the back or sides of the theater or in the wings of the stage. They use quiet-shuttered rangefinder cameras or put their SLRs in soundproof housings. Another trick is to photograph only when a musical crescendo or audience reaction covers the click of the shutter.

Photographing a live performance is rife with other difficulties, chief among which is lighting. Performers are often spotlighted against darkness. If you rely on your camera's built-in metering system, you could easily make an overexposed image, since the meter would be misled by the large area of blackness. Instead, take a reading of the performer alone with a spot (narrow-angle) meter or with a long telephoto lens on the camera. Even when the entire stage is lighted, it's a good idea to take a spot reading because there is often much brighter lighting on the performers than on the backdrop. When you can't take a spot reading, a rough rule is that average stage lighting requires a setting of *f*2/8 at 1/60 second on ISO 400 film, with strong spotlighting requiring a stop or two less exposure. Even with these guidelines, however, it's a good idea to bracket your exposures one or two stops above and below this setting.

The unevenness of stage lighting can also result in contrasty images. If the subjects are properly exposed, the backdrop may appear much darker than you remember. Another problem in most theaters is that the raised stage requires you to use awkward camera angles, shooting upward from the orchestra or downward from the balcony. For these reasons, many theater photographers work at dress rehearsals. Without sacrificing spontaneity they can create more uniform lighting by leaving on the house lights, adjusting the stage lighting, or adding lights of their own. And they can climb ladders to get straight-on shots.

When working with existing light in a theater, you usually need all the film speed you can get. A good choice is 1000-speed color negative film.

Pete Turner/The Image Bank

Most photographers strive to get a close image of their stage subjects. But by letting this quartet of ballerinas appear small against a darkened background, noted photographer Pete Turner imparts a sense of the spaciousness of the stage and the feeling of being present at a performance.

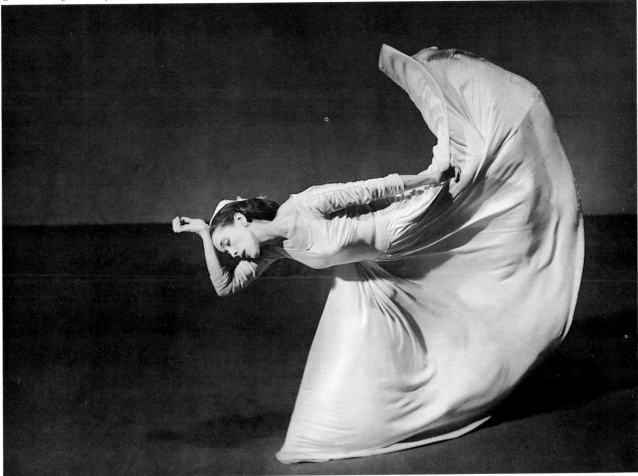

A striking position — one leg thrust in the air combined with the long, full skirt and contrasting dark background — permitted well-known photographer Barbara Morgan to take this dramatic portrait of dance legend Martha Graham.

Blur created by slow shutter speeds can suggest motion by performers. Here it conveys the furious swordplay of a group of dancers in bright Cossack tunics.

"I don't think much. I do," Martha Swope asserts about what goes into photographing theater and dance. "It's largely instinct and an ability to tune in to what is happening. You develop a way of absorbing yourself into the action so that you follow it intuitively."

Since becoming the official photographer of the New York City Ballet in 1958, Martha Swope has built a reputation as America's premier photographer of the performing arts. She originally trained as a dancer. Today she leads a hectic life running from ballet rehearsals to modern dance performances to Broadway openings, working for theatrical producers, dance publications, and major national magazines such as *Newsweek* and *People*.

Martha Swope has great respect for the actors and dancers she photographs. "They're a special breed," she says, "very hard-working, dedicated people." She sees her role as being the historian, the preserver of their art. "It is important to remember the moments of history in dance because they belong to the public."

Each type of production Swope covers – classical ballet, theater, modern dance – demands a unique photographic approach, which means that Swope herself must know a great deal about the state of the arts. "The more you know about dance itself or theater itself, the more you can contribute as a photographer," she says. Plays and musicals demand that you create an illusion that should be upheld if you are going to capture the magic. Modern dance can be photographed at many different points because of the fluidity, but ballet has certain peak moments that are the only ones you should capture. "There is a form to ballet that you must not betray. It is a disservice to photograph it incorrectly."

This picture of Baryshnikov in "Configuration," one of Swope's favorites, was obviously caught at just the right moment.

© 1982 by Delia Peters

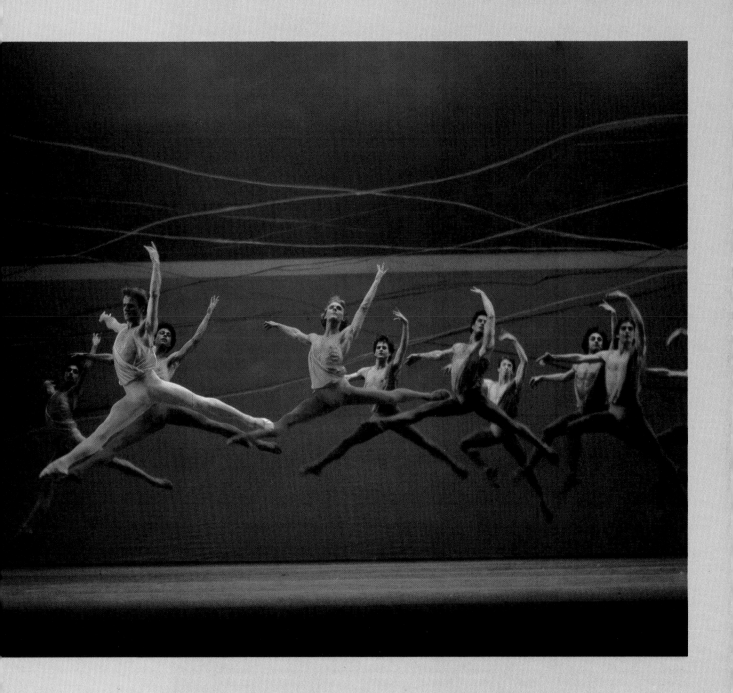

Fashion

Marcia Lippman

The simple combination of a flowered straw hat, cable-knit sweater, and pigtail suggests a young woman in springtime, while the misty, dream-like atmosphere hints at nostalgia for the past. The ethereal effect was achieved by using infrared film, which turns vegetation white and causes high-lights to spread.

Styles in fashion photography change almost as rapidly as the lines of the clothes themselves. But the function of the fashion photographer has always remained the same: to highlight a designer's work by evoking a certain mood or atmosphere. The results can be soft and romantic, as in the three pictures shown here, or hard edged, as in the pictures on the following pages.

The creation of a successful fashion photograph depends on a number of factors: setting, lighting, makeup, posing, clothing adjustments, and special effects, as well as the look and personality projected by the model and the rapport the photographer establishes with him or her.

For reasons of efficiency, most regular fashion photographs are taken in a studio, often against a plain sheet of seamless background paper. Sometimes props are introduced or sets constructed. Fashion photographers generally use a waist-level camera position because it makes the model look taller and thinner and emphasizes the clothing. They usually use a fine-grained film to get a sharply detailed image.

The lighting used in a fashion shoot depends on the effect the photographer wants to achieve, as well as the conditions on the set. Indoor settings can present the problem of mixing flash with existing incandescent lighting. Outdoors, the daylight has to be tempered with reflectors and fill flashes. Direct frontal flash is sometimes used to create bold, hard-edged effects. The best all-around illumination tends to be soft directional lighting from a flash bounced off an umbrella. This type of lighting, generally flattering to both the model and the clothes, is directional enough to reveal the drape and texture of cloth and the model's features. It can be supplemented with fill and back lights as well as reflectors. Fabrics may also dictate special lighting. Backlighting may be necessary to reveal the translucence of chiffon, strong sidelighting to show the texture of a nubby knot, or direct spotlighting to bring out the sheen of satin.

Marcia Lippman

A solid black background would normally be too severe for a fashion picture, but it works here by accenting the flaring skirt and outstretched arm of the model.

Kate Carter

In this airy, high-key photograph, the clothing's pristine styling, delicate texture, and fine embroidery are emphasized by the flowery backdrop paper and the demure way the model holds her hands.

211

Fashion

Fashion photography involves more than finding the best setting, lighting, camera angle, and special effects. It is also essential that the model create a mood. The feeling may be sweet and prim, exotic and mysterious, sophisticated and seductive, haughty and cold, or outgoing and athletic.

Sometimes the photographer has a specific composition in mind and positions the model carefully to achieve it, as in the picture of the woman in a hat below. More often, however, the photographer has several different ideas. For each, the photographer tells the model the feeling to be conveyed – then relies on the model's ability to act and present herself attractively.

With an experienced model, the photographer's directions are likely to be limited to suggesting minor adjustments in a stance, perhaps telling her to turn her head slightly more to the left or asking her to try a new pose. A professional model knows how to appear relaxed and natural, but she also knows the importance of such details as keeping her fingers close together and slightly cupped so her hands won't look awkward, as well as preventing an arm or leg from projecting toward the camera in a way that causes foreshortening.

Another important aspect of a model's appearance and the mood she projects is her makeup. She may apply it herself, but it is more often done by a makeup artist or the photographer's assistant known as a stylist. Most of the standard makeup tricks are used, such as applying highlighter to accent bone structure. But special emphasis is placed on clearly defining and giving prominence to the eyes and mouth. Extra care is taken in applying blusher to the cheeks, since it stands out darker and more contrasty on film than it appears to the eye. To prevent shiny highlights, skin must have a matte finish. The color of the eye shadow and lipstick is usually consonant with that of the outfit and setting. While makeup is likely to be exaggerated for full-length or three-quarter photos, closer views call for more subtlety.

It is also vital that the star of the fashion shot, the clothing, look its best. Stylists use tricks of the trade to assure that it appears pristine, with every pleat in place, and seems to fit the model perfectly. They rip seams or pinch excess fabric with clamps on the back of the garment out of the camera's view. Similarly, they shorten hems by turning under the edge and taping it and make oversized hats fit by stuffing them with tissue paper.

With the model's eyes hidden and her attire turned into part of a bold composition, all attention in this close-up is directed to the featured accessory, the black-enameled earring. Note how the model's dark lipstick stands out from the background.

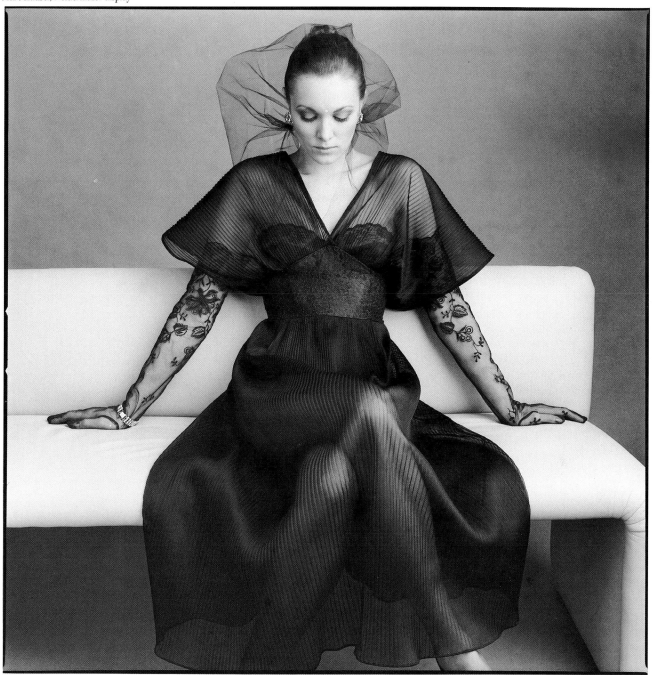

The erotic appeal of this sheer black lingerie was given a sophisticated, subdued tone by the stark setting, the model's unprovocative seated pose, and her chastely downcast eyes.

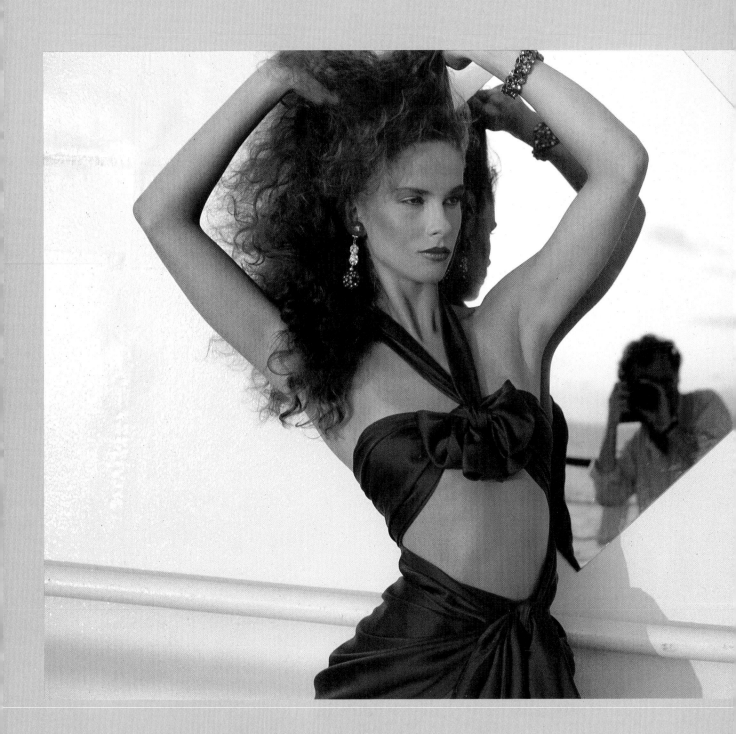

In Focus

"When I first started, I didn't know what I was looking for. I just responded."

It was that direct response, that spontaneity of vision, that made Bert Stern a photographic sensation while he was still in his mid-twenties. Over the last quarter-century his career has been one of the most successful and dramatic in the entire world of commercial photography.

From the beginning, Stern was attracted to beauty, and to truth. As a kid growing up in Brooklyn he always believed what he saw more than anything anyone told him. He loved the movies, for example, because they were simple and seemed more honest than the confusing jumble of life around him. He was fascinated by the glamorous, larger-than-life personalities on the silver screen.

Becoming a photographer seemed a natural step to Stern. With a camera he could translate his distinctive vision into lasting images. He was especially drawn to people and wanted to photograph beautiful women like the women he saw in the pages of *Vogue* magazine. Throughout his career he has photographed some of the most exotic women in the world, including Marilyn Monroe, the subject of his book, *The Last Sitting.*

"I'm good with people," Stern admits, but in this kind of photography, "it takes two to take a picture." He stresses the importance of working with his models on an emotional as well as technical level. "If you make contact, the picture snaps to life," he says. "If you don't, it's boring."

Stern uses music to aid the unique personal interaction, the "chemistry," that is necessary for a truly striking photograph.

Stern's particular talent, he acknowledges, is his ability to see photographically. "Somehow I have always been able to get a picture of anything I see," he says. He specializes in fashion photography because he likes working with beautiful women, and he finds the world of glamour intriguing. Although recognized as an artist in his field, Stern prefers magazines to galleries as a place to exhibit his work. "What's interesting to me," he confides, "is when a picture appears in a magazine and five million people turn to that page and stop."

Recognition of truth and instant response: these are still the core of Bert Stern's photography.

Photo by: Irving Penn

215

The Nude

The human body, with its grace of line and beauty of form, has long been celebrated in art. Properly rendered, the body has an appealing unique blend of the aesthetic and sensuous. Nearly all photographers agree that successfully photographing the nude ranks among the most challenging tasks in photography.

The challenge stems primarily from a photograph's ability to record details realistically. A painter can always improve a model's less-than-perfect proportions or ignore a skin dotted with goosebumps. And the painter's process tempers a picture's capacity to be provocative. Photography, by contrast, is much more immediate. The task of the photographer who wants to create a serious study of the nude is to find a form of expression – and the technical expertise necessary to achieve it – that avoids extremes. A number of elements go into achieving this balance – pose, camera angle, lighting, framing, setting, lens, and film. A simple, straightforward approach is usually best, especially at the beginning.

Seamless, studio-style backdrop paper provides the plainest setting, directing all attention to the model's body. You should choose the color to harmonize with or set off the body's color and its light or dark tones to establish an airy, high-key mood, a somber, low-key mood, or a neutral mood. Indoor backgrounds such as walls, drapes, rugs, floors, and bedspreads are easier to work with, especially for a beginner; they provide an attractive yet uncluttered setting, as in the view of a woman's torso at right.

When the nude is to be part of a larger environment, you should choose the setting with a preconception of how it will affect the image. It seems natural to have a nude in a domestic setting or an outdoor location that includes sand and water. But unexpected settings should contribute something to a picture. An appropriate location might be one that is compositionally striking – a triangular shape that frames the torso perfectly, an undulating form that repeats the body's curves, a pattern of stark, straight edges that contrasts with the body's roundness, or perhaps a pattern that complements the nude to create a mood or make a statement.

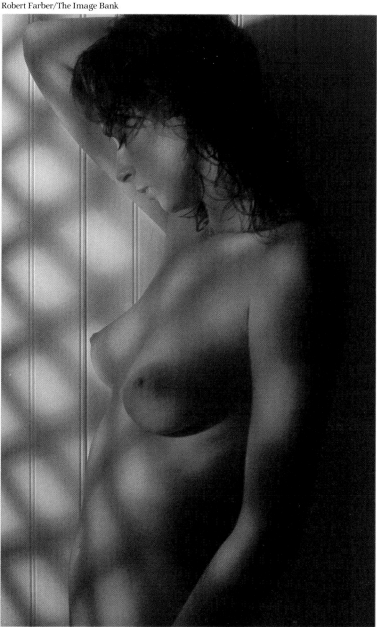

The intimate, informal mood of this study by Robert Farber comes for the most part from the warm light and the lattice shadow it casts along with the model's casual pose and uncombed hair. The simple wainscot backdrop helps convey the sense of an old – and comfortable – house.

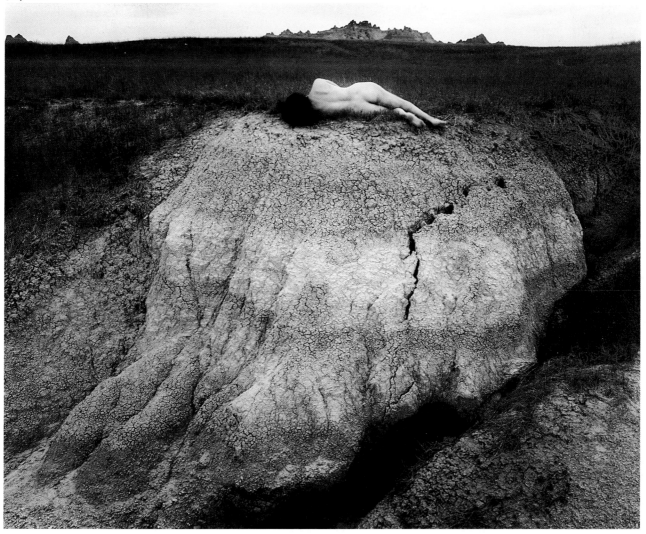

Photographer Judy Dater's choice of a stark, eroded setting for a nude study is highly unusual, but it gives the image a mysteriously surreal overtone. At the same time, the interesting visual interplay contrasts the model's soft body with the embankment's rugged texture, and her reclining position echoes the line of mountains in the background.

Posing the Nude

A good nude photograph almost invariably begins with thoughtful planning. You should always scout potential settings thoroughly – or decide on the background papers you want to use – and consider the kinds of poses you will want the model to assume and the camera angles you will use. As the pictures here show, there is an enormous difference between photographing the body from the front and in profile, between a recumbent figure seen from overhead and one at floor level, and between close-ups and full views.

In planning and directing poses, remember that a low vantage point makes the model look taller and emphasizes legs and torso. Think about how the model should hold her hands, since that element is most likely to ruin an otherwise attractive pose by looking ungainly and distracting the viewer. If you want to de-emphasize the model's hips, consider photographing them in profile or concentrating on her upper body. Similarly, having your model raise her arms lifts her breasts and makes her upper arms look thinner, throwing back her head makes her neck look longer, and reclining makes her stomach less prominent.

Poses in which the model's head is turned aside, buried in her hands, or covered by her upraised arms focus the viewer's attention on her body. In addition, they tone down the immediacy of the photographic image by making the subject appear detached and impersonal. When the model's face *is* shown, pay attention to her eyes. If she looks directly at the camera the image becomes much more direct and personal – and potentially provocative – than when her eyes are averted or hidden.

The lens you use obviously affects the model's appearance in the final picture. In general, the most effective lens is a medium (85 mm to 110 mm) telephoto. It avoids distortions, especially when you take close-ups, and it allows you to stay far enough back so the model doesn't feel crowded. For long shots in cramped settings, you may have to use a normal or a wide-angle lens. With a wide-angle lens, be sure to keep all of the model's body in a plane parallel to that of the camera.

Robert Clemens

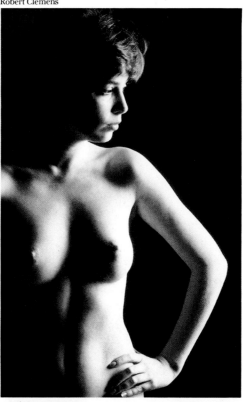

A frontal view of a standing nude represents our customary conception of the body. The pose tends to be neutral, neither adding interest to nor detracting from the image. The picture is usually improved by being taken from well below eye level to emphasize the body.

Robert Clemens

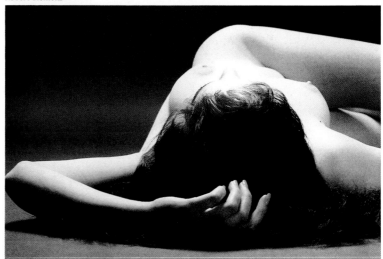

A very low viewpoint of the reclining nude, from either the head or feet, is one of the most radical you can take. It creates strikingly original images but requires careful posing of the model to avoid awkward-looking results. Be careful with your choices of lens, too. A wide-angle lens would have made this model's hand and head enormous, while a telephoto lens would have made her hip and leg appear to be closer and proportionally larger.

Robert Clemens

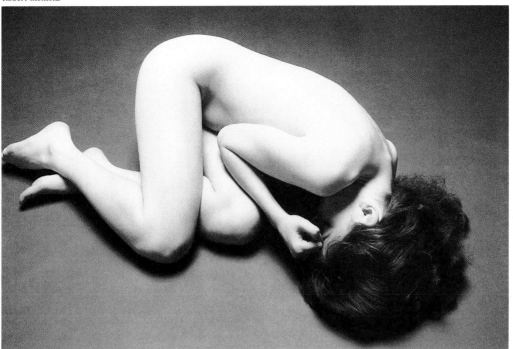

A high camera position, almost directly overhead, shows the body from an unusual angle that has more visual interest than conventional side views of a resting figure. It does, however, make the model seem less significant, so the viewer observes her with more detachment.

Robert Clemens

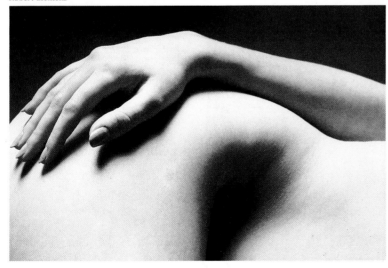

Robert Clemens

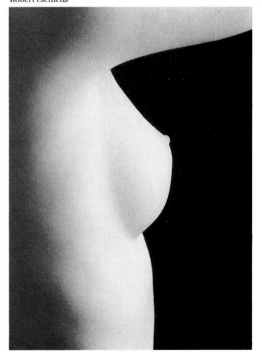

Close-ups of details of the body offer many intriguing possibilities. You can either try to isolate and emphasize the lines of one figure segment or, as with the hand and hip here, you can deliberately contrast two parts of the anatomy.

A profile view of a figure tends to make it more detached and impersonal than a front view, especially when the face is not shown. But it is not as anonymous as a back view. Whatever the vantage point, keep the arms separated from the body to avoid obscuring the lines of the torso.

219

Lighting the Nude

In general, the best lighting to use in photographing the nude is soft and directional. A classic example is the light from a north-facing window, a light that has long been a favorite of artists. When it comes from one direction, the light highlights one side of the body and creates shadows on the other, emphasizing the body's full three-dimensional form. At the same time, because it is soft and diffuse, the light makes the transition from bright to dark areas in a slow, even manner; the difference between the lightest and darkest areas is not as great as with harsh direct illumination.

Soft light also treats the skin gently and gives the image a tactile edge. It suggests the texture of the skin and hair without spotlighting every pore and crease. It does not create the impenetrable, sharp-edged pockets of shadow that unfiltered, unreflected light from the sun or a flash does.

Indoors, a window provides the simplest and easiest-to-use source of soft light. (If direct sunlight pours into the best available window, you can rig a sheet or sheer curtain to diffuse the light.) A floor-length window is preferable for full-body standing poses, but it's possible to work by a window with a raised sill if you concentrate on only the parts of the body that are well lighted or move the model farther away from the window.

The position of the camera and the angle of the model to the window determine the relative amounts of highlighting and shadow on the body. When you are off to the side of the window and the model is standing by it, facing you, about half her body will be in shadow. If she turns so she is at about a 45° angle to the window and you photograph her diagonally, less of her body will be in a shadow. If she faces the window and you photograph her straight on, say, from outside through the window, there will be minimal shadowing. And of course, if you photograph her in the exact opposite position, with the window behind her, she will be silhouetted.

The closer the model is to the window, the greater the contrast between highlighted and shadowed areas of her body. Even though the light is soft, it is best to fill in the shadows. The easiest way to do this is with a large reflector, ideally one approximately the height of the model and about three feet wide with a white or crinkled aluminum foil

A split-second burst of direct backlighting from a flash froze the highly dramatic spill of hair. The sense of excitement and action is enhanced by the graininess of the image.

David Hamilton/The Image Bank

surface. The amount of fill light will vary, depending on how close to the model you place the reflector. You can also use a fill flash (see pages 100-101) or, with black-and-white film, ordinary household lights. Since window light is often relatively weak you may find it necessary to use a tripod.

It is easy to photograph a figure outdoors by natural light when haze or high, thin clouds soften the harshness of the sunlight but leave it somewhat directional. You shouldn't need a reflector if there are enough surrounding light-toned surfaces to act as natural reflectors. With its warm hues and angular direction, the light of early morning and late afternoon, even on a clear day, can be very attractive, imparting a glow to the skin and emphasizing the body's rounded form. If you have no choice but to work on a bright, clear day, avoid midday, when the sun is directly overhead, and carefully position a reflector or flash to fill in the strong shadows the sun creates.

Any number of artificial lighting arrangements can be used with the nude – producing rim and backlighting effects as well as various balances of main and fill lights. But the simplest arragement often provides the most satisfactory results. Try simulating soft light from a window by bouncing a flash or studio light off a large umbrella or by filtering the light through a large diffusing screen. Use a reflector opposite for fill. After you have mastered this technique, experiment with more complex arrangements (see pages 102-103).

In most cases, you will want to photograph a figure as sharply and clearly as possible by using fine-grained, slow-speed film. But you may occasionally want to use a fast or ultrafast film, even pushing it for an intimate view in a dim interior or a dramatic, grainy effect in an action study, as in the picture of the model with cascading hair at left. In selecting film for a nude picture-taking session, remember that color is tricky to work with, requiring restraint in posing and framing because it heightens a photograph's realistic immediacy. Black-and-white film, on the other hand, has a slight distancing effect, making even an active nude seem subdued and classic.

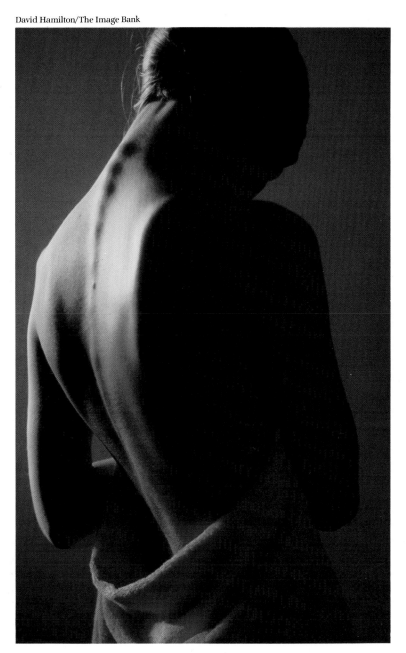

David Hamilton, a photographer noted for his romantic nudes, used directional light from the side and rear to create this striking study. Note how the light produces edge lighting that outlines the model's left arm.

221

The Abstract Nude

The human body, like a landscape or a still life, is exceptionally well suited for studies in which its form is abstracted and treated in a detached, controlled manner. The body provides an array of torso curves and limb angles with which light can interact in a variety of subtle and dramatic ways, creating rough and delicate textures, round forms, and flat shapes.

A popular way to create an abstract study is to move in for a tightly framed close-up of part of the body. In such photographs, the body is most often posed against a plain, undistracting backdrop, but you may at times want to frame the image so tightly that it is all body with no background visible. You may sometimes want to introduce in the setting an element that echoes the body's form or provides a provocative contrast. The result of such close-ups can be strikingly simple, as in the photograph of a torso at right above, or complex and puzzling, as in the picture of arms at right below. The result can also be highly sensuous, as in the photograph of the nude in water.

The nude can be used to create an abstract image in a number of other ways. It can be photographed from an unusual angle, distorted by a lens, broken into multiple images, or hazed over by a lens attachment. It can be darkened into a silhouette or framed by an environmental element. Or the model can be instructed to assume an unexpected pose that creates an eye-catching shape. The nude can also be reduced to a small but significant element in a larger setting, as in the picture at far right.

Although outdoor scenes are sometimes highly effective, an abstract nude study requires precise control of details, which is easier to achieve in a studio or other indoor setting. Unlike other nude photos, an abstract study may work well with harsh directional lighting. Shining straight on the model from camera position, it can turn the body into a flat shape. From the side, it can turn the body into a pattern of light and dark, since it produces a strong contrast between bright and shadowed areas. A medium telephoto lens is generally best for undistorted, tightly framed close-ups. And a tripod is nearly always necessary as an aid in careful framing and posing.

Jan Cobb/The Image Bank

John Lundberg

Careful posing and framing combine with dramatically strong sidelighting to produce this deceptively simple image in which the model's long torso creates a curving pattern of light and dark against the neutral backdrop.

Two arms, one from each of two models, were entwined and tightly framed to produce this puzzling pattern of lines. Such images are made to appear flat by the use of strong front lighting, which keeps shadows to a minimum, and a telephoto lens, which compresses near-to-far space.

In this surreal image by Judy Dater, a nude figure is an unexpected presence in a seemingly hostile and alien landscape. Low, raking light creates the long shadows that emphasize the rockiness of the terrain. It also heightens the figure's abstract, sculptural form.

Isolated in water, a model's back presents a voluptuous, smoothly textured body landscape. The strong overhead light creates shimmering highlights that add a lustrous, sun-drenched quality.

Nude Portraits

The nude in an abstract study is treated like an object in a still life. When the nude becomes a subject for a portrait or an interpretive image, the approach is just the opposite. In posing the nude for a portrait, the photographer explores and brings out the personality of the model, as in the picture of the woman looking over her shoulder at far right above. In an interpretive picture, the model is the medium for conveying a mood or feeling or making a statement, as in the picture of the woman on the stairs at far right below. The emphasis is not, as in an abstract study, primarily on achieving a visual effect. Equal stress is placed on telling the viewer something about the model as a person or about the photographer's perception of the world. Either way, we sense that the subject is not a mere study in form but a real individual with whom we can identify.

Posing is still important in such photographs. To convey a sense of the subject's personality, showing the face is almost always essential. For effect, however, the face may be somewhat obscured, as in the picture here of the woman in a chair, but the overall image still conveys a feeling for the person's individuality. The choice of a setting can also be important, and you should find one that expresses the mood. This is especially true for an interpretive picture, where the setting, juxtaposed with the nude figure, often carries the message. Even so, be careful to keep the setting relatively simple and visually undistracting.

Photographing nudes this way can be challenging for the model as well as the photographer. The model need not be professional. Indeed, an average-looking person may lend the picture a more realistic feeling and evoke a sense of identification in the viewer. But the model must also be able to convey a completely relaxed and natural air in front of the camera. For the photographer, the challenge is to take a picture that is at once an astute, well-composed study of the human form and an insightful look at a person. This unique challenge draws on all the skills of a photographer who is intrigued by people.

Judy Dater

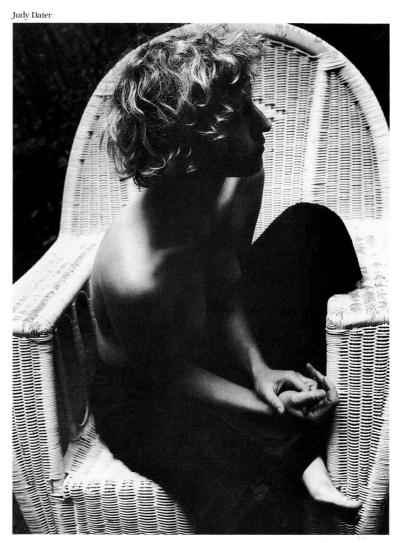

Although the subject is almost fully silhouetted, the clear profile of her face, her tousled hair, and her curled-up body all contribute to revealing the subject's personality.

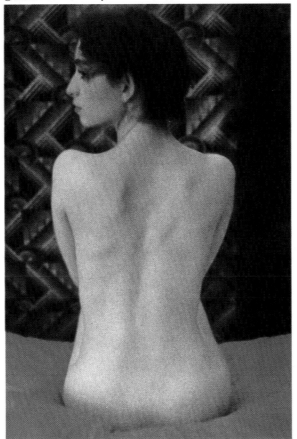

Had the subject's head been turned away from the camera, this photograph would have been most notable for the subtle interplay of color. But with the model's face visible it becomes an intriguing portrait of a young woman.

Linda Benedict-Jones

The unexpected presence of a nude on a barren, seemingly endless stairwell gives an eerie, dreamlike quality to this picture, a self-portrait of the photographer. The effect is heightened by the crouched, self-protective position of the body and the photograph's dizzying downward perspective.

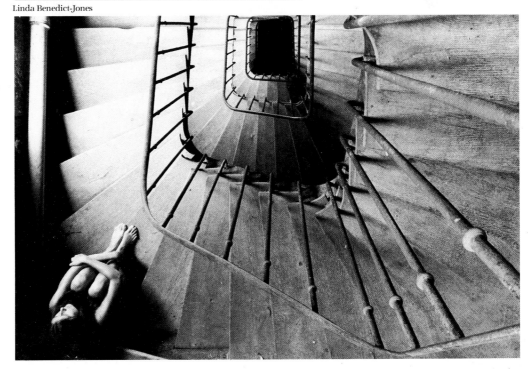

In Focus

"Even today I am as impressionable as a young boy when encountering the nude," says Lucien Clergue, the French photographer who has specialized in photographing nudes for almost thirty years. Clergue's openness is evident in his pictures. They are always fresh and healthy; they celebrate the human form, showing it simply – often playfully – in natural and constructed settings.

Clergue grew up in Arles, in southern France, where he still lives. As a child, he was impressed by the liveliness and glamour of the local prostitutes who frequented his family's grocery store. Later, he studied the structure and proportions of ancient Roman sculptures in the museum near his home. He gravitated quite naturally to nude photography.

Most of Lucien Clergue's early pictures were done on the beaches of the Mediterranean near Arles. Over the years, he has worked with many models, most of them amateurs, and toyed with themes taken from his long-standing interest in mythology. More recently, he has traveled as far as the deserts of California to make his sometimes mysterious, sometimes joyful, always very human images.

This picture, taken in 1971, was part of Clergue's exploration into the myth of the birth of Venus. Clergue's own fascination with the photograph has to do with the lines of the model's body, particularly the graceful arc from the woman's breast to her buttock. He also likes the glimmer of light under the torso that separates her body and the sea.

Clergue considers the interaction between photographer and model to be crucial to the success of nude photography. He claims that he always feels honored when a person agrees to take off his or her clothes for him, and cautions photographers to do what is necessary so that the men and women who pose nude feel natural. Clergue also encourages students to make their nude photographs very personal, to experiment and be guided by their own biases and beliefs. Finally, he is adamant that the model be a creative force, too. "The model must participate," he reminds novices. "Otherwise you can't have any sort of success."

Photo by Robert Durand

Appendix

Albums

Although much of the joy of photographing people centers on planning and taking pictures, the ultimate treat comes in seeing and sharing the resulting images. One of the best and most common ways is with a photo album. Albums are available in a wide variety of styles. Some have flippable plastic sleeves that hold individual snapshots. The more traditional albums with pages come in several sizes, and some require mounting the pictures with an adhesive or mounting corners. Others have fine lines of adhesive on the page to which you can attach your photographs. You peel a thin plastic overlay away from the page, position the photos, then return the overlay across the page to hold your work in place.

When buying an album, look for one made of acid-free materials, which are safe for photographs. As other materials age they may release chemicals that can damage photographs. Similarly, it is safest to use adhesives designed specifically for mounting photographs – especially if they are older prints on a paper base. But even with photographic mounting cement you must be careful. The pages of some albums contain dyes that can be leached out by solvents in the adhesive, thereby staining the paper print. To prevent this from happening, let the mounting cement get tack-dry before positioning the photograph. Prints can also be put in an album with mounting corners, and ones made of clear, acid-free plastic are available in photography stores. Yet another convenient way to mount prints is with double-sided adhesive tape.

Unless your album has protective plastic covers for each page, it is best not to mount prints on facing pages to avoid any possibility of the prints scratching, embossing, or adhering.

Whatever type of album you get, try to make it as visually interesting as possible. Edit your pictures carefully with an eye to eliminating unattractive and redundant photos; keep only the best images. If possible, try to arrange the pictures in a sequence so they tell a story. With larger albums, consider having one picture on every two-page spread enlarged for visual variety. And you should also consider cropping a print if it will heighten its impact. It is easy to determine how a cropped picture will look by using two L-shaped pieces of paper to frame the subject.

Martin Czamanske

Along with the traditional catch-all family album, you should think about compiling albums that are more specialized. Some parents keep an album for each child. Many people like to keep a separate album for vacation pictures or for one very special trip. And people have always made albums for special occasions like weddings.

For greatest longevity, store your albums in a cool, dry place. Heat and humidity can be especially damaging to photographic materials. Also, always store your albums upright, and don't crowd them close together.

As this proud parent's label indicates, many people find it advantageous to keep albums on individuals, especially children, who seem to grow up so rapidly.

Martin Czamanske

As this diverse collection of albums shows, the major choice to be made is between ones that display snapshots individually and larger albums that show more pictures at once. Either way, it's best to get an album with protective plastic covers for the photographs.

Martin Czamanske

Martin Czamanske

Martin Czamanske

Displaying Your Photographs

Show off your very special photographs by displaying them. Exactly how you display photos is largely a matter of preference, but you should keep a few points in mind. Select pictures that are visually strong, ones that will catch the eye of the viewer. Since photographic prints, especially pictures of people, are rarely large, you should consider grouping them. They can be arranged in an attractive pattern on the wall or stood in a cluster on a side table or desk. In such arrangements, add visual variety by using photographs of different sizes and perhaps different frames that go well together. Keep in mind, however, what the arrangement implies about the relationships between the people in the pictures. Always display your photographs where a visitor can easily view them at close range. Avoid placing the pictures in direct sunlight or near fluorescent fixtures, as both tend to fade color images quickly. If you light the pictures with overhead track lighting, make certain that the lights don't produce a glare on the surface of the glass.

There are a large number of ways to frame and mount prints for display. The selection should depend in good part on the mood of the picture. An elaborate, old-fashioned frame may be perfect for setting off an old and treasured family portrait, while a modern frame may be more suitable for a bold geometrical picture. When you look for a frame, be sure to take the picture with you to see how it looks in different frames. You should also consider how the image will look with a mat around the edges. If you can't find a ready-made frame that you like, you can have one custom-made; most framemakers have an enormous selection. If you want a simple gallery-style mounting, kits are available for assembling plain metal frames and glass-and-board sandwiches held together with clips. As with albums, always make sure the frame and mounting materials, such as the cardboard backing the print, are acid-free and safe for photographs.

Norman Kerr

This array shows just some of the many ready-made frames available. Oval frames can be interesting when they repeat the shape of the face or some other oval element in the picture.

Norman Kerr

Custom frames cost more than ready-made frames, but they come in a much wider selection of styles, as evidenced by the rows of samples in the background of this frame shop.

Martin Czamanske

*A simple modern frame
perfectly suits this angular
and fragmented figure
study.*

Norman Kerr

Sam Campanaro

*Each of these stand-up
frames has a different
style – one suited to the
style and period of the
image it contains. Even
so, they go together in a
manner as eclectic as
memories.*

*Pictures of different sizes
and frames of different
styles add visual interest to
this collection of a family's
favorite portraits.*

Restoring Old Photographs

Restoration by Joe Valenti

Some of your most valuable pictures may be old photographs of family members. The passage of time may have caused them to fade, discolor, or crack – the cumulative effects of exposure to light, heat, humidity, dust, soiled hands, and perhaps fungus or insects. They might be torn or folded, written on, or yellowed from tape or glue used to mount them. Most damaged images can be restored by copying them photographically and retouching the resulting print or negative. Never attempt to make corrections on the original. Depending on your skills and interests, you can do it yourself or have it done professionally.

One of the chief problems with very old black-and-white photographs is fading. One solution is to copy the image on a panchromatic, continuous-tone film. And usually, since the image has yellowed uniformly, the copying is done through a No. 47 blue filter. Blue absorbs yellow, its photographc complementary color, thus restoring contrast to the image. Filters can also be used to remove stains, provided the stains are not so dark that they obscure the image. The general rule is to use a filter the same color as the stain. For example, the yellow areas left by tape or improper fixing when the image was processed can often be removed by photographing the image through a No. 15 deep-yellow filter.

When a photograph is scratched, cracked, or similarly marred, it is usually necessary to retouch the copy print. Such corrections require the skillful application of special transparent photographic dyes with a brush. The dyes for black-and-white prints come in three tones of black – warm, cool, and neutral. To the neutral tone is added warm or cool dyes to match the print – warm dye if the print is brown-black, cool dye if it is more blue-black. Similar warm, cool, and neutral tones of opaquing materials can cover dark spots, although most professionals prefer to do this with an airbrush or by retouching a large-format negative. Special dyes are available for retouching color prints.

A copy of the badly damaged original at far left was retouched not only to correct the blemishes but also to lighten the background so that the woman's hair would stand out against it, framing her face.

Restoration by Joe Valenti

The only remaining photograph of a family member is not necessarily lost if it is damaged. Even an image as heavily scarred as this one at left can be professionally restored using several retouching techniques.

Collection of Keith Boas

When you want an individual portrait of a person who lived in the past you can sometimes obtain one from a group shot. This portrait was copied and enlarged from a family grouping. Then it was retouched and sepia-toned to give it a period look.

Bibliography

Boys, Michael. **The Book of Nude Photography.**
New York: Alfred A. Knopf, 1981.

Busselle, Michael:
The Complete Book of Nude and Glamour Photography.
New York: Simon and Schuster, 1981.
The Complete Book of Photographing People.
New York: Simon and Schuster, 1980.

Cappon, Massimo, and Zannier, Italo. **Photographing Sports.**
Chicago: Rand, McNally, 1981.

Daval, Jean-Luc. **Photography: History of an Art.**
New York, Rizzoli International, 1982.

Dennis, Lisl. **How to Take Better Travel Photos.**
Tucson, Arizona: HP Books, 1979.

Editors of Eastman Kodak Company, Rochester, New York:
Adventures in Existing-Light Photography (AC-44). 1980.
Electronic Flash (KW-12). 1981.
**Filters and Lens Attachments for Black-and-White and Color
Pictures** (AB-1). 1980.
The Here's How Book of Photography, Volume II (AE-101). 1977.
How to Take Good Pictures (AC-36R).
New York: Ballantine Books, 1982.
The Joy of Photography.
Reading, Massachusetts: Addison-Wesley, 1979.
KODAK Films—Color and Black-and-White (AF-1). 1981.
KODAK Filters for Scientific and Technical Uses (B-3). 1981.
KODAK Gray Cards (R-27). 1982.
KODAK Guide to 35 mm Photography (AR-22). 1983.
KODAK Infrared Films (N-17). 1981.
KODAK Master Photoguide (AR-21). 1981.
KODAK Pocket Guide to 35 mm Photography (AR-22).
New York: Simon and Schuster, 1983.
KODAK Professional Photoguide (R-28). 1981.
More Joy of Photography.
Reading, Massachusetts: Addison-Wesley, 1981.
The Ninth Here's How (AE-95). 1976.
Photo Decor (O-22). 1982.
Photographing with Automatic Cameras (KW-11). 1981.
Preservation of Photographs (F-30). 1979.
Professional Portrait Techniques (O-4). 1980.
The Tenth Here's How (AE-110). 1982.
Using Filters (KW-13). 1981.

Gatewood, Charles. **People in Focus.**
New York: Amphoto, 1977.

Gowland, Peter. **The Secrets of Photographing Women.**
New York: Crown Publishers, 1981.

Hattersley, Ralph:
Beginner's Guide to Photographing People.
New York: Doubleday, 1978.
**Beginning Photography: Beginner's Guide to
Photography.** New York: Doubleday, 1981.

Hedgecoe, John:
The Art of Color Photography. New York: Simon and Schuster, 1978.
The Book of Photography. New York: Alfred A. Knopf, 1976.
John Hedgecoe's Complete Course in Photographing Children.
New York: Simon and Schuster, 1980.
John Hedgecoe's Pocket Guide to Practical Photography.
New York: Simon and Schuster, 1979.
The Photographer's Handbook. New York: Alfred A. Knopf, 1979.

HP Books, ed., Tucson, Arizona.
How to Photograph People. 1981.
How to Photograph Women. 1981.

Izzi, Guglielmo. **Photographing People: The Creative
Photographer's Guide to Equipment and Technique.**
New York: Watson-Guptill, 1982.

Kobre, Kenneth. **How to Photograph Friends and Strangers.**
Somerville, Massachusetts: Curtin and London, 1982.

Leckley, Sheryle and John.
Moments: The Pulitzer Prize Photographs.
New York: Crown Publishers, 1982.

Langford, Michael:
Basic Photography, 4th ed. New York: Focal Press, 1978.
Better Photography. New York: Focal Press, 1978.
The Step-by-Step Guide to Photography.
New York: Alfred A. Knopf, 1978.

Lewinski, Joyce, and Magnus, Mayotte.
The Book of Portrait Photography.
New York: Alfred A. Knopf, 1982.

Manning, Jack. **Fine 35 mm Portrait.**
New York: Amphoto, 1978.

Mark, Mary Ellen. **Falkland Road: Prostitutes of Bombay.**
New York: Alfred A. Knopf, 1981.

Meyerowitz, Joel:
Cape Light. Boston: Museum of Fine Arts, 1978.
St. Louis and the Arch. Boston: New York Graphic Society, 1980.

Newhall, Beaumont. **The History of Photography: From 1839 to
the Present Day, 5th ed.** Boston: The New York Graphic Society, 1982.

Nibblelink, Don D. **Picturing People.**
New York: Amphoto, 1975.

Nibblelink, Don D., and Monica. **Picturing the Times of Your Life.**
New York: Amphoto, 1980.

Patterson, Freeman. **Photography and the Art of Seeing.**
New York: Van Nostrand Reinhold, 1979.

Sahadi, Lou, and Palmer, Mickey. **The Complete Book of Sports
Photography: How to Take Quality, Action-Packed Pictures of
Amateur and Pro Sports.**
New York: Watson-Guptill, 1982.

Scanlon, Mark, and Grill, Tom. *The Art of Photographing Women.*
New York: Watson-Guptill, 1981.

Slavin, Neal. *When Two or More Are Gathered.*
New York: Farrar, Straus, and Giroux, 1976.

Swedlund, Charles. *Photography: A Handbook of History,
Materials, and Processes.*
New York: Holt, Rinehart, and Winston, 1974.

Swope, Martha:
Baryshnikov on Broadway. New York: Crown Publishers, 1980.
*A Midsummer Night's Dream: The Story of the New York City
Ballet's Production,* Nancy LaSalle, ed. New York: Dodd, Mead, 1977.
The Nutcracker, New York: Dodd, Mead, 1975.

TIME-LIFE Library of Photography, Alexandria, Virginia:
TIME-LIFE, INC.:
Photographing Children. 1971.
Special Problems. 1982.

Wade, John. *Portrait Photography.*
New York: Focal Press, 1982.

Welsch, Ulrike:
The World I Love to See.
Boston: The Boston Globe/Houghton Mifflin Company, 1977.
Faces of New England. Dublin, New Hampshire: Yankee Books, 1983.

Wiener, Leigh. *How Do You Photograph People?*
New York: Viking Press, 1982.

Index